THE
ANDES
AS THE CONDOR FLIES

TUI DE ROY

FIREFLY BOOKS

A FIREFLY BOOK

Published by Firefly Books Ltd. 2005

First Printing

Publisher Cataloging-in-Publication Data (U.S.)

De Roy, Tui.
 The Andes : as the condor flies / Tui De Roy.
[160] p. : col. photos. ; cm.
Includes index.
Summary: Examination of the Andes Mountain chain in South America, including geography, geology, vegetation and animal life, in particular the Andean condor.

ISBN 1-55407-070-8
1. Andes. 2. Natural history -- Andes. I. Title.
918 22 F2212.D47 2005

Library and Archives Canada Cataloguing in Publication

De Roy, Tui
 The Andes : as the condor flies / Tui De Roy.
Includes bibliographical references and index.
ISBN 1-55407-070-8
 1. Andes—Guidebooks. I. Title.
F2212 D47 2005 918.04'4 C2005-900492-4

Published in the United States by
Firefly Books (U.S.) Inc.
P.O. Box 1338, Ellicott Station
Buffalo, New York 14205

Published in Canada by
Firefly Books Ltd.
66 Leek Crescent
Richmond Hill, Ontario L4B 1H1

Front cover: The full moon sets over Hualca Hualca at dawn in southern Peru. MARK JONES.
Back cover: Andean condors on the edge of Colca Canyon in southern Peru.
Front flap: Andean condor.
Back flap: Author photo. MARK JONES.

Editorial services: Jeanette Cook
Index and glossary: Mark Jones
Book design: Jag Graphics
Printed in China through Colorcraft Ltd.

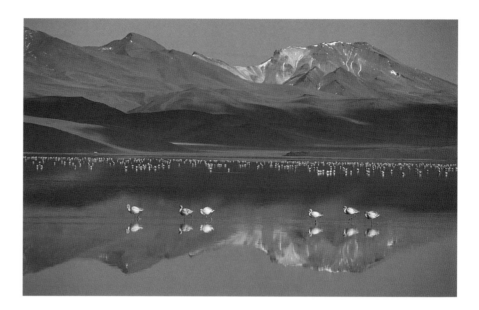

Small feeding flocks of the rare James' flamingos spread out across the mirror-smooth waters of Laguna Colorada in southern Bolivia.

Photographer's Note: All photographs in this book are by Tui De Roy except where credited to Mark Jones. None of the images have been altered digitally or otherwise retouched. They are all taken in wild and free conditions, except for the following where the animals were captive: spectacled bear (pages 18 and 25); Andean condor (pages 28 and 72); taruka (page 52); puma (pages 52 and 121); pudu (page 121).

PAGE ONE: *Condors soar over the mist-filled gorge of Peru's Colca Canyon on the first thermal updraft of the morning.*
PAGE TWO: *The splendid granite peaks of the FitzRoy Massif glow in the sunrise on the Argentine side of the Andes, while storms brew on the Pacific seaboard.*
PAGE THREE: *An Andean condor soars above the Chila mountains of southern Peru.*
PAGE FIVE: *Caught in slow motion, a rufous-tailed hummingbird hovers briefly before vanishing in the cloud forest of Ecuador.* MARK JONES.
PAGE SIX: *The wet paramo grasslands of the rolling Andes of northern Ecuador and Colombia are studded with tall* Espeletia *plants, called frailejon by the locals.*
PAGE EIGHT: *Two- or three-week-old baby vicuñas play away from the herd amid frosty ichu grass shortly after sunrise on Peru's high puna plateau.*

This book is dedicated to the special people who, each in their own unique way, have helped it to evolve from an idea into reality.

To my parents who bred into me the capacity to dream – my father André whose dreams are all that remain, and my mother Jacqueline who dreams with us still.

To Alan, with whom I began my Andean explorations long ago, and to Mark for sharing their magic for the last 22 years.

And to those, unnamed, whose spirits soar as vividly as the condor flies; two of whom reside deep within my soul.

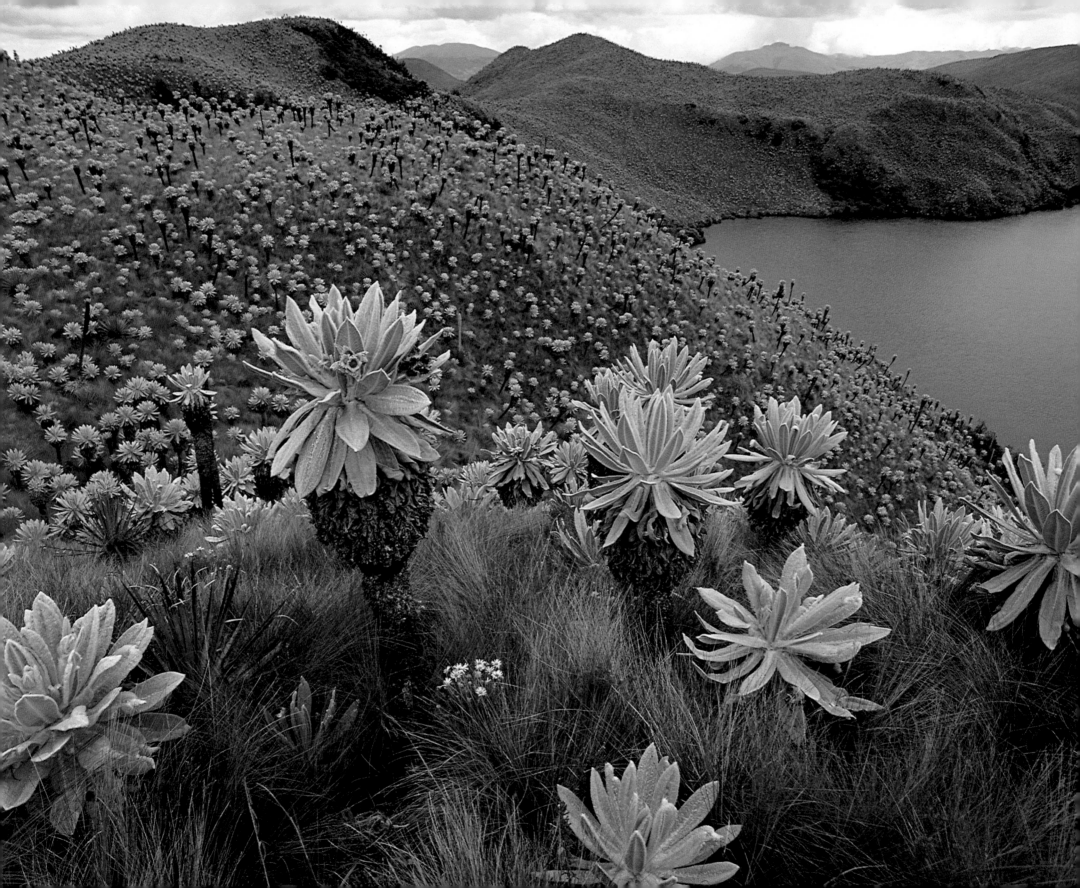

ACKNOWLEDGEMENTS

It may not come as a surprise that a book that spans the longest mountain chain on earth, and was almost a third of a century in the making, should have relied on an inordinate number of people to come into existence. Indeed, so many have contributed their knowledge and shared precious experiences that it would be quite impossible to list them all individually. By reflecting on just a sprinkling of those special moments and unique ways in which they gave to this project, I would like to express by inference my deepest gratitude to all the many more whose names will not figure.

In the very beginning, I thank Jack Couffer (who gave me my first professional camera), David Cavagnaro (who taught and inspired me with his own work), George Lindsay (who entrusted me my first solo audience) and Les Line (who gave light to my teenage images in *Audubon* magazine) for launching me, unawares, into the wonderful realm of nature photography. Jonathan Fisher and Barbara Burn, in publishing much of my later work, coaxed and shaped my career as an author/photographer.

Out in the wilds, Raymond Leveque and Mike Harris opened my young eyes to the mysteries of little-known birds, and Tom Simkin bestowed upon me a fascination for active volcanoes. By giving me my very first job and trusting me implicitly to run parts of his business when I was just 18, Julian Fitter gave me the wings to fly towards numerous explorations to follow. Just short of my 20th birthday, Allen Steck introduced me to mountain climbing and my very first icy Andean summits.

In the decades that followed, innumerable friendships have been cemented through a common interest in the Andes, and all have given freely toward the completion of this book. In Ecuador I'd like to thank Minard (Pete) Hall, Patricio Ramon, Marcela Garcia, Sylvia Harcourt-Carrasco, Alfredo Carrasco, Jim Claire, Friedemann and Heide Koester, Fernando Polanco, among others, for their enthusiasm and invaluable help. Richard Parsons of Bellavista Nature Reserve and Murray Cooper deserve special mention for opening the doors to the bird magic of the cloud forest for me.

In Peru, my admiration goes to several pioneers in conservation: Heinz Plenge for his incredible work on behalf of the beleaguered spectacled bears of Chaparri, Mauricio de Romaña's efforts towards the Andean condors of the Colca Canyon, Kurt Holle and Eduardo Nycander with macaws in the Andean foothills of the upper Amazon, Antonio Brack, Catherine Sahley and Zenon Wharthon for giving a future to the magnificent herds of vicuñas, as well as Stephan Austermulle and his colleagues for their enthusiasm and conservation leadership. In Bolivia, my respect and thanks go to Omar Rocha, Georgina Gonzalez and Alvaro Baez for making my recent venture in the Altiplano a success and for their work to preserve its flamingo paradise. Likewise in Chile and Argentina there are many staunch advocates of the mountainous wilderness.

Although dedicated to him in part, I would like to reiterate my profound appreciation to Mark, my partner, for sharing in every aspect of the spirit that this book is made of, as well as all of the very real support throughout thousands of miles of South American dust, not to mention the contribution of 27 of his splendid photos and the very detailed index in this book. To Deb, my assistant, thank you for your attention to detail.

And finally, I would like to express my gratitude to Tracey Borgfeldt and Paul Bateman, my New Zealand publishers, for their support, patience and trust in making this book far more to me than a mere document of a distant mountain chain.

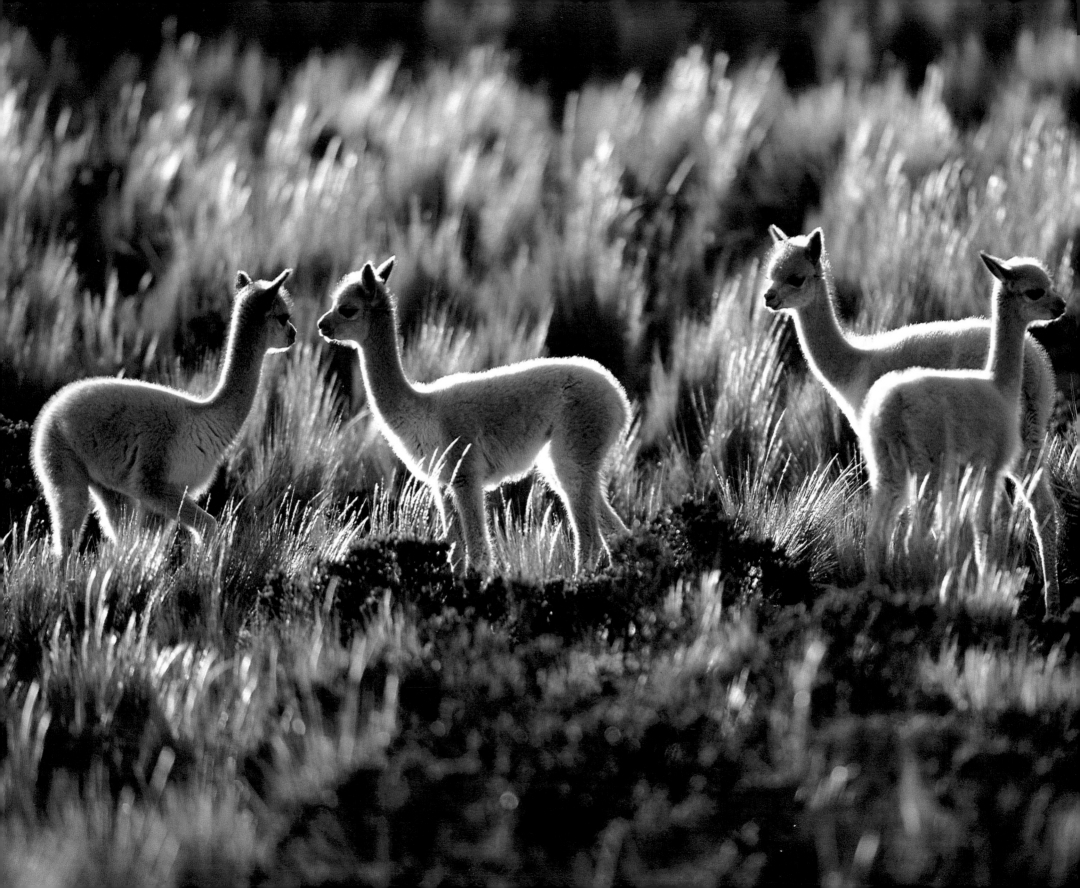

CONTENTS

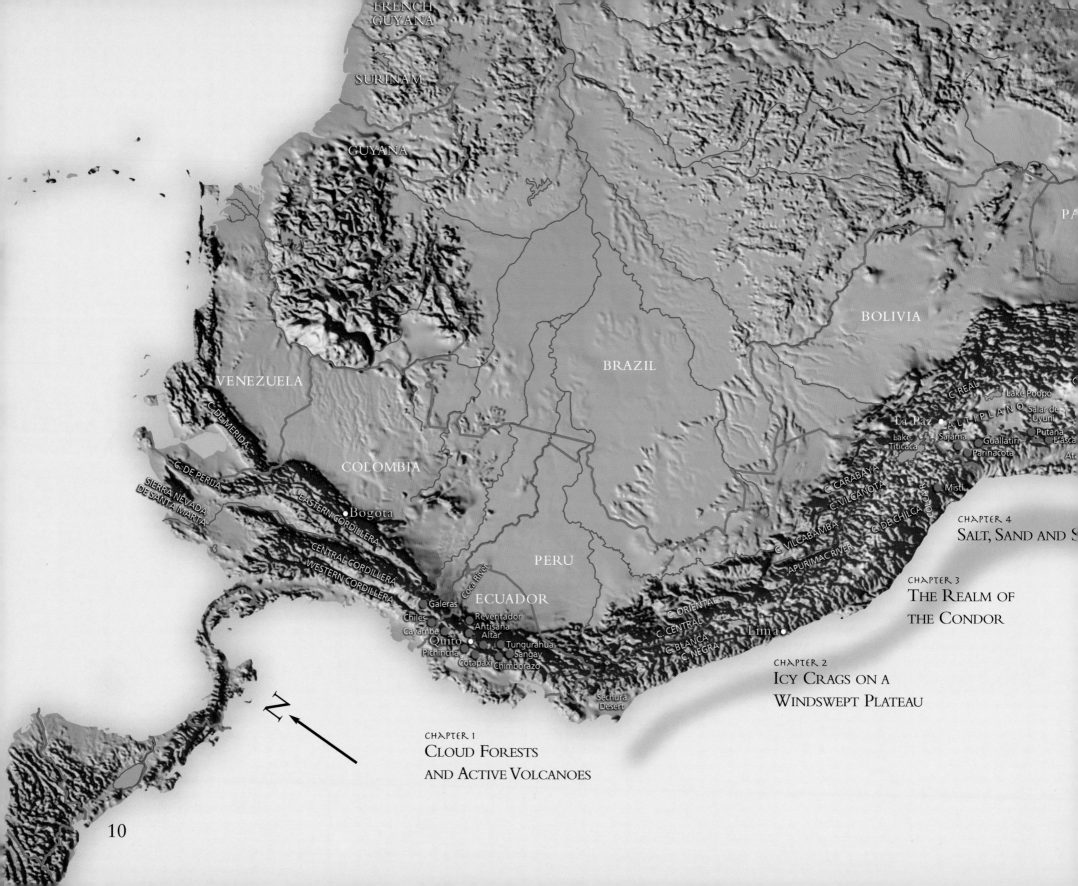

FRENCH
GUYANA

SURINAM

GUYANA

VENEZUELA

C. DE MERIDA

C. DE PERIJA

SIERRA NEVADA
DE SANTA MARTA

COLOMBIA

EASTERN CORDILLERA

● Bogota

CENTRAL CORDILLERA

WESTERN CORDILLERA

Galeras

Chiles

Coca River

ECUADOR

Cayambe

Reventador
Antisana
Altar

Quito ○

Pichincha

Tungurahua

Cotapaxi Sangay
 Chimborazo

Sechura
Desert

BRAZIL

PERU

BOLIVIA

C. REAL Lake Poopo

La Paz ○ ALTIPLANO Salar de
 Uyuni

Lake Sajama Guallatiri
Titicaca Parinacota L'asca

Misti

C. CARABAYA

C. VILCANOTA

C. VILCABAMBA

C. DE CHILCA

APURIMAC RIVER

C. ORIENTAL

C. CENTRAL

C. BLANCA
C. NEGRA

Lima ●

PA

15

N

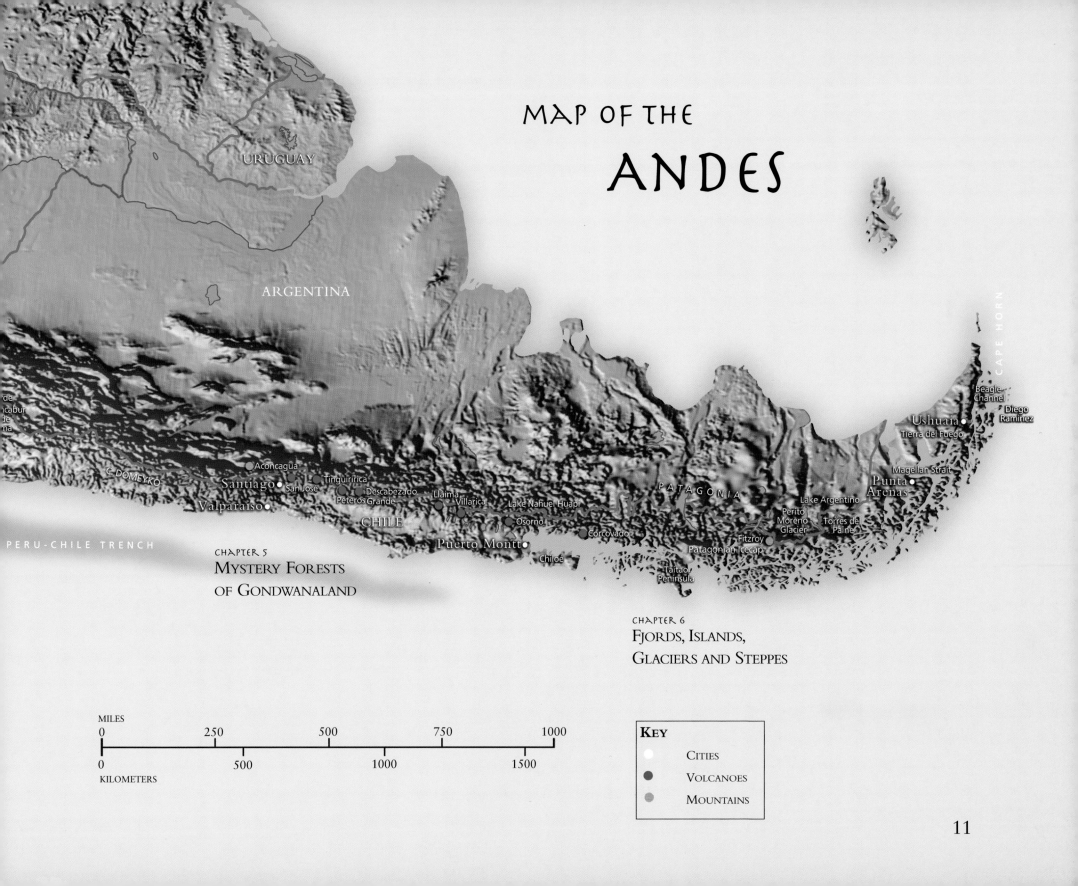

MAP OF THE
ANDES

URUGUAY

ARGENTINA

CAPE HORN

Beagle
Channel

Ushuaia •
Tierra del Fuego

Diego
Ramirez

de
cabur
na

C. DOMEYKO

Aconcagua

Santiago •
San Jose

Tinguiririca

Descabezado
Peteros Grande

Llaima
Villarica

Lake Nahuel Huapi

PATAGONIA

Magellan Strait

Punta
Arenas

Lake Argentino

Valparaiso •

Osorno

Perito
Moreno
Glacier

Torres del
Paine

CHILE

Corcovado

Fitzroy

PERU-CHILE TRENCH

Puerto Montt •

Patagonian Icecap

CHAPTER 5
MYSTERY FORESTS
OF GONDWANALAND

Chiloé

Taitao
Peninsula

CHAPTER 6
FJORDS, ISLANDS,
GLACIERS AND STEPPES

MILES
0 250 500 750 1000

0 500 1000 1500
KILOMETERS

KEY

○ CITIES

● VOLCANOES

● MOUNTAINS

11

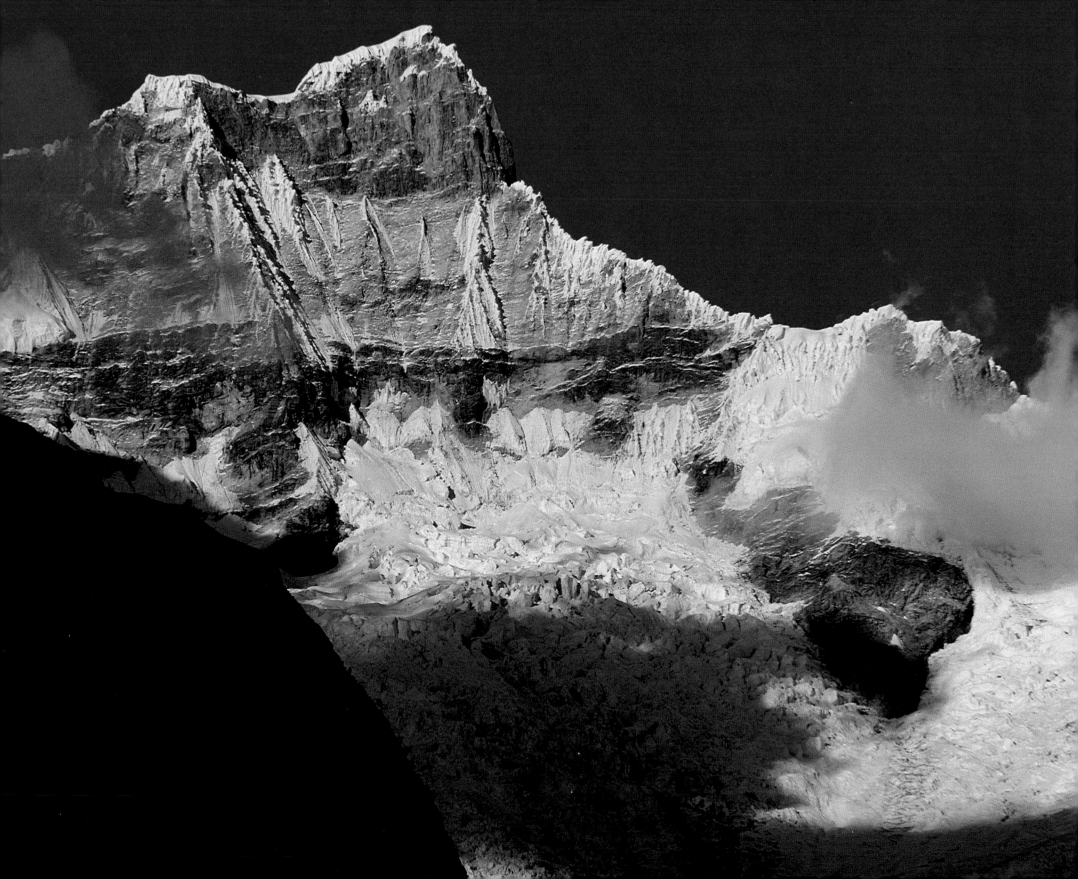

A Land of Superlatives

I magine a single mountain chain stretching uninterrupted over the same distance as that from New York to Moscow – over 4500 miles (7000 km) of rock and ice, smoldering volcanoes and needle-sharp granite spires, buffeted by storms and interspersed with dripping cloud forests and searing deserts. Above its entire length the mightiest bird alive soars on 10-foot (3-m) wings, effortlessly riding the thin, frigid winds 3 miles (5 km) above sea level.

Far from a fantasy, this place exists. It is called the Andes of South America, the youngest, longest, most varied mountain range on earth. Here lives the great Andean condor, which, though a fraction of the size of its Pleistocene ancestor, is the largest, heaviest flying land bird in the world. Like an enigmatic mountain spirit, it can be seen gliding high over icy crags and abyssal canyons, intelligent and wary, personifying all that is wild and free throughout this ultimate wilderness.

FACING PAGE: The sheer icy face of Chacraraju in Peru's Cordillera Blanca is a classic upthrust peak.

PLATE TECTONICS

The Andes are a geologically dynamic mountain chain, still in the full throes of formation. Think of the surface of our planet as a great restless tectonic jigsaw puzzle made up of jagged, jostling plates of earth crust shifting this way and that, a process known as continental drift. Driven by the deep inner forces of heat convection within the earth's mantle, some plates separate (such as that forming the Great Rift Valley of East Africa), while others collide (as in the Himalayas), and still others rasp and scrape uneasily past one another (as in California's San Andreas fault). Where two plates of unequal density converge, the heavy oceanic plate will sink beneath the older and lighter rocks of the continental plate, very often giving rise to violent volcanism as seen in Japan, Russia's Kamchatka Peninsula and Alaska.

Nowhere does a continent and ocean floor plate meet on a vaster scale than the encounter between South America and the eastern Pacific Ocean's Nazca Plate. Having separated from the great supercontinent Gondwanaland some 200 million years ago, South America drifts steadily westward, whereas the oceanic Nazca Plate is propelled just as inexorably eastward by the undersea volcanism feeding the actively spreading mid-ocean ridge like a gigantic conveyor belt. Where the two meet the basaltic seafloor is forced to take a deep plunge beneath the

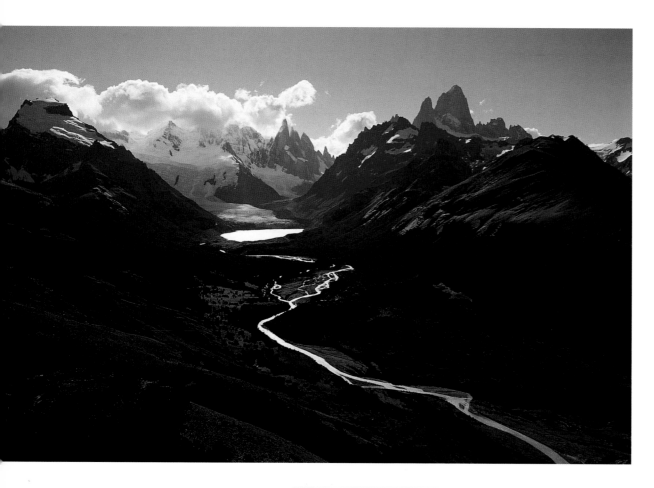

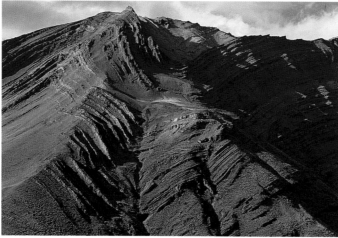

ABOVE: *Glaciers tumbling off the granite spires of the FitzRoy Massif feed lakes and rivers that meander down toward the Patagonian plains of Argentina.*

RIGHT: *Fold upon geologic fold, the Andes were built from a tectonic crumple zone, where the South American continent continues to buckle while riding over the oceanic Nazca Plate.*

floating continent, creating what is known as a subduction zone, where the crust is reabsorbed into the earth's mantle. At a rate of several centimeters (about an inch or two) per year, the two plates thus override one another, grinding and buckling as they go, and rumpling South America's entire western seaboard into a geologic-scale crumple zone: The Andes.

This mountain-building process, which began 70 million years ago, gave rise to the great mountains we see today in just the second half of that period, a mere bat of an eyelid in geologic time-scales. And it is still constant and ongoing, revealing itself in a breathtaking variety of contorted shapes and forms many thousands of feet high. Seashores are thrust skyward and ancient layers of sediment are folded and rolled upon themselves as if they were dough. In central Peru massive slabs of bedrock are squeezed up into sawtooth cordilleras, growing by several feet with each shuddering earthquake. Far to the south granite spires likewise claw the stormy Pata-gonian skies. Elsewhere swarms of volcanoes add their stamp to the already tormented ridges and plateaus, more than 200 of them grouped into three separate clusters. These are the products of intense heat released by friction deep within the subduction zone, where the oceanic plate is reabsorbed. Between the upward thrust of the continent and the downward plunge of the seafloor the vertical contour of the mountains is mirrored below the sea where the crust angles down some 25,000 feet (7500 m) into the abyssal Peru-Chile Trench before vanishing beneath the continent.

NORTH OF THE EQUATOR

As the condor flies, so the Andes keep changing, for no two areas are similar. From the shores of the Caribbean to Cape Horn, at the doorstep of Antarctica, they slash unbroken through 67 degrees of latitude. Acting like a great rampart blocking some of the earth's major wind patterns, the Andes even create some of their own extremes of climate.

At the Equator, where intense sunshine glints off small rounded glaciers topping smoldering volcanoes like white woolly hats, the Andes run roughly north-south in two parallel

cordilleras that are separated by Ecuador's fertile, heavily populated central valley at about 9000 feet (2700 m) elevation and 50–100 miles (80–160 km) wide. Further to the north, in Colombia, the volcanoes give way to gentler mountains. Here they swing eastward while forking into three distinct ranges separated by even deeper agricultural valleys. Bathed on either side in moist tropical air from the Pacific Gulf of Panama and the Caribbean Sea respectively, these mountains are rain-drenched throughout, save for dry, sheltered microclimates. At the Colombia-Venezuela border, as if losing their momentum, the easternmost of these three branches divides one last time before petering out. One final hurrah comes with the impressive 18,935-foot (5775-m) massif of the Santa Marta mountains – Colombia's highest range – which stands alone near the Caribbean coast.

SOUTHWARD THROUGH PERU AND BOLIVIA

From the Equator looking southward, both mountains and climate change radically. At the Ecuador-Peru border the bold march of the Andes seems to hesitate, momentarily fragmented. With low saddles dropping to about 1500 feet (450 m), this is the closest to a gap in the chain as the Andes experience over virtually their entire length. Making a sudden kink, they then quickly re-form and run fair and straight in a southeasterly direction throughout most of Peru, a backbone laid bare by upthrust, with several parallel ridges rippling a broad, sere plateau known as the puna. Here the western slopes of the Andes herald some of the driest environments on earth, the Sechura and Atacama deserts, starved of moisture even though the Atlantic air flow that saturates the Amazon basin laps their eastern flanks.

At the junction with Chile and Bolivia everything changes once more. Here major faults gouge the chain and create some of the deepest canyons in the world, surrounded by snowy volcanoes sputtering ash into the thin mountain air. Like a teeming army these active volcanoes advance in a column for hundreds of miles due south far into Chile, while another, much more tranquil string of mountains, the Cordillera Real, takes an

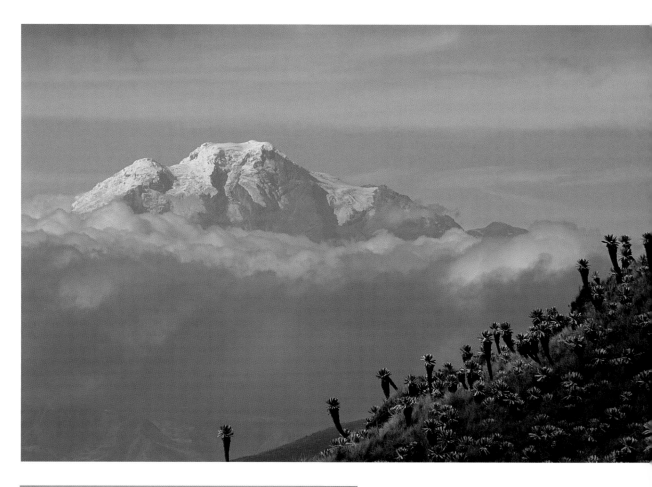

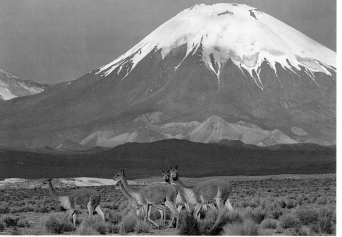

ABOVE: *Heavily glaciated Antisana Volcano, at 18,891 feet (5758 m), guards the gates of the Amazon, separated from the western chain by the broad and fertile central valley.*

LEFT: *Vicuñas are at home on the high plateau below the young volcano of Parinacota, rising to 20,760 feet (6330 m).*

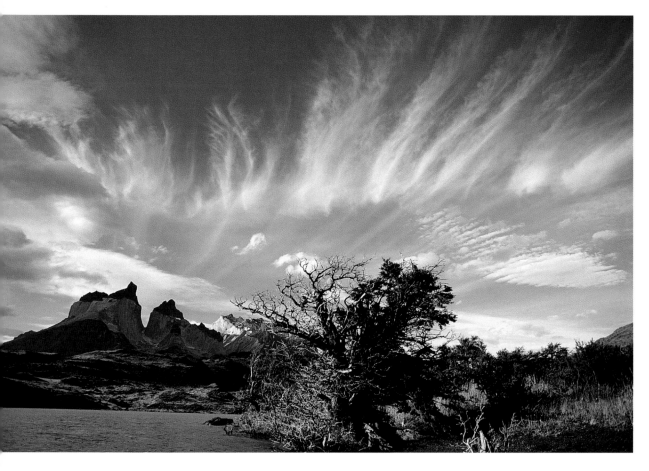

enormous detour eastward through Bolivia. Between the two is encased a vast high-altitude basin known as the Altiplano, bordered by mountains all around and perched more than 2 miles (over 3 km) above sea level. This bowl once held huge inland seas, which were transformed by a gradually desiccating climate into a series of enormous salt pans, eerie white crystallized expanses stretching as far as the eye can see under the cold glare of the sun.

THE CHILEAN SUBTROPICS

For the rest of the journey the Andes trace a straight and narrow line southward, barely curling east one last time just as they reach the tip of the continent. In central Chile another dramatic climate reversal takes place where the prevailing South Pacific winds from the west spread a cloak of humidity onto the Andes' seaward slope. Gradually they are transformed from the parched, snowless volcanoes and geyser fields of the north into the increasingly wet and wild realms of the temperate south.

Lakes and waterfalls mold the great Valdivian forest of Chile, which soon gives way to the much cooler fjords and islands of the more extreme latitudes. Here, Southern Ocean tempests in full force unleash their fury, carving the land and feeding the only icecap outside of polar regions. Temperate rainforests of Gondwanaland character envelop the misty slopes. Massive tumbling glaciers slice and wend their way from the Patagonian Icecap down precipitous valleys that feed directly into the sea. The Argentine steppes to the east, meanwhile, are dry and windswept, sheltered from the Pacific moisture.

By the time they reach the Beagle Channel of Tierra del Fuego the Andes have dropped in height by more than half, but they are so wild and foreboding the impression is that the sea has risen into the mountains, rather than the mountains descended to the sea. At last they shatter into a jumble of islands, rocks and stacks lost in the storms and fogs of Cape Horn, a fitting punctuation at the end of the greatest mountain chain on earth.

ABOVE: *Cirrus wind clouds streak the skies over the southern Andes in Chile's Torres del Paine National Park.*

RIGHT: *At dawn, a double rainbow marks the end of the Andes, where the rugged island of Cape Horn faces the constant wrath of Southern Ocean storms.*

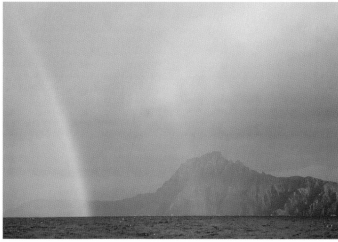

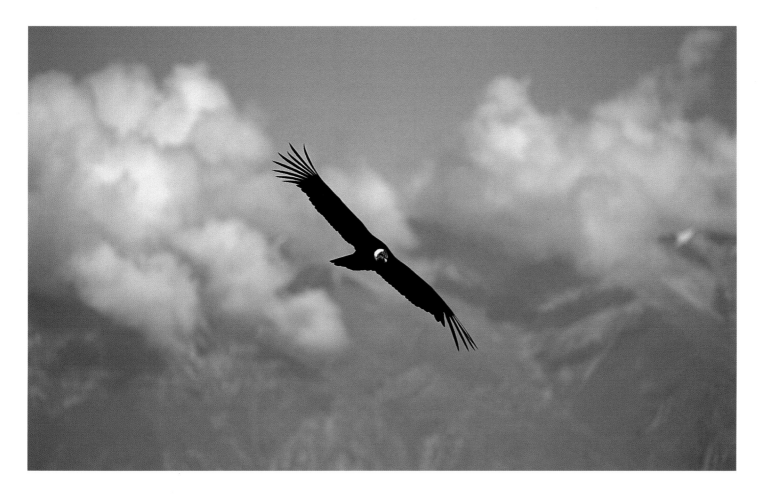

Riding the morning thermals, a male Andean condor soars on 10½-foot (3.2-m) wings among the snowy peaks of southern Peru.

FLYING WITH THE CONDOR

The condor seeks – indeed requires – both space and wildness. In the central Andes of Ecuador it soars along the volcano-studded cordillera, shunning the central valley where humans abound. It ascends high above rocky moraines and shrinking glaciers and makes furtive forays into deep, cool, misty canyons overlooking the Amazon basin to nest out of sight on mossy escarpments. Further north, in Colombia and Venezuela, it ventures forth rarely these days, having relinquished its ancestral homeland to human encroachment. In Peru the condor clings shyly to the high plateaus but thrives in the vertical landscapes of ice-rimed canyons near the Chilean border, a shrinking stronghold. Still further south the condor is truly at home, master of the wildest of wild mountains and forests of Patagonia on both sides of the divide.

Like the condor, this book seeks out those wild and untouched spaces where the air is pure, the mountains are silent, the huemul (Andean deer) steps silently out of the shadows, and galloping vicuñas raise dust clouds over the puna. This is a book about hummingbirds in the cloud forest, flamingos in the desert and, indeed, condors in the mountains. Culminating 25 years of photo journeys, it is a book about the Andes untouched by humanity, the way they have always been.

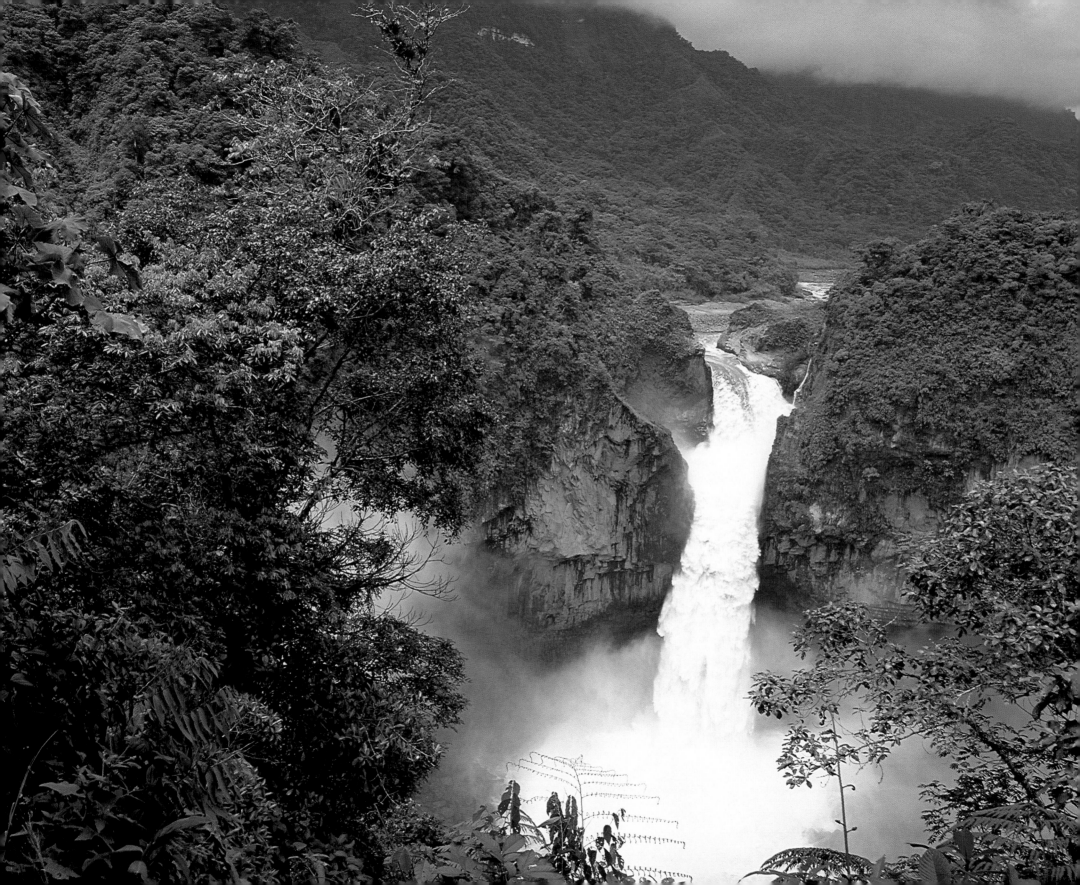

CLOUD FORESTS AND VOLCANOES

THE TROPICAL ANDES OF ECUADOR

Drawing its source from high in the Andes, the Coca River flows into the San Rafael Falls, eventually joining the Amazon River and finally the distant Atlantic on the far side of the continent.

I t is dusk in the Andes of Ecuador, just a few miles south of the Equator proper. A damp chill settles on the dripping, boggy fields of ichu grass at 12,000 feet (3600 m), even as warm supersaturated air wafts up steep valleys from the Amazon, roiling into thick, billowing clouds. As the clammy vapors rise and cool, drizzle envelops the moss-laden, bamboo-tangled cloud forest nestled beneath sheltering bluffs. Far above, strands of ground-hugging mist obscure the sunset-tinged snows of the 18,891-foot (5758-m) Antisana Volcano.

THE EASTERN SLOPE

In the dimming light, two bulky black figures suddenly catch my eye, tumbling through the tawny grasses upslope. They scramble over a ridge and down a dark rock face. There, partially concealed by vegetation, they settle on a mossy ledge – spectacled bears, a mother and cub. These rare and secretive animals are almost never observed, even by those who study them. She sits back surveying her world and allows her cub to suckle for long minutes before reclining to rest while he clam-

bers and plays along the rock ledges and on her back. I take no photos in the gathering twilight. The moment lingers and I'm transported by the magic of a timeless encounter, until darkness reclaims the vision.

Not far away, a pair of white-tailed deer has emerged into a swale to graze. Even though they sense my presence, the approaching darkness gives them enough confidence to continue nibbling. Glancing down the slope where the nearly impenetrable *Polylepis* forest – the highest growing tree species in the world – spreads in a somber blanket, I can imagine the stealthy movements of the puma and perhaps the most shy of all Andean mammals, the woolly mountain tapir. Many years ago I hiked several days around the snowy base of another icy volcano north of here, Cayambe, and down into a similarly encased, forest-filled valley in search of this elusive, almost prehistoric creature. I was able to follow its deeply rutted tracks and tantalizingly fresh spoor, but never caught a glimpse of the animal itself.

These vignettes of pure, unadulterated wildness, where ancient times stand still and nature is at peace, linger in hidden corners of the Andes, still escaping the increasingly harsh glare

A captive pair of spectacled bears in a rehabilitation center. Spectacled bears lead secretive lives in the dense cloud forest, making surreptitious forays into the high paramo grasslands to feed on bromeliad stalks.

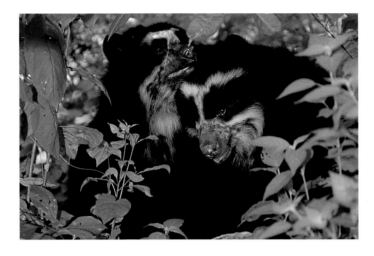

of humanity. Such hiding places are shrinking and their numbers dwindling, but their spirit is as free and timeless as it was before the first humans crossed the land bridge from Asia into the Americas, wielding spears and fire thousands of years ago. Only a few miles away from the busy Papallacta road connecting the crowded Andean central valley with the oil fields of the Amazon basin, this is one such miracle, a closely guarded secret of the Cayambe-Coca Reserve stretching from snowline to Amazon.

Here two worlds meet, the lofty, glaciated volcanoes of the Eastern Cordillera, many of them active, and the steaming jungles lapping at the base of this massive geologic rampart. Bathed in equatorial climate, there are hardly any seasons here, though some times of year are even wetter than others. Only the altitudinal gradients define the layer upon layer of habitats and microclimates where innumerable plants may flower and fruit year-round. Birds and insects need neither to migrate nor hibernate, a condition reflected through their myriad forms and riotous variety. Nowhere is the contrast more palpable than here, where the last tendrils of gnarly cloud forest give way to rolling, wet paramo grasslands.

The night after seeing the bears my partner and I pitch our tent in the cold, swirling fog, listening to the plaintive calls of antpita and the electrifying wing-swirl of courting snipe while reveling in the peacefulness of the natural Andes as they have always been – a rare nugget in place and time and the kind of

moment I live for. For nearly 30 years I have been seeking out such elusive enclaves and treasuring the notion that they endure, often unsung, even today. These are the Andes where the condor flies.

The next morning we drop quickly some 2000 feet (600 m) into the luscious Papallacta Valley. Passion flower vines festoon the forest edges and hallucinogenic datura shrubs lean over stream banks. These are magnets to one of the most amazing birds the world has ever seen, the sword-billed hummingbird, whose incredible 4-inch (10-cm) beak is longer than its body. Perhaps unsurprisingly, it seems to fly cautiously among the vegetation tangles, its upturned sword held high, inserting it hypodermic-like into the dangling corollas of flowers made to order, turning on its dizzying hummingbird speed only when powering away high above the canopy after a meal.

With each mile traveled down the Papallacta Valley the air warms perceptibly, and the forest becomes taller and its leaves larger. Bromeliads, heliconias and orchids provide splashes of color, and hummingbird species multiply apace, with a dozen or two types often sharing a single habitat.

ACTIVE VOLCANOES

Volcanoes fertilize the high forests, their sudden violence periodically rejuvenating the growth cycle. Ecuador, the smallest Andean country, has one of the highest densities of active volcanoes in the world, with no less than 16 grumbling away and blowing their tops from time to time. The Eastern Cordillera's volcanoes are among the most restless. In November 2002, 11,678-foot (3562-m) Reventador Volcano, far below Antisana in the jungle-clad foothills, exploded without warning, possibly the largest eruption the young country has seen in over two centuries. A *nuée ardente*, or pyroclastic flow, cut a huge swath through virgin forest, obliterating all in its path, and also striking a road and an oil pipeline. The devastation stopped just short of blocking the mighty Coca River not far from where it plunges, thundering, off the sheer edge of a massive ancient lava flow on its way toward the distant Atlantic.

Our musings with bears and hummingbirds are interrupted

when another volcano calls our attention. This time it is Tungurahua, a 16,470-foot (5023-m) classic cone perched, like Antisana, at the threshold of the Amazon basin, spitting fire and brimstone. After more than a half century of snow-clad slumber it came to life literally with a bang in October 1999, and now its turbulent cycles have reached another outburst. The following evening we join a vulcanologist friend at the Civil Defense Observatory, which has taken up temporary residence in farm buildings some miles from the mountain. We spend long wakeful hours on volcano watch as stars, clouds, lightning bolts and lava bombs combine into a mesmerizing all-night pyrotechnic show. Rumbles and booms echo through the darkness and car-sized incandescent rocks streak down the flank of the cone toward the blinking lights of Baños town tucked beneath the volcano's fertile apron. The 12,000 inhabitants of Baños sleep fitfully, perhaps remembering the evacuation and their return three months later after the October 1999 eruption.

Along the eastern chain, Tungurahua's southern neighbor is 17,147-foot (5230-m) Sangay. Enshrined in wilderness, it has been active for as long as anyone can remember. Frequently engulfed in Amazon-generated mists, its highland flanks are a woolly tapir's haven, while harpy eagles hunt monkeys in the unexplored forests draped along its eastern foothills. Part of the same chain, but far older and somewhat higher on the Andean plateau, is Altar Volcano, perhaps my favorite of all, not least because it was my first introduction to the truly wild Andes almost three decades ago. Back then, a long and arduous hike took us beyond thatched adobe huts, eucalyptus wood-lots and oxen-ploughed potato fields up onto the serene paramo grasslands and into a wide, winding U-shaped glacial valley. After a long day under heavy packs we eventually entered the sun-warmed sanctum of El Altar – The Altar – a perfectly shaped breached volcanic amphitheater facing the sunset. Long inactive, its ancient caldera once held a massive glacier that, in today's warmer climate, has left a circular lake perched just below snowline. Its excess melt waters overflow into a cataract, feeding a silvery ribbon that meanders down the grassy valley floor toward the west.

We arrived just in time to pitch our tent next to a clear

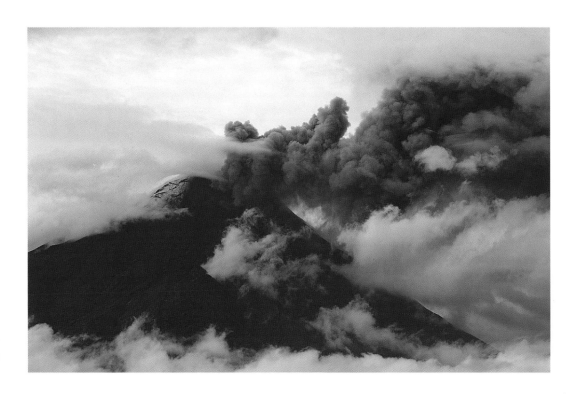

waterfall at the edge of a small elfin forest of orange, flaky-barked *Polylepis* clinging to the base of the crater wall. Next day we found deer prancing across snowy avalanche slopes where small hanging glaciers pierced the sky. Clouds and wind were kept at bay by the encircling volcanic fortress, climbed for the first time only in 1929. Back in camp, warmed by the sun's golden rays, the world seemed far away indeed.

But even dormant volcanoes and glaciers do not stand still through time. So it is that 22 years after my first impression of El Altar, in October 2000 a section of the vertical rock and ice face collapsed into the lake, causing a wave of tsunami proportions to wash down this idyllic valley obliterating all in its path.

Other changes in the tropical Andes of Ecuador seem more ominous, both in sheer scale and by the fact that their cause – global warming – may well be far removed from nature's tried and tested brief. Just before my twentieth birthday a group of mountaineering friends offered me the opportunity to climb Cotopaxi Volcano for the first time. A picture-perfect cone, heavily blanketed in snow and ice, rising to

Tungurahua Volcano, perched at the very edge of the lowland eastern jungles and often enveloped in warm rising mist, is a young and active volcano that has been erupting almost continuously since 1999.

The glaciers tumbling down the flanks of Cotopaxi Volcano have been receding and fragmenting alarmingly in recent years due to a warmer and drier climate.

Each Andean volcano acts as a separate high-altitude island where many hardy plants survive frequent snowfalls that soon melt away under the equatorial sun.

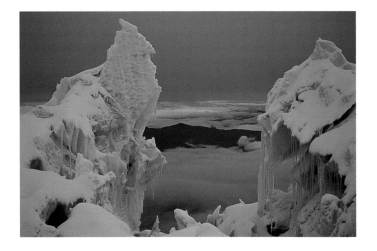

19,334 feet (5,897 m) from the 10,000-foot (3000-m) plateau, this was another ideal introduction to the Andes. Thus on a glorious November day in 1973, I stood on its summit under the searing noonday sun, gasping in the thin air and looking down upon a sea of clouds, detached from the world below. Asleep for the better part of the century, Cotopaxi's crater was still warm enough to prevent snow and ice from building up around much of its rim and center.

Thirty years later almost to the day I strapped on my crampons once more, eager to fulfill a dream. I wanted to camp on Cotopaxi's summit, and watch the sun rise over the Amazon haze and set beyond the distant Pacific. I set off with a guide for a nighttime ascent, when avalanches often triggered by the sun's warmth are least likely to occur. But what had seemed hardly ambitious soon turned into a mad challenge. In the intervening decades the glacier had receded by nearly a mile, leaving loose, bare, volcanic scoria slopes exposed to erosion. Recent turbulent storms had dumped copious loads of snow over the fractured glacier, which had surged and crevassed in the exceptionally warm weather over the past couple of weeks. For hours we floundered under heavy loads amid black icy chasms and treacherous, wet snow bridges, causing my perplexed guide to announce that the mountain was unrecognizable and, for the moment, unclimbable.

The volcanoes of the parallel Eastern and Western Cordilleras, which run roughly 50–100 miles (80–160 km) apart, each act like an isolated high-altitude island with its own plant community and unique habitat, decked in a dazzling range of low-growing flowers whose survival strategy consists mainly of soaking up the equatorial sunrays while eluding the frigid high-altitude climate as much as possible. To this end some have developed elaborate hairy coverings, while most duck their heads low among the spiky paramo grass stools that seem impervious to desiccating winds and frequent frosts.

These "islands" are also home to one of the highest-living hummingbirds in the world, the Ecuadorian hillstar. It has three distinct species, one of which is restricted to the tallest volcano, 20,688-foot (6310-m) Chimborazo. A splendid cobalt-headed gem partial to the nectar from the orange scaly flowers of the chuquiraga shrub, this amazing bird lives and breeds between 13,000 and 16,000 feet (4000 and 5000 m) where nighttime temperatures often drop well below freezing. That it can survive right up to snowline is thanks to a remarkable ability to spend the night tucked away in caves or rock crevices in a torpid state by lowering its metabolism 80–90 percent when air temperatures plummet.

Living at slightly lower elevations of 8000–14,000 feet (2500–4300 m) the shining sunbeam, another feathered jewel of the paramo, mountain-hops more readily and ranges far into Colombia. Here the habitat changes dramatically as the mountains become somewhat less abrupt. Thanks to a damper climate, the grasslands are dominated by a strange and

wondrous plant, the *Espeletia* or frailejon – growing to 20 feet (6 m). A composite with a thick fleshy trunk crowned with rosettes of long, thick, furry leaves like rabbit's ears and yellow daisy-like flower clusters, it seems impervious to the wind that buffets it almost daily. Great armies of these uncanny plants stud a quilted landscape of rolling hills, wetlands and high tarns.

THE WESTERN CLOUD FOREST

Hummingbirds and volcanoes epitomize the Andes of Ecuador. The Western Cordillera, like its eastern counterpart, is bathed in moisture rising from the lowlands. Overlooking the Pacific coast, it receives considerably more sunshine than the Amazon slope, resulting in some of the most exquisite alpine blooms anywhere in the Andes. In subtle carpets of mauve, pink, blue and yellow they flourish high above the ravaged central valleys, where urban sprawl and agricultural production have replaced the montane forest ecosystems forever.

The twin summits of Pichincha Volcano, at 15,328 feet (4675 m), loom directly above the metropolis of Quito, where nearly two million people bustle beneath a pall of trapped man-made smog. Rucu Pichincha consists of an ancient volcanic plug, festooned in dazzling plant cushions, while its young neighbor Guagua Pichincha remains an ardent young volcano that swells, rumbles and from time to time coughs loudly, causing fear to ripple through the capital. In recent years it has spewed large columns of ash into deep blue skies, shutting down the city's airport and schools while simultaneously nurturing the fertility of high alpine meadows and lush cloud forests that cascade down along its Pacific slopes.

These precipitous western flanks are swaddled in some of the richest and most diverse montane forests, where a fairytale world of tree ferns and silvery cecropia trees, bromeliads and orchids are home to a virtual blizzard of hummingbird species bearing names as ethereal as their resplendent plum-ages. Names that include the Andean emerald, empress brilliant, sparkling violetear, collared Inca, violet-tailed sylph, gorgetted sunangel, buff-winged starfrontlet, buff-tailed coronet, white-

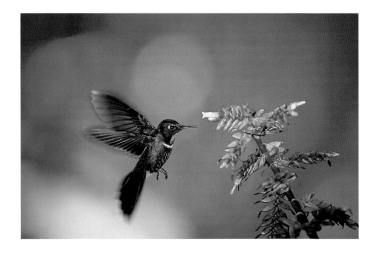

One of several dozen species of hummingbirds that inhabit the cloud forest flanking the equatorial Andes, this gorgetted sunangel visits an aerial bromeliad flower.

tailed hillstar, purple-throated woodstar, green-crowned wood-nymph, green-fronted lancebill, green-tailed trainbearer, sapphire-vented puffleg, glowing puffleg, booted racket-tail, great sapphirewing, golden-breasted puffleg, Tyrian metaltail – the list goes on and on.

Only an hour's drive west from the stress and noise of Quito traffic, I walk in silence along the mossy trails of the privately owned Yanacocha Reserve, amid thickets of gunnera plants with leaves the size of beach umbrellas. At the end of the trail several inconspicuously placed nectar feeders ensure that the local hummingbirds, stressed by encroaching deforestation, are never short of a food supply. A half dozen different species flit in and out of the dark, moss-festooned elfin forest at 10,000 feet (3000 m), their feathers shimmering blue, green and gold as if metal-dipped. This is the home of one of the rarest hummers in the world, the midnight-hued black-breasted puffleg, its little world clinging improbably to a secluded fold in a mountain that still holds sway over civilization.

From here the view plunges impressively into furrow upon green furrow of deeply sculpted valleys and knife-edge ridges falling away toward the sea. An ocean of clouds covers the lowlands, sending tendrils of mist creeping up toward the naked brim of the volcano above. By noon the skies have blackened and the hummingbirds vanish as lightning cracks overhead and the first heavy drops of the daily downpour hit the eager funnels of expectant bromeliads.

At daybreak, a male Andean cock-of-the-rock screams and dances in the dim recesses of a cloud forest lekking site in Ecuador to attract passing females.

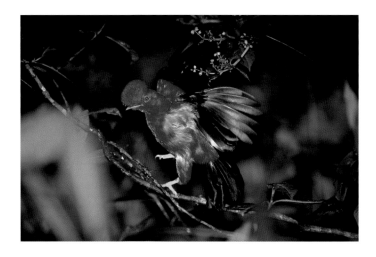

FACING PAGE: A classic glaciated stratovolcanic cone rising from the central plateau to 19,334 feet (5897 m), Cotopaxi has erupted dozens of times in the last 450 years since records have been kept.

Within a stone's throw of Yanacocha I descend some 3000 feet (900 m) into the secluded Tandayapa Valley where another private reserve, Bellavista, straddles a sharp forested spur. Leaving the tree line world of sapphirewings and pufflegs behind, here I enter the lush domain of racket-tails and sunangels, sylphs and woodstars. Twenty-eight species in all frequent the proffered feeders in whirring, buzzing, chattering clouds. Just a few more hundred feet further down the slope the count reaches 38 species, though not all are present at the same time. Now comes the turn of woodnymphs, lancebills and hermits.

Just as the hummingbirds thrive on year-round flowers, so a riot of multi-colored euphonias and tanagers feed on ever-present fruits and berries. A staggering 320 different species have been recorded in these forests, from manakins to cotingas, trogons and quetzals to potoos. The breathtakingly beautiful plate-billed mountain toucan and equally gaudy, stubby-billed toucan barbet are two of the many extraordinary looking birds restricted to this forest.

COCK-OF-THE-ROCK EXTRAVAGANZA

Another plunge just a few more miles down from the Tandayapa Valley takes me to the Mindo Valley at about 5000 feet (1500 m). The valley is famed for the leks (mating displays) of the bird known as the cock-of-the-rock, a member of the Cotingidae family.

Well before daybreak I am at the appointed place, anxiously awaiting one of the greatest natural spectacles on earth. Without warning, an incredibly loud, raucous "kraaaah" tears through the stillness, so close it sends chills down my spine. A clatter of wings in the mid-canopy confirms the first bird's arrival only about 20 feet (6 m) away. Soon another swoops in and settles even closer, almost at eye level, in the crown of a sapling emerging from the precipitous slope below. To my amazement I suddenly discover that even though the half-light of dawn is still dim enough that the luscious foliage remains colorless in shades of gray and black, the bird's plumage is so brilliant it appears to glow like an orange flame.

In the next few minutes a dozen or more male cock-of-the-rocks come streaking in like comets from far and wide in the still-sleeping valley. They call, hop around, stare, call some more and wait. When a female, much smaller and drabber, finally arrives all hell breaks loose. Every male suddenly gives it all he's got in the hope of out-competing his rivals for her attention. The effect is almost deafening. They hop up and down, flash their large black-and-white wings, cock their heads and disk-like crests from side to side, and scream at the top of their lungs. Even their feet, beaks and eyes are bright yellow.

The female comes a little closer, surveys the scene for a while, and departs, leaving a disappointed silence behind, until a couple more appear and the frenzy is repeated. Each female takes her time to choose carefully who will be the one lucky male with whom she will mate before flying off to raise a family alone.

The show only dies down when the first rays of the sun crest the high ridge above the valley. Just as surreptitiously as they appeared the whole flock of expectant males melts back into their vibrant green realm – a realm where exuberant behavior and form is the counterpoint for mysterious and cryptic lifestyles, where myriad species interact in a fabric of life so complex we have barely begun to sketch out its most basic tenets. Such is the essence of abundance in the tropical Andes.

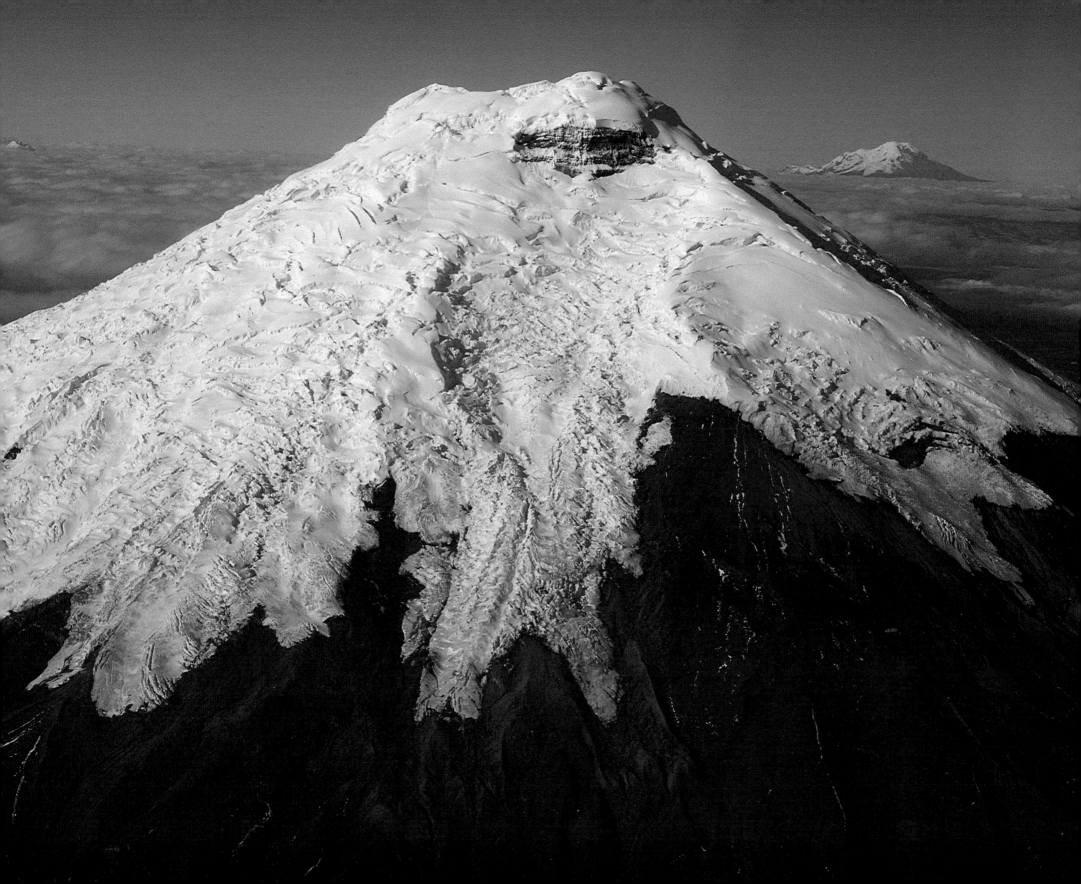

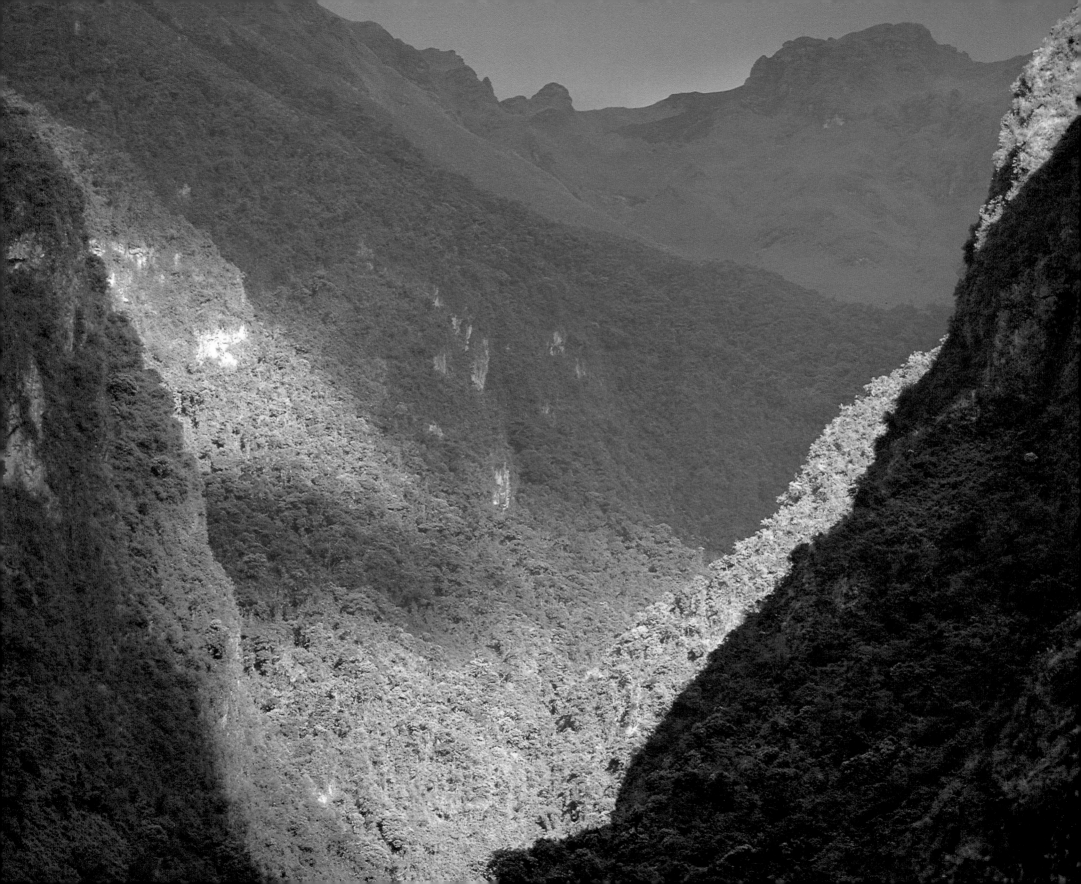

Although persecuted for their nocturnal raids on maize fields, spectacled bears subsist in the forested parts of the tropical Andes, including the semi-arid foothills of northern Peru. Bears, such as the one pictured, can be seen at the Mount Chaparri Rehabilitation Center.
MARK JONES

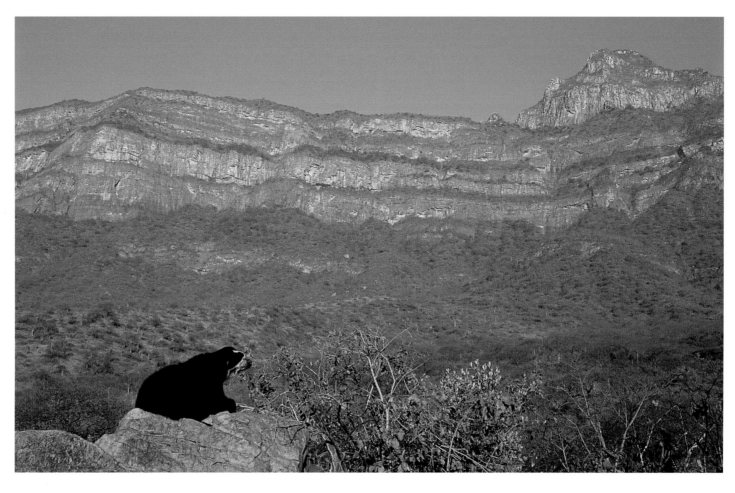

FACING PAGE: *Deeply carved canyons, scoured by glaciers in past ice ages, gouge the base of the massive Cayambe Volcano, which sits directly astride the Equator. Here spectacled bears hide in the dense montane forest.*

Spectacled bears are a primitive species and the only bear species in South America. This one was rescued from near death in a tiny illicit cage and given a new chance at the Mount Chaparri Rehabilitation Center in northern Peru.

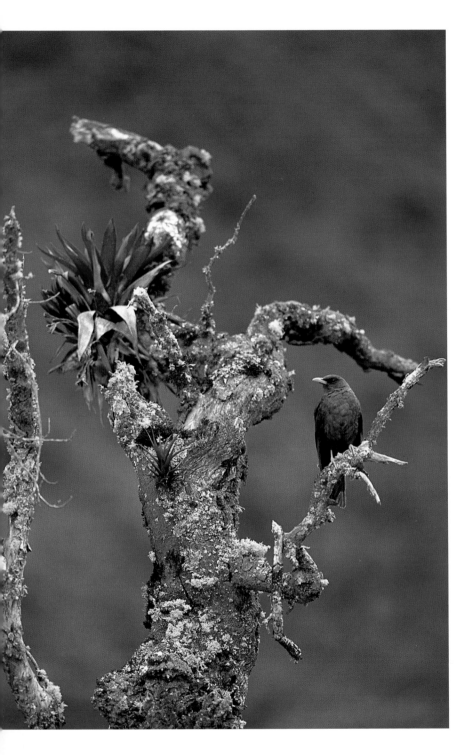

The glossy black thrush is a prevalent species of the cloud forest edges. Here it is seen among epiphytes in the Papallacta Valley.

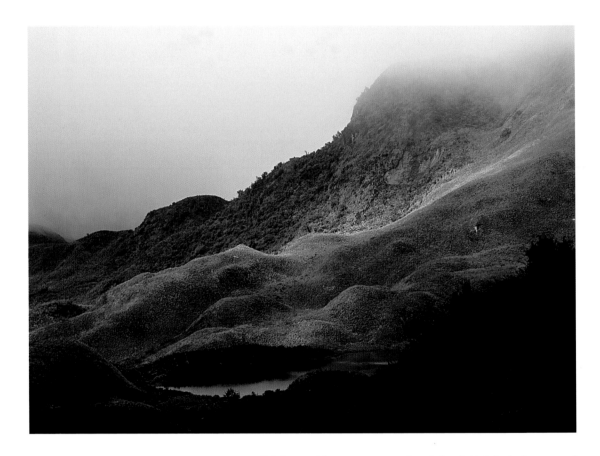

Small lakes and bogs interspersed with hardy Polylepis forests and rolling paramo grasslands are typical of the humid edge of the Andean plateau, which drops off toward the Amazon.

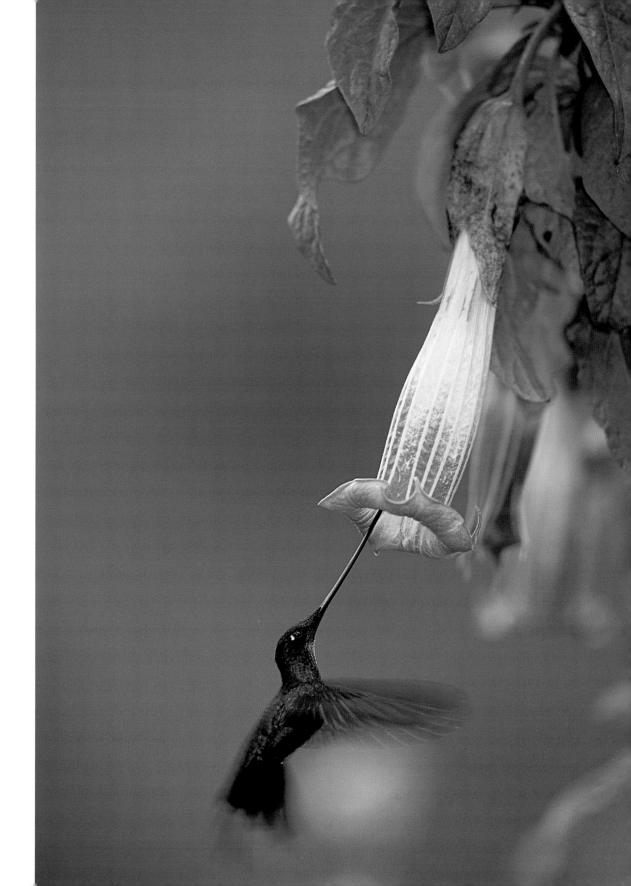

In a most amazing adaptation, the sword-billed hummingbird's beak is longer than its body. It enables it to feed on flowers with long corollas, such as the trumpet datura, but it is hard to imagine how this bird can preen, build a nest or feed its young. MARK JONES

Gnarled and mossy, this remnant Polylepis *forest befitting a home for elves and leprechauns clung to the base of the volcanic cliffs of El Altar, but was recently obliterated by a natural landslide.*

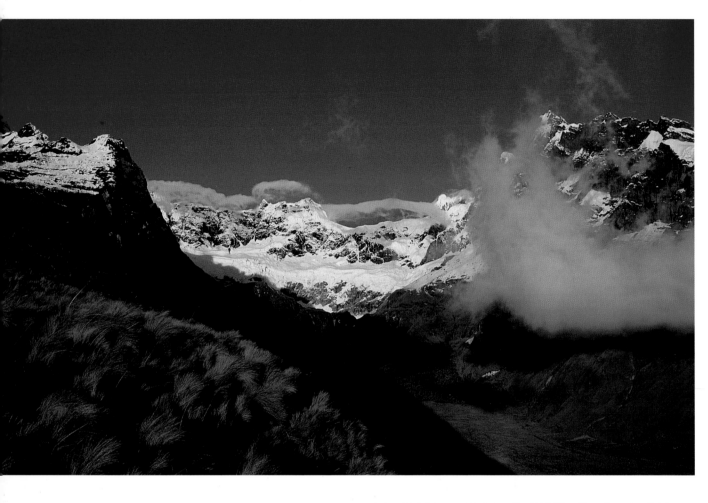

The crater of El Altar, an extinct volcano, has been breached by the action of glaciers, which still cling to its upper ramparts.

A male Andean condor in his prime, rescued from illegal captivity, awaits release at a private rehabilitation center aimed at boosting the dwindling wild population. It is estimated that only 80 of these birds remain in all of Ecuador.

The golden grasses of the windswept paramo glow under storm clouds on the rolling plateau of Cotopaxi Volcano National Park.

In this nighttime half-hour exposure showing the path of stars across the equatorial sky, lava bombs can be seen arching over the crater of Tungurahua Volcano and streaking down its flanks during a spell of violent activity.

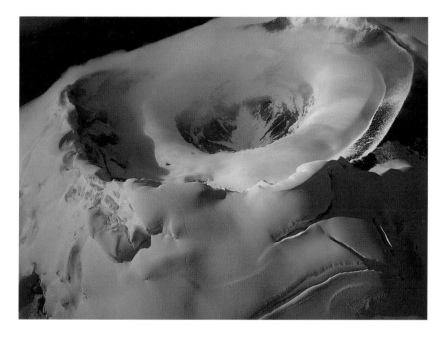

The crater of Cotopaxi Volcano, which last erupted half a century ago, is still warm enough to prevent the build-up of snow and ice along its fumarole-dotted lip.

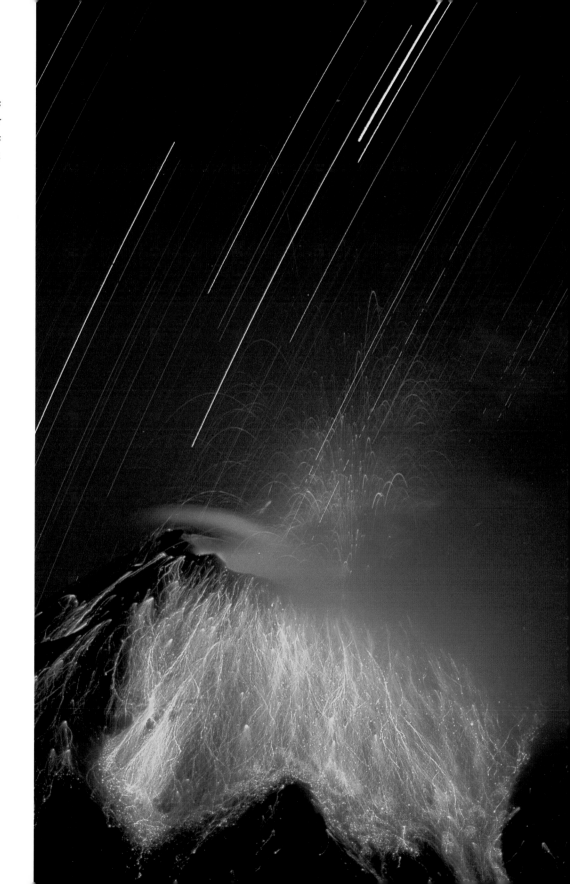

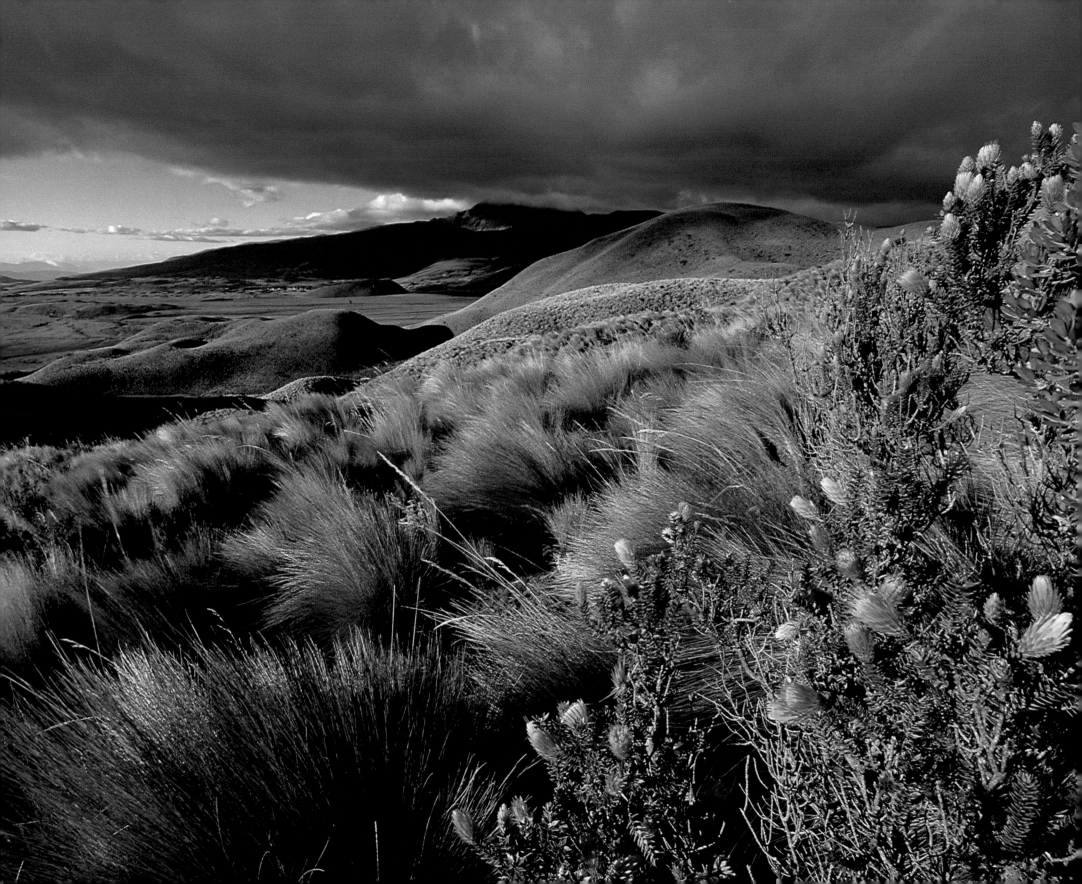

FACING PAGE: *With its rigid spiky leaves and flowers, the chuquiraga shrub is often the tallest plant dotting the open fields of hardy ichu grass that make up the typical paramo habitat of the tropical Andean plateau.*

Hairy leaves and flower stalks are a common defense against both frost and drying winds, as shown by this mountain lupin growing above 13,000 feet (3965 m) on the upper slopes of Pichincha Volcano.

Like so many other paramo flowers, a delicate gentian uses the protection of the stiff clumps of ichu grass to raise its flower clusters into the equatorial sunshine on the slopes of Pichincha Volcano.

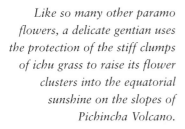

ABOVE: *The Ecuadorian hillstar is a splendid hummingbird that favors the scaly flowers of the chuquiraga shrub. It lives well above the tree line at up to 16,000 feet (4880 m) and survives plummeting nighttime temperatures by lowering its body temperature.*

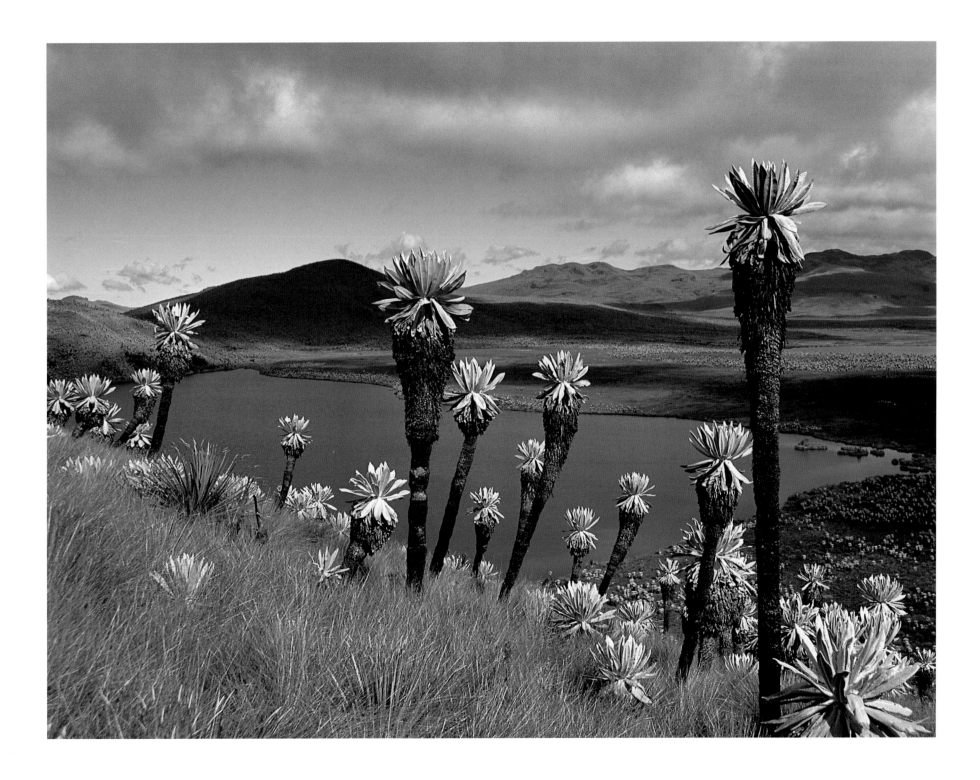

PREVIOUS PAGE, LEFT: *Where the elfin cloud forest gives way to cool paramo grasslands, innumerable delicate flowers have adapted to the harsh mountain conditions. From daisies to bromeliads, gentians and fuchsias, some grow in saturated bogs while others brave windy scree slopes and many more take shelter among the thick stools of stiff grass to protect them from the extremes of weather. Only a few dare to raise their heads more than a few inches above the sun-warmed ground.*

PREVIOUS PAGE, RIGHT: *The strange woolly frailejon, or tall friar, an* Espeletia *composite that is well adapted to the rigors of the climate, grows in the expansive wet northern Andes that stretch northward of the Ecuador-Colombia border.*

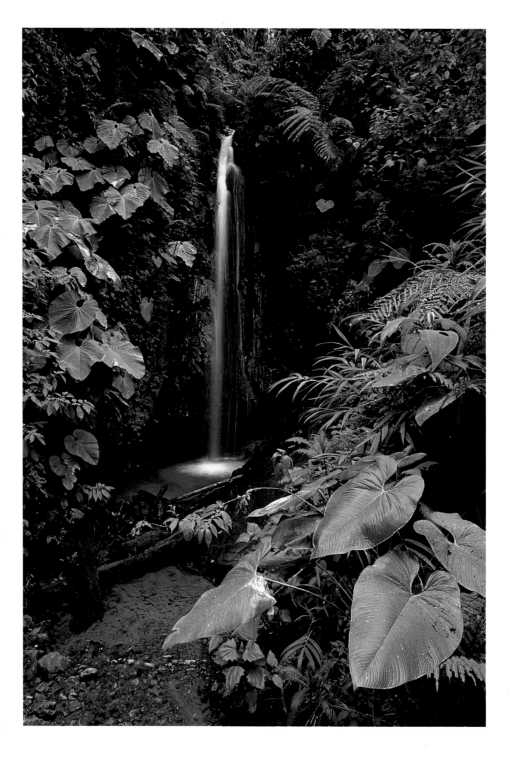

ABOVE: *The splendid plate-billed mountain toucan must be one of the most beautiful birds endemic to the western cloud forest of Ecuador.*

LEFT: *Countless waterfalls large and small bounce their way through the lush cloud forests swaddling both slopes of the tropical Andes.*

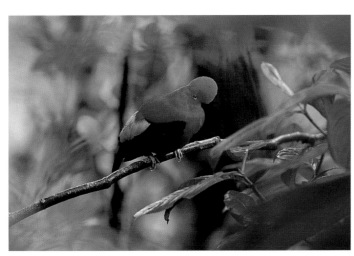

RIGHT: *In the humid cloud forest, epiphytic plants – which grow atop others without taking anything from them – come in an infinite variety of forms, including ferns, vines, bromeliads and many more.*

TOP: *Dapper and shy, the secretive female cock-of-the-rock raises its chicks in a mud nest cemented to a damp creek wall, receiving no help from the male.*

ABOVE: *The plumage of the male Andean cock-of-the-rock is designed for such brilliant effect that it appears to glow like a flame, even in twilight. Several dozen males gather at a traditional lekking tree to call and dance, trying to out-compete one another for visiting females' attention.* MARK JONES

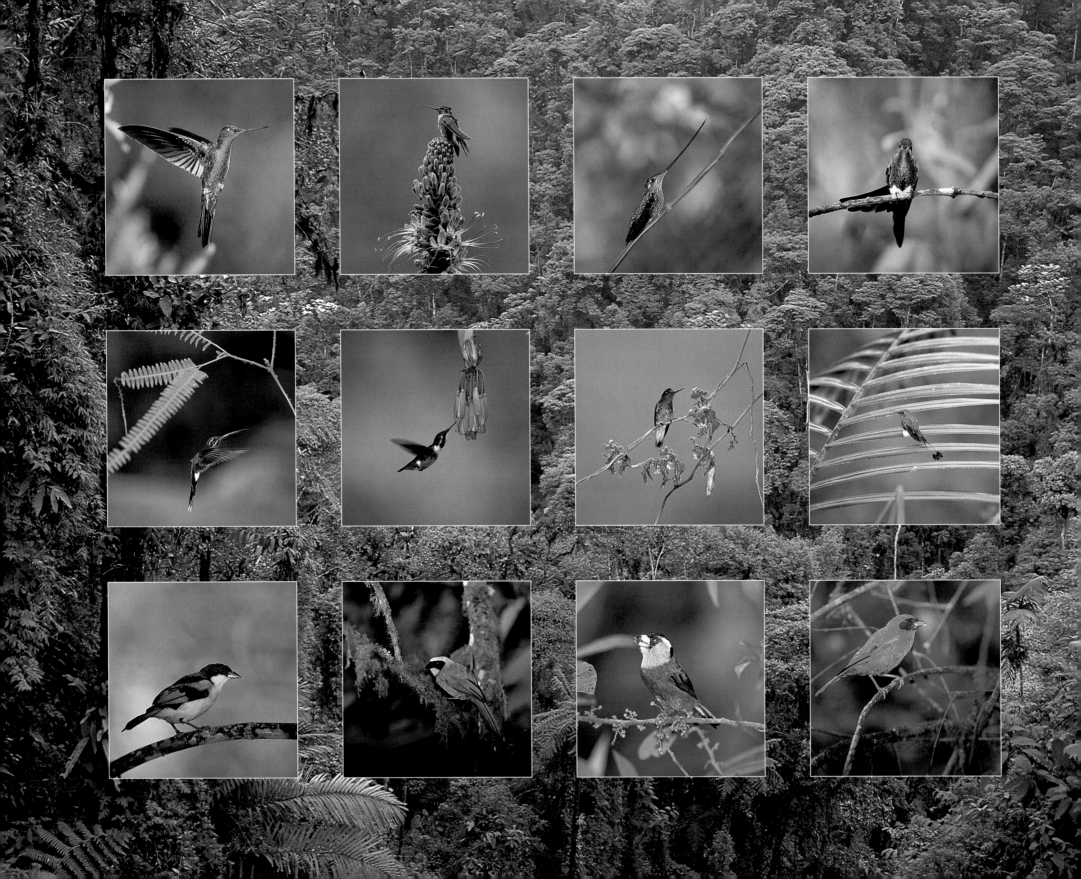

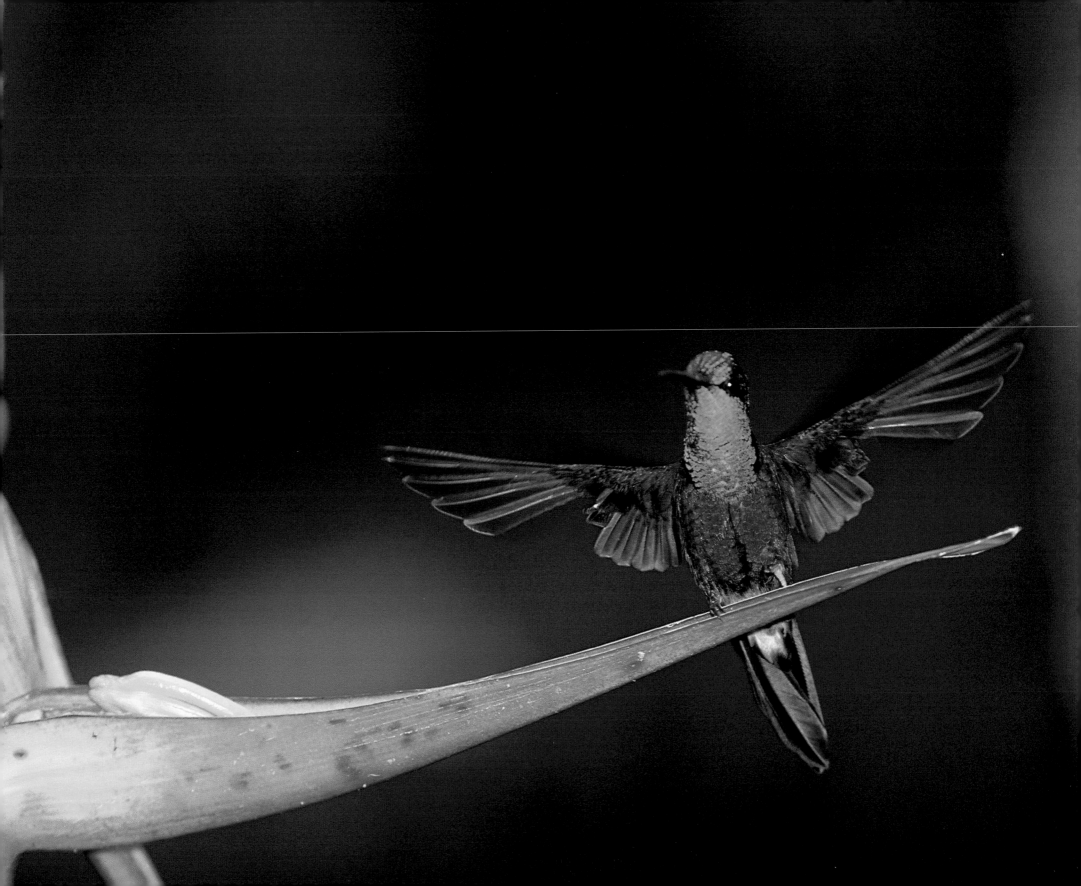

PREVIOUS PAGE, LEFT: *Cloud forest along Ecuador's precipitous western slope, between about 4000 and 10,000 feet (1200 to 3000 m), displays some of the richest biodiversity in the world. Top row, left to right, are some of the high altitude hummingbirds found near the tree line: great sapphirewing, shining sunbeam, sword-billed hummingbird, sapphire-vented puffleg. Middle row, from left to right, are lower elevation species: white-whiskered hermit, purple-throated woodstar, buff-tailed coronet among the orchids, and tiny booted racket-tail on the palm frond. Bottom row, left to right, are the blue-winged mountain tanager (MARK JONES), turquoise jay (MARK JONES), toucan barbet and grass green tanager (MARK JONES).*

PREVIOUS PAGE, RIGHT: *A tiny male green-crowned woodnymph hummingbird with molting wing feathers alights on a heliconia flower.* MARK JONES

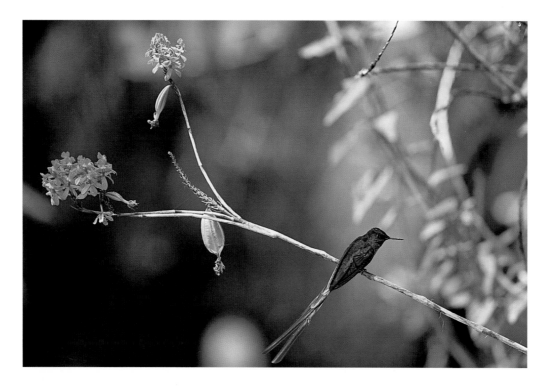

A violet-tailed sylph, perched on an orchid stalk in the Tandayapa Valley, is one of about four dozen species of flying jewels that inhabit the vertiginous cloud forest clinging to the western slope of Pichincha Volcano.

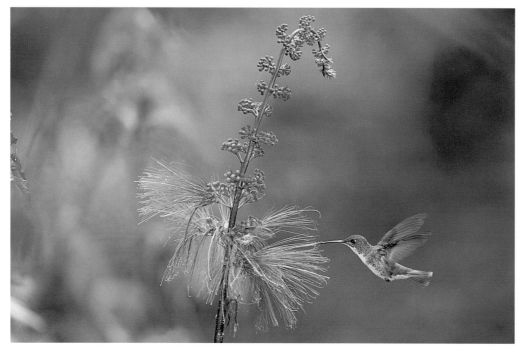

A female Andean emerald is one of many hummingbirds that help pollinate the flowers designed for such winged nectar lovers.

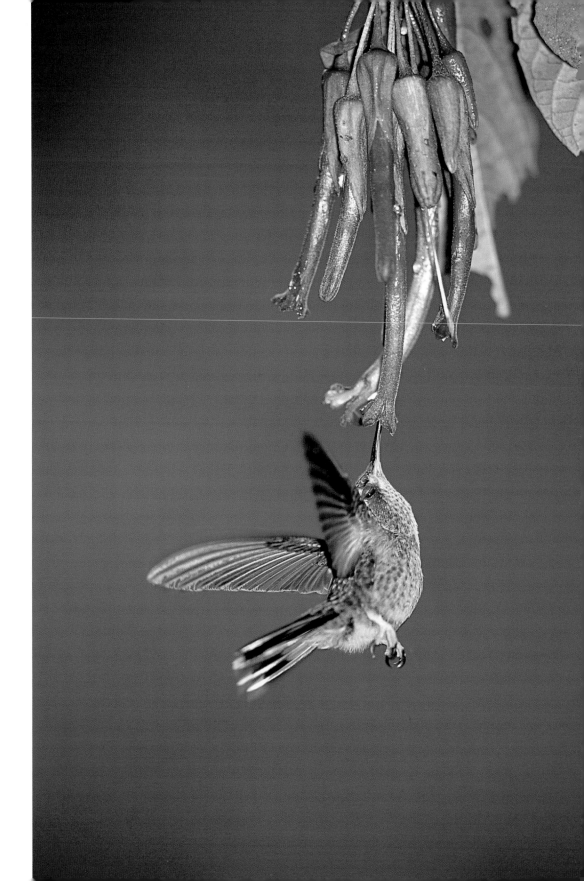

A tiny, modestly colored, speckled hummingbird feeds on one of the many extravagant flowers of the cloud forest at 7000 feet (2135 m).
MARK JONES

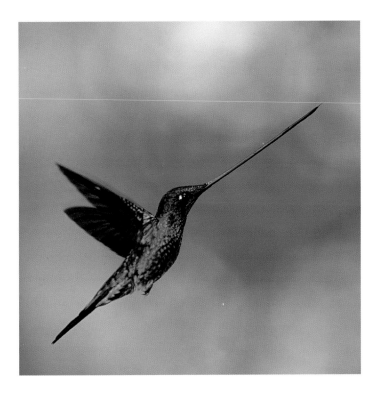

The extraordinary long bill of the sword-billed hummingbird (here a dark-plumaged male) is perfect for feeding on flowers that no other bird can access.

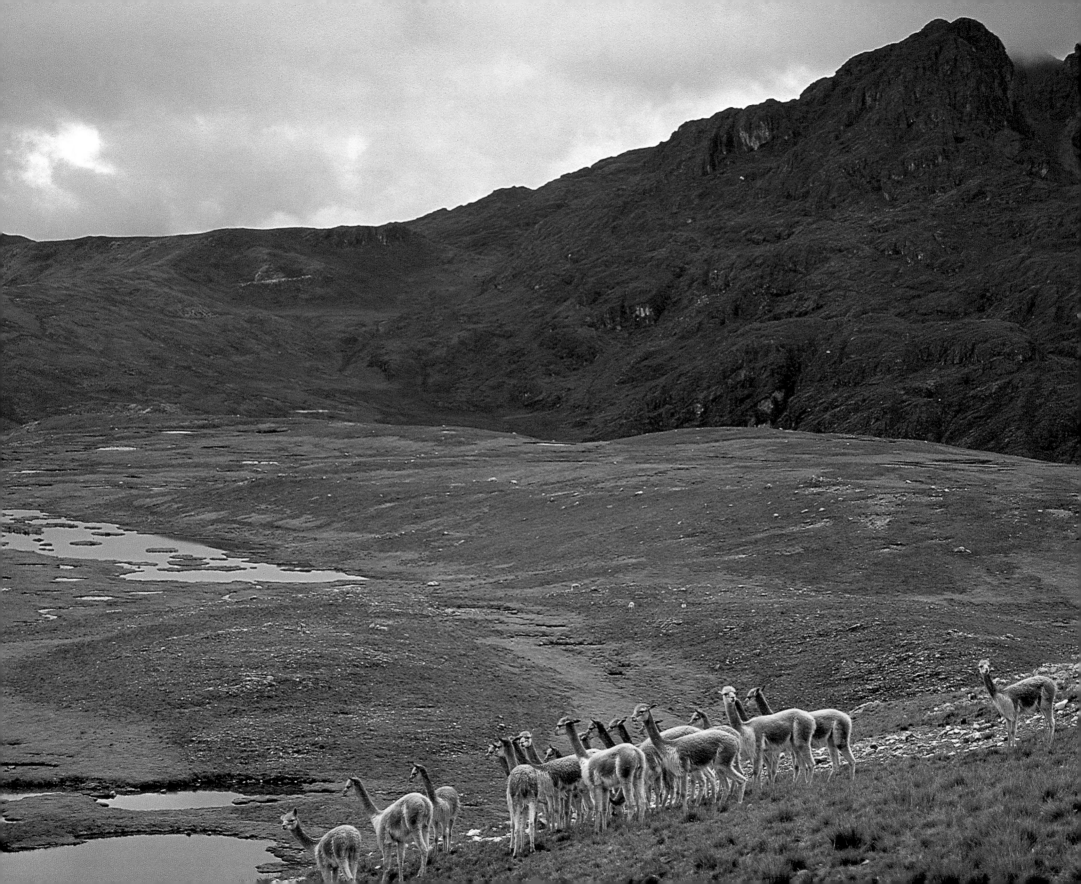

ICY CRAGS ON A WINDSWEPT PLATEAU

THE CORDILLERA BLANCA AND THE PUNA OF CENTRAL PERU

A flock of young bachelor male vicuñas wander the hills in the boggy Apurimac highlands, each waiting for an opportunity to displace a breeding male and gain his herd of females.

Dancing shafts of morning sun break through the roiling clouds, strafing the sere, windswept plains with new warmth. Curtains of steam rise from the still-frozen ground, where last night's snowfall lingers in crusty patches. Unperturbed by the chill, herd upon family herd of elegant caramel-brown vicuñas dot the sparsely vegetated valley sandwiched between ice-clad peaks. Wearing some of the finest wool in the world, these lithe and diminutive distant relatives of old world camels find their prime habitat on the wide, rolling plateaus and treeless valleys of the central Peruvian Andes. Grazing, playing, fighting and rest-ing, utterly at home between 12,000 and 16,000 feet (3600 and 4800 m) altitude, such herds present a primal spectacle of abundance – South America's answer to the grazing herds of the African savannah.

THE PERUVIAN PUNA

Much drier than the lush grassy paramos of Ecuador and Colombia, the treeless Peruvian puna consists of semi-desiccated, high-altitude plains above 13,000 feet (4000 m) stretching almost the full length of the country. Sparse yellowish grasses and coarse shrubs sprout from the sun-baked

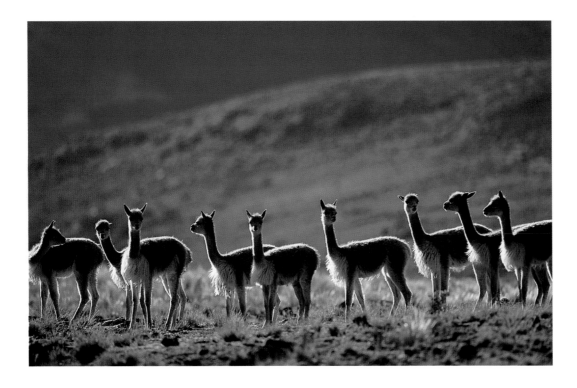

Wearing some of the finest and densest wool in the world, vicuñas remain snug in the frosty morning temperatures of Pampa Galeras at 14,000 feet (4270 m).

be known only by the remains of their prey. A smaller and even more elusive hunter is the pampas cat, while the mighty Andean condor surveys the scene from its soaring vigil in search of these predators' spoils. Only the vicuña stands tall and proud; its hardy nature seemingly contradicted by its delicate, spindly stature. Excellent vision, speed and stamina easily make up for its inability to hide; it flees so swiftly and effortlessly if pursued that its pale golden coat soon blends into the shimmering distance.

VICUÑA SOCIETY

Vicuñas are superbly adapted to this harsh environment, thriving where many other grazers would starve. Their three-chambered stomachs can process the roughest of forage, and their feet, leather-padded and flexible, can handle all terrain. Lanky and tough, they are capable of galloping at a sustained 30 miles per hour (48 km/h) over extremely rough ground. Exceptionally high numbers of red blood cells transport oxygen efficiently to their muscles and organs in the rarefied mountain air; they have 14 million red cells per cubic milli-meter of blood, as opposed to 7 million in a person fully acclimatized to altitude and 5 million for a normal human being. Their adaptations are also kind on an easily stressed habitat. With cushioned steps and prehensile lips, they neither pug nor tear at the scanty, tundra-like mountain vegetation.

Another survival secret is the vicuña's extraordinarily fine wool, which protects it from the fierce climate of the high puna. Measuring between 10 and 12 microns in thickness, the wool is more than twice as fine as most sheep's wool. Much lighter even than cashmere, this beautiful fawn-colored fleece has been coveted by people through the ages.

In Inca legend the vicuña began as the incarnation of a disdainful young damsel who, when courted by an old and ugly king, refused to acquiesce unless he could provide her with a coat of pure gold. The king agreed to the deal, and the vicuña was thus considered sacred and the death penalty imposed on anyone who should kill it. Once every four years or so, the great Inca ruler called upon thousands of his subjects for a huge wildlife drive, or chaccu, in which the vicuñas were carefully shorn and released unharmed. Their

gray-brown earth, which is relieved only by seasonal rains whose moisture soon sublimates into the thin atmosphere. The puna's more folded eastern reaches are tinged with green-ery and pock-marked with wetlands, receiving some spill-over moisture from the Amazon, whereas frigid winds parch the flatter landscape progressively to the west even before the mountains give way suddenly to the lifeless sandy plains of the coastal desert.

Most puna animals lead furtive lives, concealing them-selves as best they can in this open habitat through stealth and camouflage or by taking refuge in rocky terrain from which they venture mainly at night. Gravel-patterned seed-eating tinamous fossick between clumps of ichu grass, freez-ing in response to danger and exploding into flight at the last possible moment. Stocky Andean deer, named taruka or huemul, lead goat-like lives along the edges of canyons, taking cover in small caves where their ashy coats blend into the boulder slopes. Stealthy culpeo foxes and even more secretive reddish-brown puma let their surreptitious presence

fleece, woven into jewel-studded garments, was reserved exclusively for royalty. When the Spaniards later conquered the Inca's realm, so the story goes, the elders conferred with the mountain spirits to devise a plan to safeguard their riches. Henceforth, it was agreed, the vicuñas would evade musket-toting hunters eager to cash in on their sacred fleece by melting unseen into the mountainside. And wherever prospectors began to dig the ground in search of Inca treasures, the fleet-footed animals would rise again and flee wearing the precious gold on their backs. And so it is said that the conquistadors never succeeded in usurping either the Inca dynasty's gold or its vicuñas.

In practice this noble plan worked less effectively than in legend. Relentlessly pursued in modern times, the vicuñas dwindled to the very brink of extinction. By the early 1960s only a scant 6000 or so remained in all of Peru, but stringent protection and a scheme to ensure indigenous Andean people benefited from the vicuña's valuable wool as in ancient times has brought today's population back to exceed 150,000. Thanks to this quasi-miraculous recovery, it is once again possible to see family herds sparring and playing on the frosty ground and showing relatively little fear.

Among the mountains of the Apurimac region on a classic stormy morning at the end of the rainy season, the picture of a superbly adapted species at peace with its rugged environment couldn't be more complete. With the birthing season timed to end with the last rains, breeding fervor is at its peak in preparation for the females' 11 months' gestation. Under the ever watchful eyes of vigilant males poised on hillocks like regal sentries, tight family clusters nibble diligently at ice-encrusted, spiky cushion plants amid the blooms of white daisies and deep blue gentians. Three-week-old babies, Bambi-eyed and swaddled in plush coats of pale downy wool, already show their spunk by ignoring their fathers' territorial boundaries and gamboling together to practice skills that will prepare them for adult vicuña society. They prance, kick, bite and leap at each other playfully on long spindly legs.

Further down the valley is a large group of subadult males that mirror the actions of the older males in earnest, testing their mettle against each other in hopes of someday gaining a territory and family of their own. Screaming and growling like fighting stallions, two of the contestants break away from the main group and streak up a steep rocky ridge, kicking and spitting. They sail over rough boulder fields as if they were running on air, unfazed by terrain that would halt any galloping horse. Their nimble cushioned feet find unfailing purchase among sharp rock slabs, their sinewy bodies and fragile-looking legs pumping as effortlessly as racing greyhounds. Vanishing beyond the ridge, they reappear several minutes later, still screaming and chasing at full tilt. Down the valley they bolt, sod and mud flying as they circle a dark mountain tarn, then shoot back up to where they started. None the worse for wear after their 5-mile (8-km) chase, they finally engage in mock combat, rearing up, entwining their necks, biting each other's legs and furiously trying to trip, knock and topple each other to the ground. Their struggle is only interrupted when at last they stray onto a territory holder's turf, from which they are briskly evicted by a glaring, head-down, ears-back charge.

Survivors par excellence, vicuñas are gradually repopulating many regions of the Peruvian puna. I have been a witness to many an endearing family scene from the hardpan plateau of Pampa Galeras to the volcanic dust plains of Aguada Blanca far to the south. I watched rambunctious youngsters prance carefree through sprays of frost-spangled ichu grass at sunrise and observed watchful sentries stand against the flaming sunset on a high freezing ridge, emitting their shrill alarm calls at the furtive presence of a twilight fox. A week-old baby played with its mother's flapping tail, while the harem master confronted his rival with all the panache of a successful breeder. Such exuberance is exceedingly rare among the wildlife of the Andes.

THE CORDILLERA BLANCA

Far from uniformly flat, Peru's vast Andean plateau is wracked by deep tectonic rumples, rising and falling like great ocean waves, which fold the land into symmetrical ranges and valleys that bisect the puna down its length at regular intervals. Several such deep rifts hold remnant clumps of cloud forest, where spectacled bears still lurk shyly. In northern

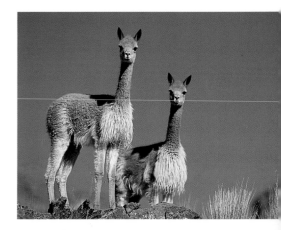

Sharp-eyed vicuñas survey the open landscape from high ground for any sign of danger.

Tangles of wildflowers bedeck the bottoms of U-shaped glacial valleys carved below the high peaks of Peru's Cordillera Blanca in Huascarán National Park.

During the short rainy season, huge thunderheads come rolling in from the Amazon side of the Andes, sweeping over the high plains of Pampa Galeras.

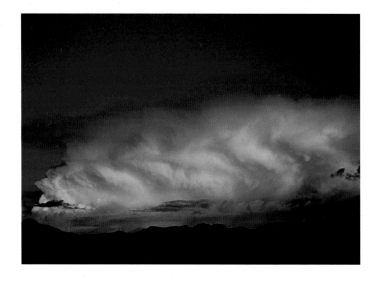

FACING PAGE: The gnarly evergreen Polylepis *is the highest growing tree in the world, clinging to polished rock slopes just below the 21,000-foot (6400-m) crags of the Cordillera Blanca.*

Peru no less than four parallel Andean mountain chains separate the desert coast from the eastern jungles. Akin to shark's teeth jutting row upon row from the predator's jaw, four such sawtooth ranges succeed one another in raw splendor: the Cordillera Negra (Black), Blanca (White), Central and Oriental.

The grandest by far is the Cordillera Blanca, straddling the heart of the most acutely dynamic segment of tectonic upthrust anywhere in the Andes. Some two dozen corniced blades of rock and ice, fluted and polished by avalanches, jut up to well over 20,000 feet (6000 m) altitude, growing faster than gravity and erosion can reclaim them. The underlying subduction zone here is so shallow that gigantic slabs of subsurface rocks, known as batholiths, are thrust forcibly skyward like mountain-sized pips squeezed from cherries. This activity, which has occurred mainly in the last 15 million years and continues unabated, to the accompaniment of violent earthquakes, has produced the garland of breathtaking peaks we see in the Cordillera Blanca today. Their precipitous flanks are festooned with shimmering icefalls, turquoise glacial tarns and sparkling melt water streams. Mossy *Polylepis* forests and gaudy fields of purple lupins and yellow snapdragons fill their narrow valleys. On the highest snow-free ground cling some of the strangest iceplants imaginable, the otherworldly, dessert-plate-sized, ground-hugging *Stangea henrici*, oblivious to

frost-heave, while below grow giant sentinels of *Puya raymondi*. In complete contrast to all other puna plants, this extraordinary member of the Bromeliacae family produces a mammoth flower stalk over 30 feet (9 m) high covered in spiraling rows of as many as 10,000 nectar-filled flowers. This is a once-in-its-lifetime effort which may take it between 30 and 100 years to attain, after which the plant will die. For a few extraordinary weeks, as the blooms open progressively from bottom to top, each lone giant becomes an irresistible focal point for nectar-hungry birds from hummingbirds to flickers, attracting their attention from far and wide across the seemingly deserted landscape.

The puna stretches in a mosaic down the entire backbone of Peru. It is dotted with discreet cushion bogs, which are home to Andean geese, Andean gulls, Andean lapwings and Andean coots. From such humble beginnings flow tiny streams, which in turn gather momentum as they carve their way through the high grasslands. They cascade down rocky gulches where torrent ducks hide, and eventually feed into the greatest river system of all, the Amazon, many hundreds – if not thousands – of miles away.

Parallel to the Cordillera Blanca on its west side is the Cordillera Negra, which is in fact black only because the complete rain-shadow effect robs it of any precipitation. It rises stark and bare to 16,000 feet (5000 m), rarely receiving so much as a snow dusting. To the east rises the Central Cordillera and the Eastern Cordillera beyond it – rumples of earth crust separated by major rivers, each feeding eastward long after escaping the mountains' embrace. Farther south, more peaks and ranges raise their glowing icy crowns high into the tropical sunlight above the puna: the Cordillera Huaywash within sight of the Blanca, and much further south still, the Vilcabamba and the Vilcanota presiding over the lush canyons on the Amazon doorstep.

Yet the puna remains a world unto itself, a world of cold winds and wide open spaces, awesome mountains and enduring life forms – from the defiant vicuñas to the stately flowering puyas and all their attendant bird pollinators. The puna speaks both of the freedom of the high mountains and the resilience of a new land being born and shaped by overwhelming geologic force.

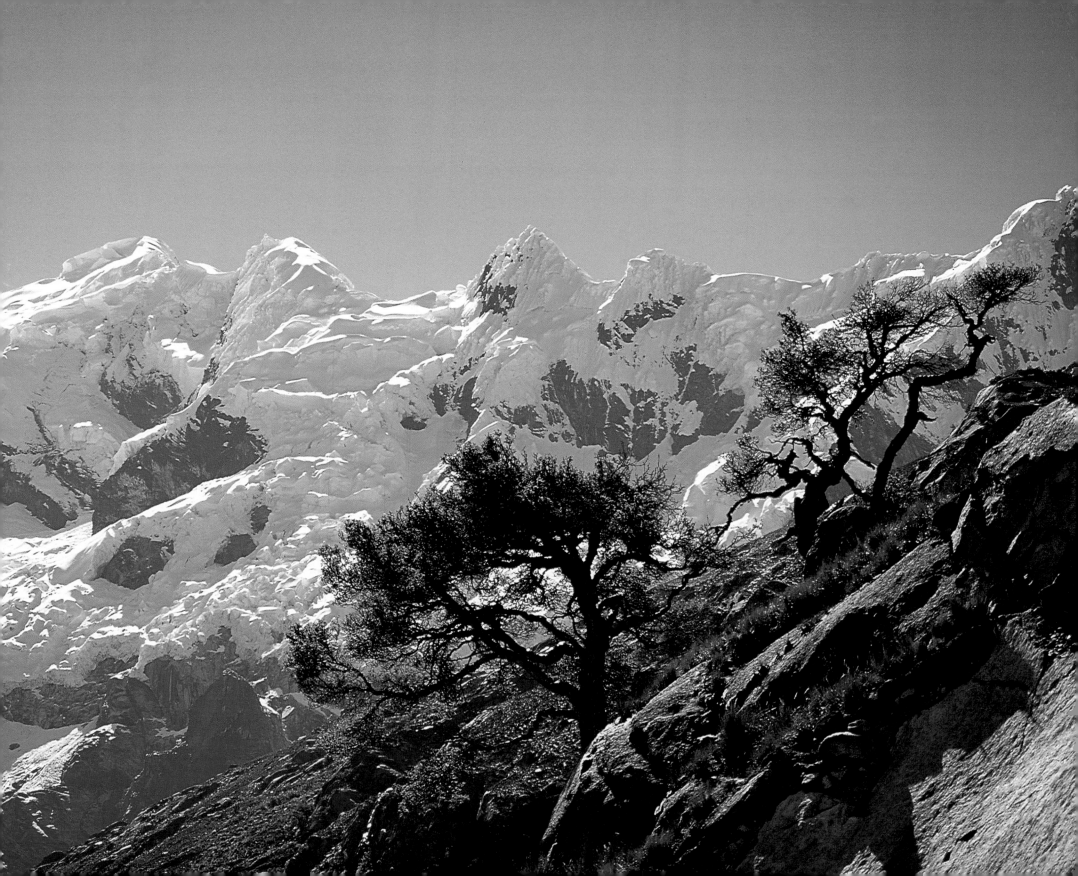

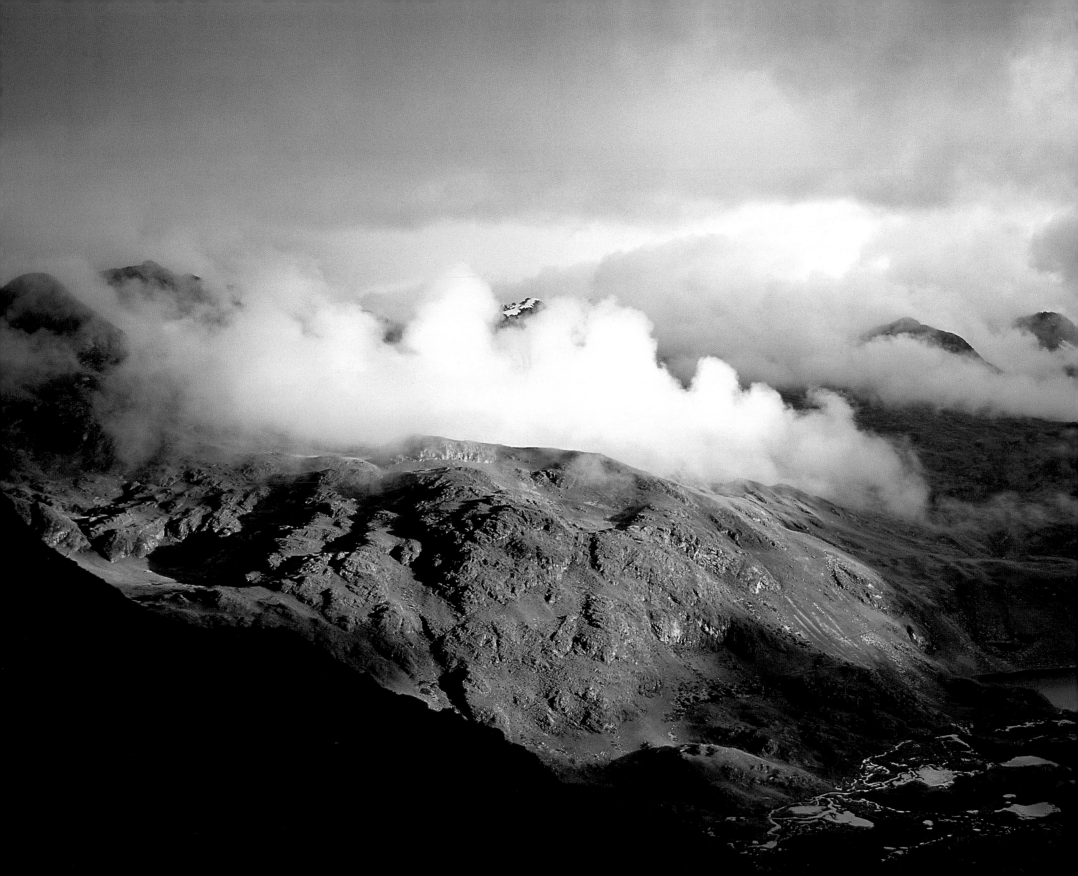

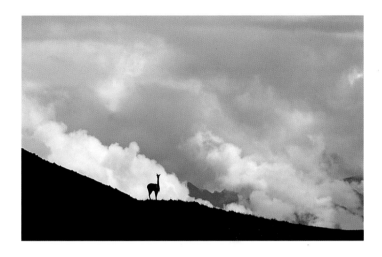

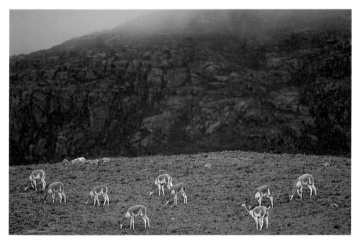

TOP: *A proud sentry above the clouds, a male vicuña stands watch over his family herd on the Llullita Plateau of Apurimac.* MARK JONES

ABOVE: *A family herd of vicuñas grazes peacefully on the high plains as storm clouds gather over the Apurimac mountains.*

RIGHT: *After being ousted from his herd by a younger rival, a lone male vicuña wanders the lush hills alone.*

FACING PAGE: *Amazon moisture rising high into the mountains through the Apurimac River gorge makes the puna plateau near Chuquibambilla unusually lush and boggy.*

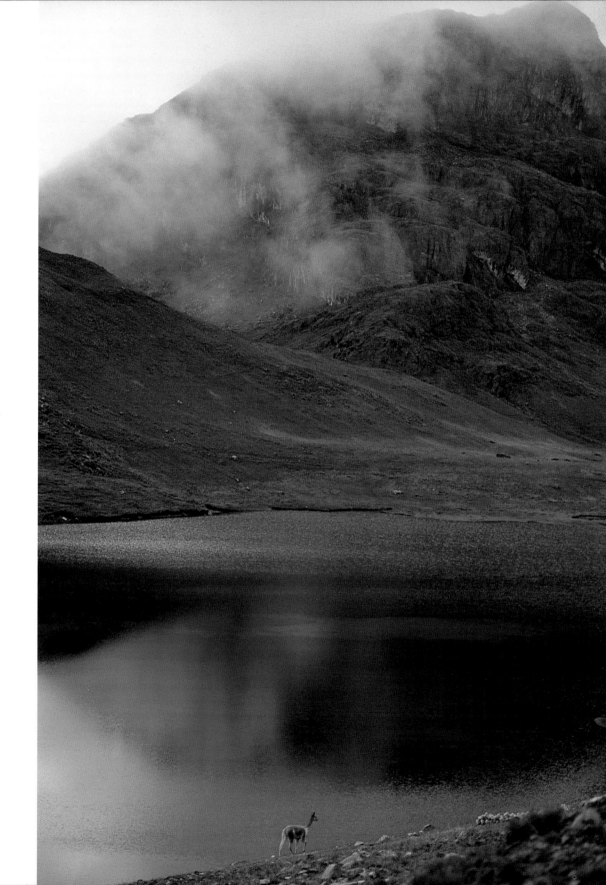

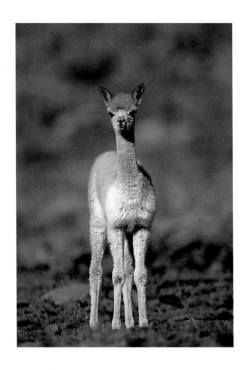

LEFT: *At only two weeks of age a young vicuña already demonstrates the alertness and independence of its elders.*

RIGHT: *An adult vicuña pauses daintily while browsing rough scrub.*

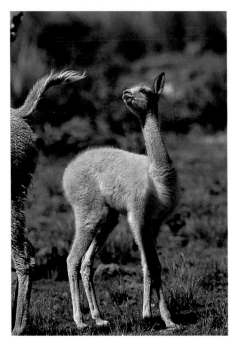

LEFT: *A three- or four-week-old vicuña baby plays with its mother's wiggling tail.* MARK JONES

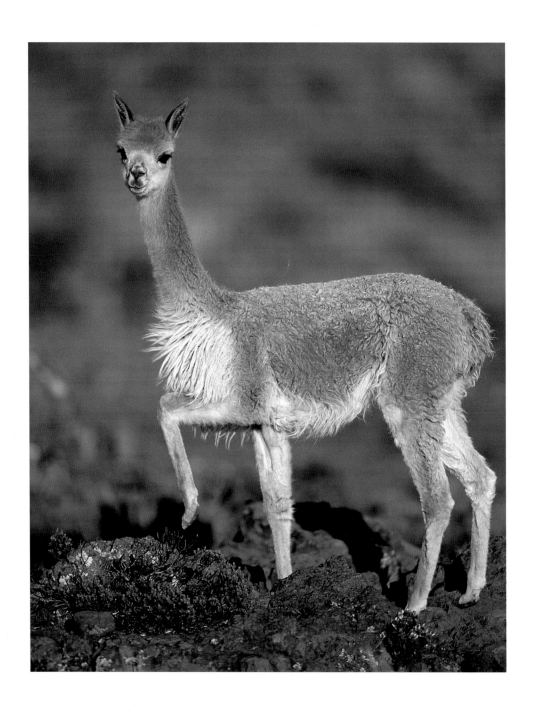

FACING PAGE: *A three-week-old baby vicuña explores alone some distance from the herd among tall ichu grass at Pampa Galeras.* MARK JONES

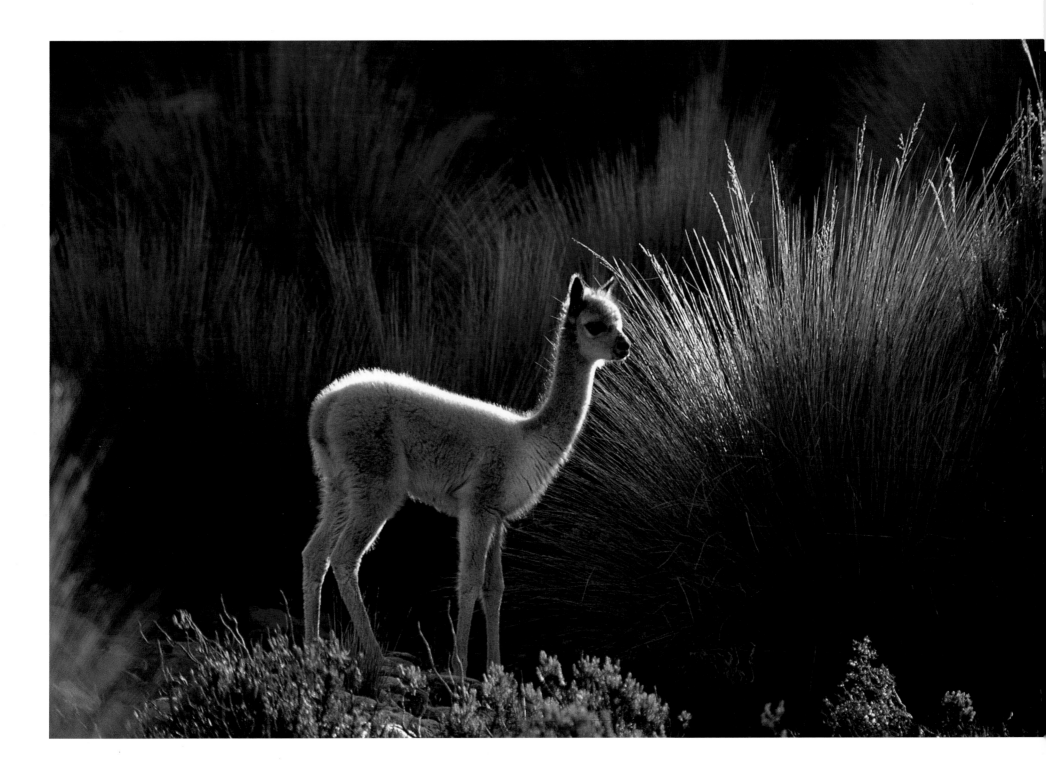

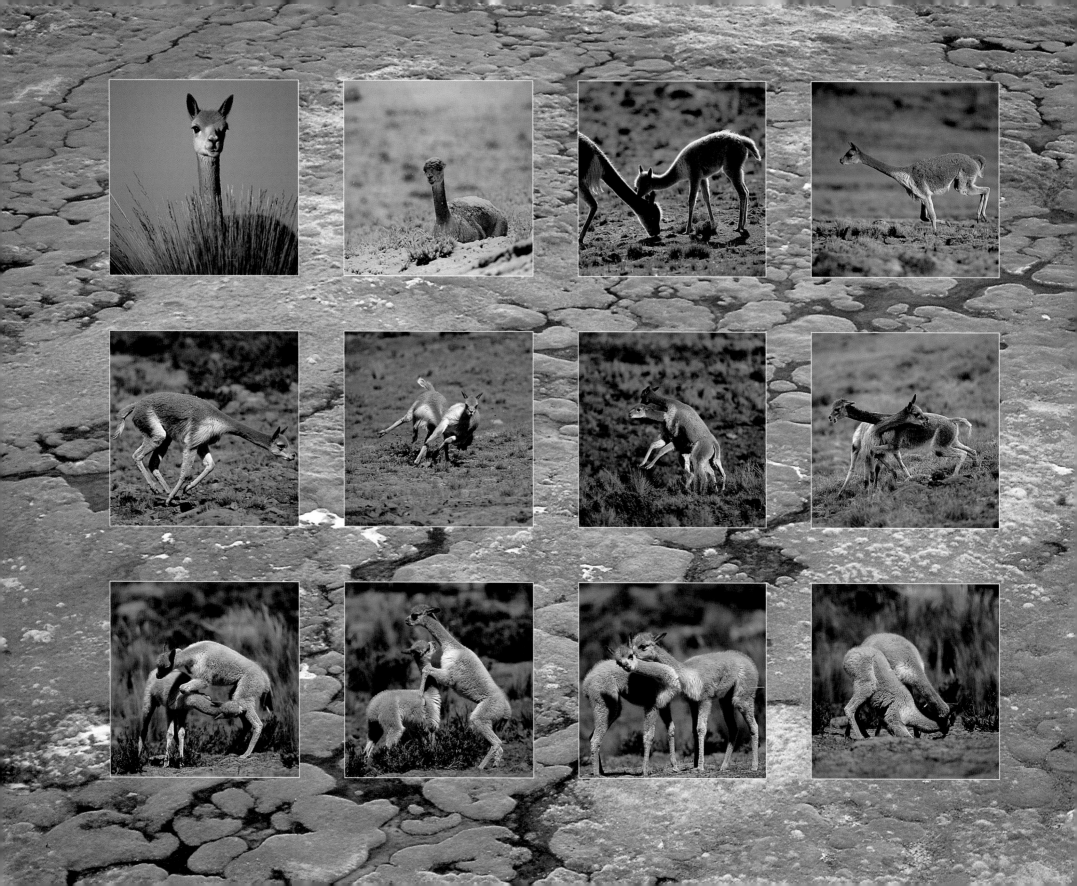

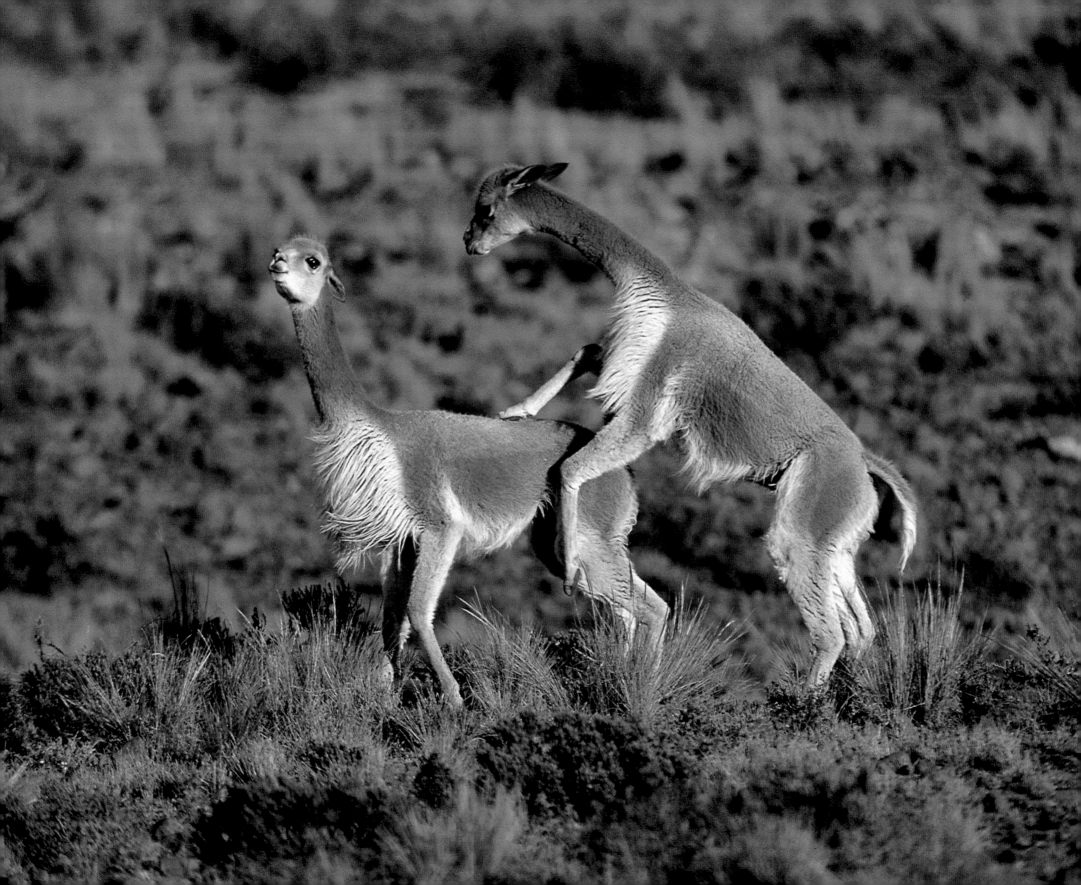

PREVIOUS PAGE, LEFT: *The vicuña's entire family life is played out on the windswept puna where small seeps create dense cushion bogs and snow and hail can whiten the ground at any time of year. Territorial males chase away rivals, easily sustaining speeds of 30 miles per hour (48 km/h) over rocky terrain, and fight to gain a breeding herd of females. Babies mimic their elders in play, and show rare moments of tenderness with their mothers. (Top row, third from left,* MARK JONES*)*

PREVIOUS PAGE, RIGHT: *Fighting males use every available trick to establish dominance and a right to breed, kicking, biting and trying to topple each other to the ground using chest rams and neck wrestling.*

FACING PAGE: *The Cordillera Blanca consists of ridge after ridge of precipitous slabs of rock and ice rising above 20,000 feet (6100 m), which are still being actively thrust skyward by the squeeze of tectonic plates.*

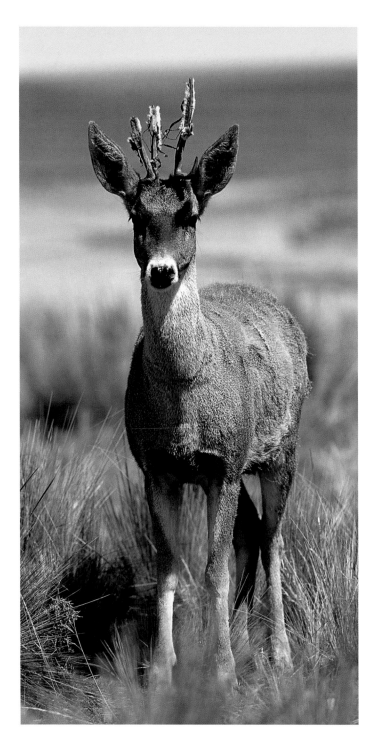

ABOVE: *Shy taruka does wander out onto the high plateau of Patapampa to graze on sparse vegetation, retreating to rocky canyons at the slightest danger.*

LEFT: *A taruka buck losing its velvet. The taruka, or Peruvian huemul, is a stocky deer that lives in the high reaches of the puna. A poor runner, it takes refuge in rocky terrain where it blends into the landscape.*

BELOW: *The puma, known elsewhere as the mountain lion, is an adaptable predator found along the entire length of the Andes, from rocky canyons and plateaus to the damp forests of the south.*

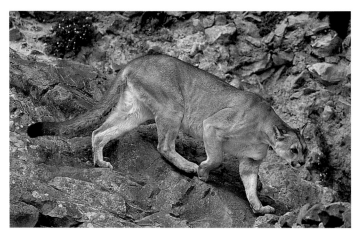

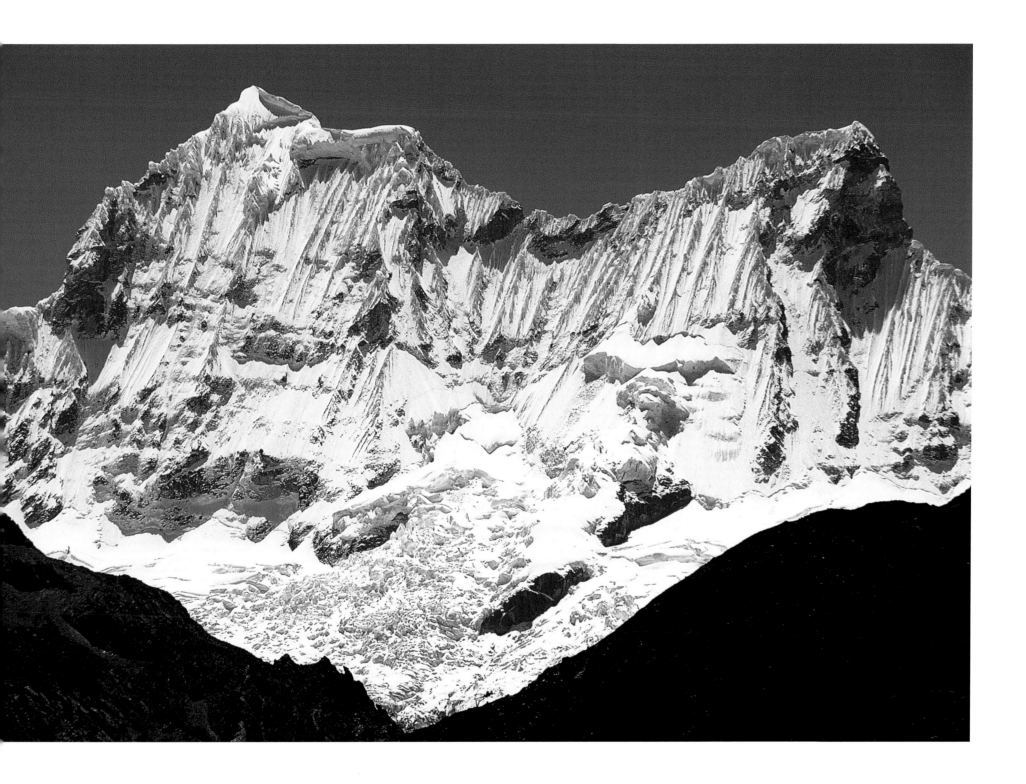

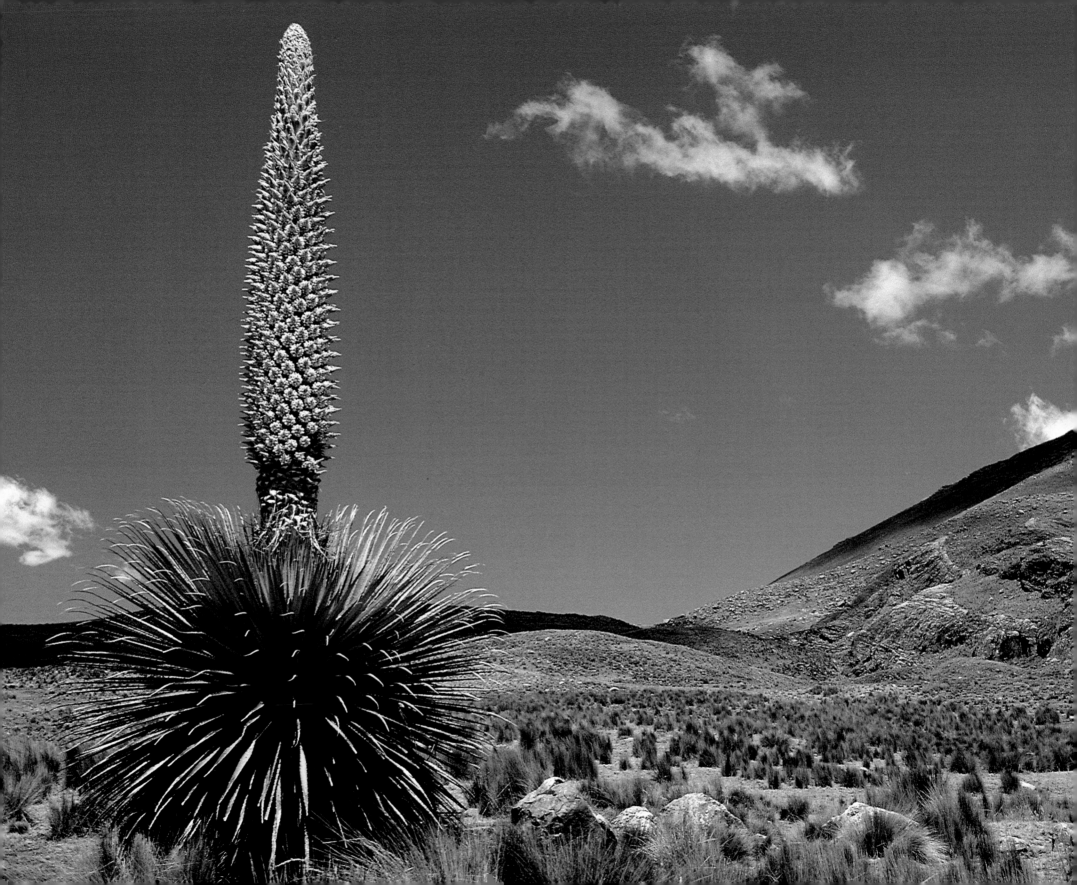

At 22,200 feet (6770 m), Huascarán is the highest peak in the Cordillera Blanca. Its rock and ice face collapsed in 1973 causing a devastating landslide that traveled far down this valley and buried an entire village, Jungay.

FACING PAGE: *The enormous bromeliad* Puya raymondi *towers above the dry puna, producing a single flower stalk that can reach more than 30 feet (9 m) in height after many decades of slow growth.*

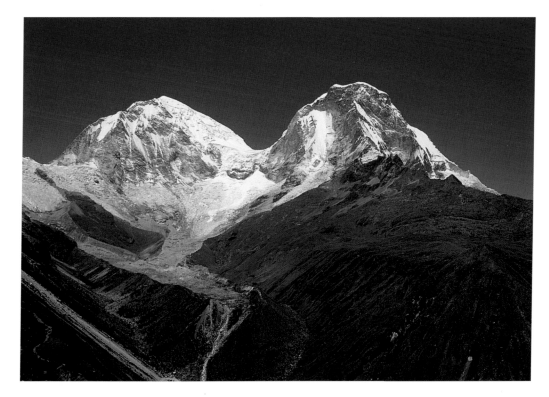

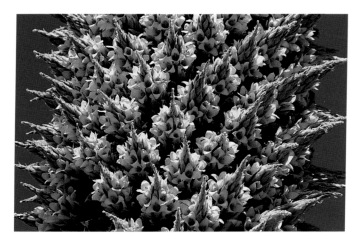

Cool, crystalline springs well up on the dry puna below the snowy peaks of Huascarán National Park.

Blooming only once in its lifetime, the bromeliad Puya raymondi *(above center) grows an enormous stalk that may carry 10,000 flowers. Andean flickers (above left), who normally feed on the ground in the open puna, flock to the abundant nectar-bearing flowers, as do giant hummingbirds (above right), the largest of all hummingbird species.*

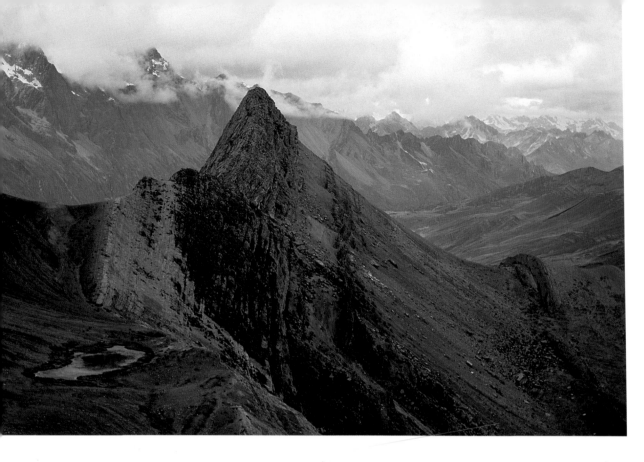

LEFT: *What were once horizontal layers of sediment have twisted and tipped as the mountains of northern Peru rose when the edge of the continent buckled.*

RIGHT: *Incredibly, the strange iceplant* Stangea henrici *manages to grow on high windy ridges where deep frost-heave churns the ground each night.*

ABOVE: *Cacti grow at amazingly high altitudes and may even freeze solid during cold spells. Like most plants in this harsh climate, different species resort to either hugging the ground (above right) or to growing woolly hairs (above center), or sometimes both (above left), to resist the wind.*

FACING PAGE: *A furry Senecio plant braves frost and windchill to bloom on dry rocky buttresses at 17,000 feet (5180 m), just below the snow line in the Cordillera Blanca.*

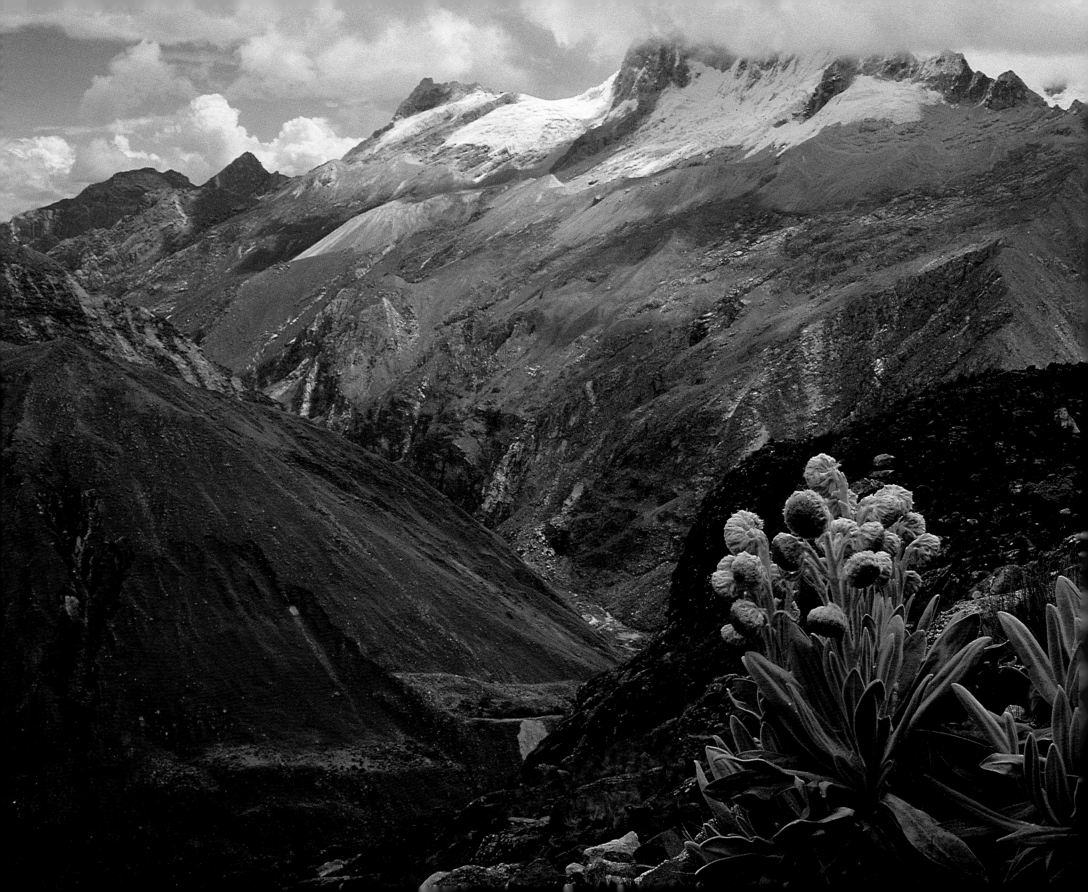

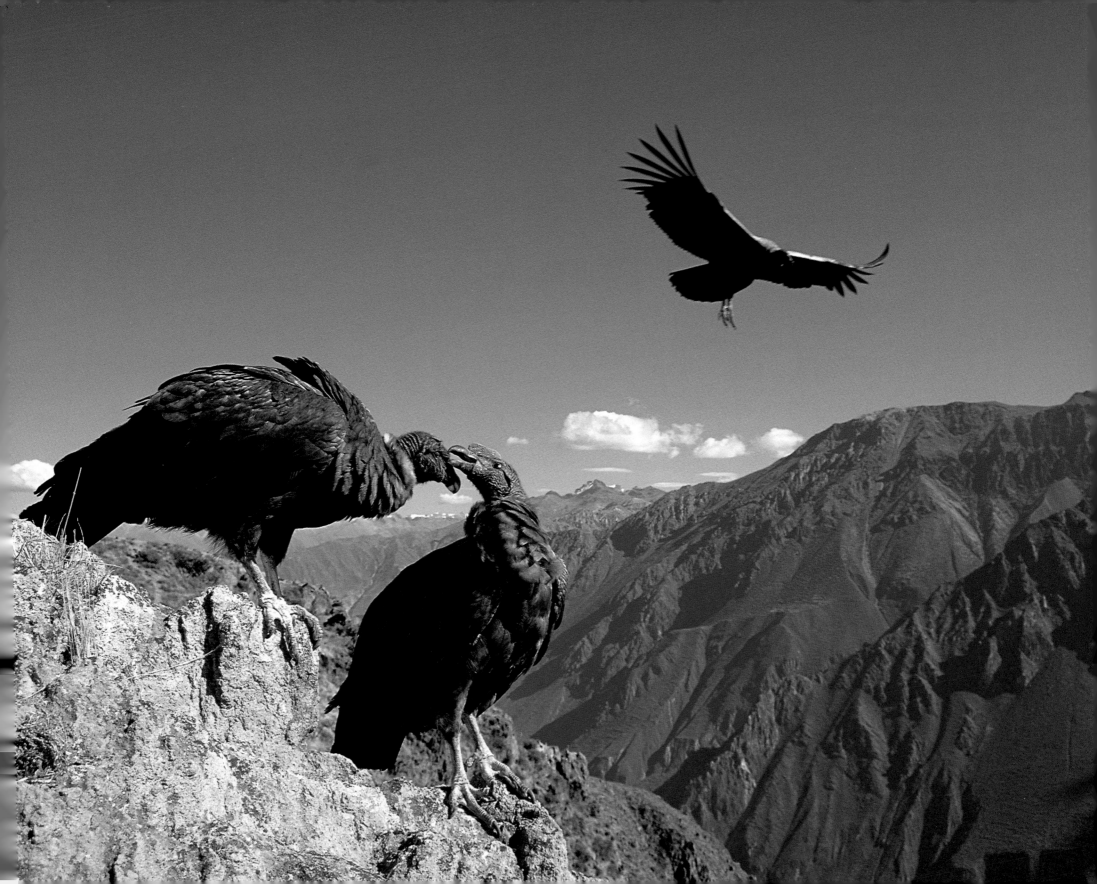

THE REALM OF THE CONDOR

CANYONS, VOLCANOES AND WETLANDS OF THE PERU-CHILE BORDER

FACING PAGE: Wild and free, young Andean condors perch momentarily on the edge of the Colca Canyon to play and socialize.

Sunrise over the Colca Canyon is a magic moment. The first rays appear to explode into the crystalline air high over the snow-spangled crags at 18,000 feet (5490 m), and immediately begin their slow probe into the twilit canyon far below. As the shafts of light slant deep into this breathtaking chasm, a tiny black-and-white speck appears a long way below. Indistinct at first, it circles and grows as it rises. Within minutes it draws level.

THE COLCA CANYON

An Andean condor is ascending on the first of the day's thermal air currents, which have been generated by the sun's intensifying warmth striking the canyon wall. Suddenly I find myself staring into the eye of the largest flying bird alive today. A splendid adult male, he banks on 10-foot (3-m) wings and returns, white blazes flashing on broad black wings, his fluffy white ruff pulled snugly over a featherless rosy neck to ward off the chill. Adjusting his flight imperceptibly, he veers for an even closer pass, not 15 feet (5 m)

distant. His gaze meets mine with a mixture of curiosity and confidence, his strange fleshy crest flapping in the breeze as he turns his head to watch as he passes. Supporting a massive 33-pound (15-kg) body, his splayed, upcurved wingtip feathers slice through the air with a sound akin to wind in a sailing ship's rigging.

As the morning sun grows warmer, more condors appear from the depths of the canyon, as they do almost every morning. Today, 18 in all rise and fall in effortless circles, never flapping a wing but simply adjusting their feathers ever so slightly to harness the vertical air currents. They chase and play on the icy breeze, rising ever higher toward the lofty snows. A group of dark juveniles dive-bomb each other in a mock dogfight, while a stately pair of adults cruises back and forth in perfect synchrony within a wingspan of the cliff face, courting in mid-air.

The breeze picks up, giving the airborne ballet extra lift, and all disappear high in the sky. Where to remains a mystery, as does most of the condor's life. That it is a formidable scavenger cannot be doubted. The undertaker of the natural world,

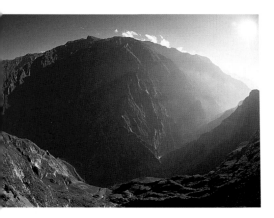

Dropping 11,000 feet (3355 m) from sheer mountain crests to whitewater river, the Colca Canyon of southern Peru is nearly twice as deep as the Grand Canyon of Colorado.

whose role it is to quickly clean up carcasses wherever death strikes, it prevents the spread of disease among large mammals. Each year, from December to March, condors by the dozens appear along the desert coast hundreds of miles away to feast on sea lion placentas and stillbirths. No-one knows where they come from, the route they take, how they navigate or what alerts them to the timing of the pupping season. Could they be coming from this place, riding the desert winds from the Andes to the sea at the appointed time each year, all by memory?

For centuries the majestic bird has been revered by ancient Andean civilizations, appearing prominently in pottery, stone sculptures and even a gigantic figure etched into the desert surface of Peru's Nazca Plains. Today it is featured on the coat of arms of no less than four Andean countries – Colombia, Ecuador, Bolivia and Chile – and its name surfaces repeatedly in everyday South American life, from an airline logo to the syndicated comic strip, *Condorito*. Yet of the bird itself precious little is known, except that its numbers are dropping alarmingly over many parts of its mountainous range down the length of the continent.

One day I learned of a special place downriver where I was told the condors fly in from afar just to bathe. At the end of a long day's walk, there was indeed a spectacular waterfall plummeting thinly down a series of stair-like ledges high on the canyon wall. Scrambling up to this precarious perch, I found the most idyllic setting imaginable. Sparkling spring water cascaded down the desert cliff, bouncing from bowl to crystalline bowl, with a plunging vista only mountain gods could dream of. Discarded condor feathers were proof enough that this account was real.

Fascinated by the condor's abundance around the Colca, I spent over two months with my partner Mark exploring the region in search of clues to the bird's private life. The native Collagua people, whose tradition of cultivating extensively terraced irrigated fields on the canyon walls may go back to the 14th century BC, were friendly and talkative, recounting how in times past children used to fetch condor eggs from nests in the crags just above their villages.

A young Indian, Silverio Cutira Llallacachi, offered to guide us high into the mountains to where he claimed the condors still nested. For days we walked under the searing Andean sun, over pale yellow sand dunes and up red-rock mesas, across corrugated ice slopes and fields of faceted boulders shaped by wind-blown sand. We followed traditional llama train routes over high passes and down ancient stone staircases into secluded valleys used by alpaca herders. At sundown we camped amid pillow-like mossy bogs and awoke to silent waterfalls frozen into glittering ice stalactites. But of condors we saw nothing. Crag after crag, Silverio showed us perfect condor nesting sites – small deep caves on the faces of utterly vertical cliffs, with a guano splattered perch to one side affording expansive panoramas of the Andean ranges. But the ledges where the birds should have sat now harbored delicate plants, testimony that no condor feet had stamped here for some time. One cave where Silverio claimed to have seen the birds nest was located only a few dozen yards below the legendary El Mismi's 18,360-foot (5597-m) summit.

Our quest ended days later and far below, inside the canyon itself, where a guano-encrusted cave opened along the vertical wall above the fast flowing river. With no condors in sight I decided to rappel down and investigate more closely. Dangling on my rope like a spider, with the rushing waters of the river snaking 600 feet (180 m) below me, I swung into the cave. About 12 feet (4 m) high at the entrance, it led back horizontally to a snug triangle of flat ground deeply littered with huge black feathers. A strange musky smell hung in the air, not unpleasant, but more suggestive of a large mammal's lair than a bird's nest. Among the feathers on the nest floor I noticed some bones. These were not food remains, but the remains of an adult condor. Had a condor died here while tending its chick, perhaps the poisoned victim of persecution for its purported habit of driving cattle off cliffs?

Condors may live naturally for 50 years or more, but it appears they can raise at best only one chick every two years. To hatch the single huge egg – over 4 inches (11 cm) long – takes nearly two months incubation. The chick will spend a further six months in the nest before fledging and needs many more months of assistance to learn all the tricks of condor survival, such as memorizing the lay of the land, where to find food, how to avoid danger and, above all, perfecting its flying skills through lengthy practice. Not until six years old

will a young condor begin to swap its murky brown coloration for adult plumage and find its place in condor society, selecting a life-long mate to begin breeding. If a few too many adults come to an untimely end, this cycle is broken as deaths outstrip hatchings, and population numbers plummet.

By the time we prepared to leave, the Colca winter was setting in. The thin flush of grass on the high slopes was fast shriveling up and condors were hungry. Eager to see condors feed, Mark and I constructed blinds beneath large boulders near a freshly culled horse carcass. Miserably cold in our sealed dungeons, day after day we watched growing numbers of condors circle high overhead, inspecting the site. Each day we returned before dawn and sat motionless in icy conditions until after dusk. Condor numbers grew until I could count 28 through my peephole field of view. The eerie sound of the wind in their wings differed with each bird, depending on the condition of its feathers; in some it produced a low treble, in others a high whistle, and one emitted a bizarre siren-like whine.

Far in the distance I could see the condors interacting around favorite perches, revealing intriguing behavior that hinted at a complex social fabric. Two old males engaged in tender mutual preening. Two others seemed to be playing, nibbling each other's beaks and intertwining their necks, even taking turns shoving and pushing each other around. Some birds appeared to take pleasure in knocking others off their perch. An adult male performed a spectacular wings-out, head-down, chest-inflated display toward a nonchalant subadult. Further away a pair was busy courting, the magnificent male's head flushing brilliant hues of orange and red as he strutted and nodded around the attentive female, occasionally cupping his outstretched wings forward and slowly pivoting in full circle. The two would then fly off together and sketch a few beautifully choreographed figure-eights in the sky before landing and repeating the whole performance.

The days passed and we waited. A culpeo fox made regular visits, carrying away food to a secret cache. A nervous Peruvian huemul doe walked by unsuspectingly. One night a large chunk of meat was taken from the carcass, possibly the work of a puma. But still the condors only watched. An Indian story I'd heard began to intrigue me. According to

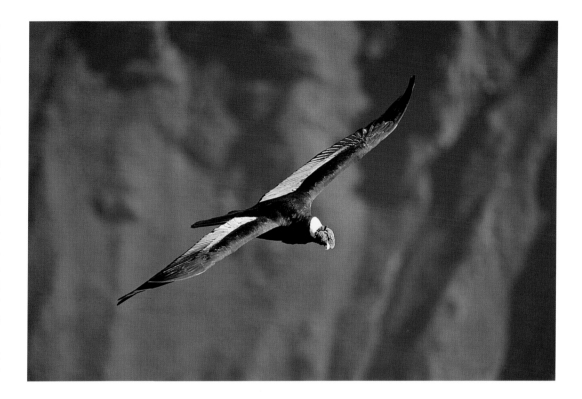

local lore the condors have their own leader, a very old male the natives referred to as the apu, meaning "the wise one," in local tongue, a term also used for mountain gods. Supposedly, no matter how hungry condors might be, they would not approach a carcass to feed until the apu had decided that it was safe to do so.

On the fifth day, an hour before sunset a stupendous male flew in and landed close by. Head held high, shoulders squared, feet planted far apart, his entire body language spoke of dominance, a great presence emanating from every feather. All at once I realized I had the apu before me. For an hour he stood stock still, surveying the scene. Then, very deliberately, he began walking. The apu led the charge while some 40 condors dropped out of the sky and closed ranks behind him, marching like an advancing army through tall tussock grass.

They descended on the carcass in a hissing, grunting mêlée of black and white wings. For 20 minutes the sounds of

A fully mature male with striking white wing-blazes soars along the sheer wall of the Colca.

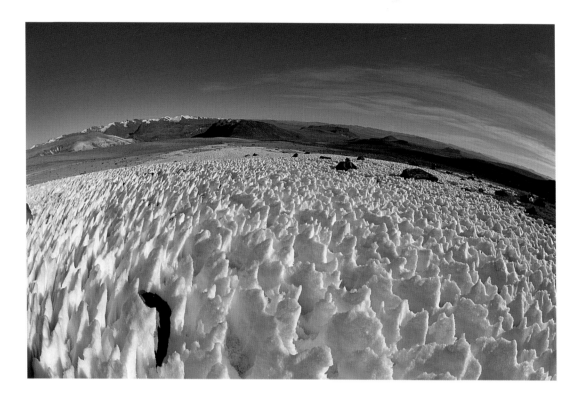

tearing hide and snapping cartilage filled the air as they feasted. Then, all at once, they took off, flapping away heavily into the gathering night, leaving a lingering vision of prehistoric times, long before humans came onto the scene, when great hordes of giant scavengers fed upon Pleistocene mammals.

VOLCANIC FORCES

The vast defile of the Colca Canyon remains the condor's chosen domain. A vertical landscape providing an ideal habitat, it acts as the species stronghold in an increasingly hostile world. Directly overlooking the canyon to either side are two snow-clad, slumbering volcanoes rising well over 18,000 feet (5490 m) each, El Mismi and Hualca Hualca. From their lofty heights to the roaring river, the canyon's nearly sheer walls plummet almost 11,000 feet (3300 m), nearly twice as deep as the Grand Canyon. Draining toward the Pacific – some 280 miles (450 km) from source to sea – the Colca River has kept pace through geologic time with the rising Andes mountains, carving deeper and deeper through folded layers of rock to maintain its westbound flow even as other rivers born in its vicinity meander back toward the distant Amazon to the east. It has survived the original continental buckling, as evidenced by bedrock of Precambrian gneiss at its lowest levels, through layers of 280 million year-old marine fossil deposits, to helter-skelter rumples of sedimentary rock. Thick deposits of quartzite, slate, limestone and sandstone give way to a final topping of heavy volcanic caps that have formed in just the last two million years. Many a youthful volcano in the region is still rumbling and spewing today, such as Sabancaya at 19,563 feet (5967 m) and Ubinas at 18,596 feet (5672 m), or Misti Volcano farther south at 19,089 feet (5822 m). At lower elevation Andagua, a side valley 50 miles (80 km) long, runs as a deep fault that spills into the Colca, its floor covered with a swarm of some 80 young basaltic cones and lava flows dating from 200,000 years ago to the present.

Throughout this eerie geologic realm the condor prevails, but farther south the landscape changes. Although this young and active volcanic zone extends across the border well into Chile, moving south the earth is less tormented, its peaceful

ABOVE: Wind-sculpted snowfields mark the sere plateau at 16,000 feet (4880 m) where meltwater from El Mismi begins to trickle toward the Amazon.

RIGHT: Cinder cones of relatively recent origin dot the Andagua Valley, a tributary to the Colca Canyon, by the scores.

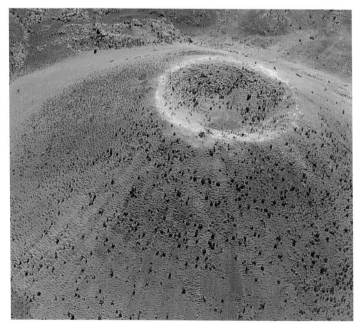

THE REALM OF THE CONDOR

plateaus not so deeply broken. The smoldering entrails of dormant volcanoes feed countless hot springs and major geyser fields, the most notable being El Tatio, where dozens of vents spew spectacular columns of steam into the frigid air. Nestled among the mountains or cradled in broad valleys are clear lakes and spongy wetlands known as bofedales, fed by melt water from snowy peaks.

WILDLIFE RICHES OF LAUCA NATIONAL PARK

The largest and most pristine lake is Lake Chungará, nearly 15,000 feet (4600 m) above sea level in northern Chile, presided over by the perfect volcanic cones of Parinacota at 20,827 feet (6348 m) and Pomerape 20,426 feet (6230 m). Encompassing a variety of lakes, ponds and spring-fed cushion bogs, Lauca National Park offers an oasis of life in the high mountains, where wildlife enjoys an unusual level of protection. Today the scene here is just as splendid, the wildlife just as trusting, as it was 25 years ago in cherished memories of my first long Andean explorations.

On a winter's day the warm morning sun streams in through the tent door. Soft as velvet, it gently swamps our snug campsite nestled in a sandy hollow between steep, jumbled lava flows. The air is so perfectly still it feels quite balmy even though the temperature has only just risen above the nighttime frost. And like the sun's heat, sound is magnified as it spreads through the stillness, seemingly suspended in the quiescent air layer.

One of Lauca's many small lakes lies enclosed between the rocky embankments before our tent, and across its mirrored surface rings a concert of coos, cackles, chatters, gurgles and squeaks as its feathered inhabitants greet the new day. A thin sheet of ice along its shores is beginning to break up as they paddle and splash, churning up insects and weeds and animating the bright reflections of snowy peaks.

Graceful Andean avocets pluck insects from the water's surface while crested ducks and speckled teals dabble slightly

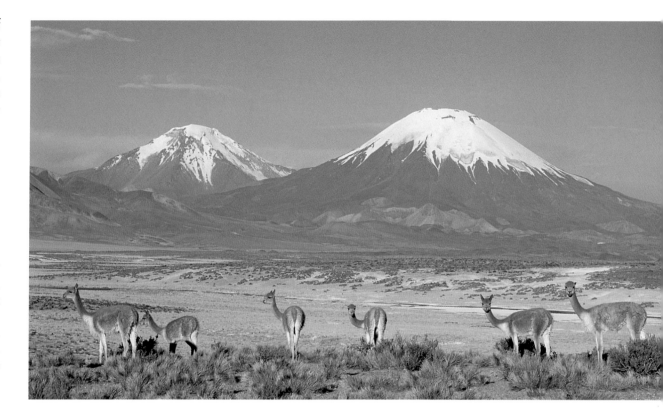

deeper, joined here and there by stunningly beautiful puna teals with sky-blue bills. Silvery grebes parade and curtsy in busy courtship trios and quartets. Andean gulls circle above while their chicks sun themselves on offshore boulders. Wintering phalaropes twirl like wind-up toys alongside dark glossy puna ibis probing the shallows. Small chocolate-brown and black passerines work the shorelines.

The most ubiquitous by far is another unusual Andean endemic, the giant flightless coot. As large as a very plump chicken and black as coal, they are the uncontested owners of these lakes and ponds, cackling, cooing and splashing in constant disputes over territorial boundaries. In the early morning they pace heavily on massive, bright red feet across sheets of ice left over from the night. Later, as the sun thaws the surface, they use those same oversized feet to dive down into aquatic plant beds and paddle about dragging great wads of weeds onto large frosty rafts where they feed the tender

A family herd of vicuña is at home on Chile's 15,000-foot (4600-m) plateau under the watchful presence of Pomerape and Parinacota volcanoes.

ABOVE: Mated for life, a pair of Andean geese graze on lush wetlands dotting the dry plateau.

RIGHT: A stout, flightless giant coot guards its floating nest against neighboring intruders on Lake Chungará.

FACING PAGE: The imposing bulk of Sajama Volcano in Bolivia looms beyond the waters of Lake Chungará on the Chilean border.

like high-speed paddle-wheelers. Differences are settled with frequent fights, as there is much at stake for a bird whose entire world consists of a section of semi-frozen lake perched high among the silent mountains of South America.

The lake is fed by numerous small springs seeping from the gravely volcanic slopes, lining gentle swales in green swaths of springy ground-hugging vegetation. Conspicuous pairs of plump black-and-white Andean geese crop the dense cushion plants, while strutting Andean lapwings pick insect larvae, and long-legged ground tyrants snatch gnats along icy rivulets.

Although temperatures may fluctuate between –4°F (–20°C) at night and 68°F (20°C) in full noonday sun, these verdant pastures are shared by a whole community of mammal grazers, from tiny leaf-eared mice to peaceful herds of vicuñas. With the cushion bogs nightly being encased in ice, many of the smaller scurrying creatures cash in on the sun's warmth to dart out into broad daylight, chasing and nibbling and carrying precious tufts of soft vicuña wool to line their nests. The most remarkable and endearing of these is the improbable looking mountain viscacha, a member of the chinchilla family with rabbit ears and a squirrel-like curly tail, which scampers about nearby boulder fields somewhat like a marmot. Clad in luscious fur, the viscachas share with other rodents in this environment the common design of stubby legs and compact proportions to resist cold. They also spend many hours dozing in the sun, eyes half shut and plump bodies comfortably plastered on warm polished rock slabs, venturing out to feed in the bofedales at sunrise and dusk. Highly social, they live in complex colonies, warning one another of danger with high pitched whistles and bouncing from ledge to ledge on short, spring-loaded legs and padded feet with such extraordinary agility they almost appear airborne.

Between deep canyons and lofty lakes, the volcanic Andes of southern Peru and northern Chile offer a treasure-trove of wildlife, demonstrating to perfection the adaptability of all life forms to the elemental qualities of these young mountains. With the ranges running narrow and straight here, there are no hidden forests and secret microclimates. Everything is laid bare in all its splendor, yet in its variety it remains a region that delights and surprises.

bits to fluffy black chicks and pile up the rest to maintain their own private floating islands. Parents take it in turns to guard the family and patrol their patch, scooting at top speed across the surface toward any intruder, feet and wings flailing

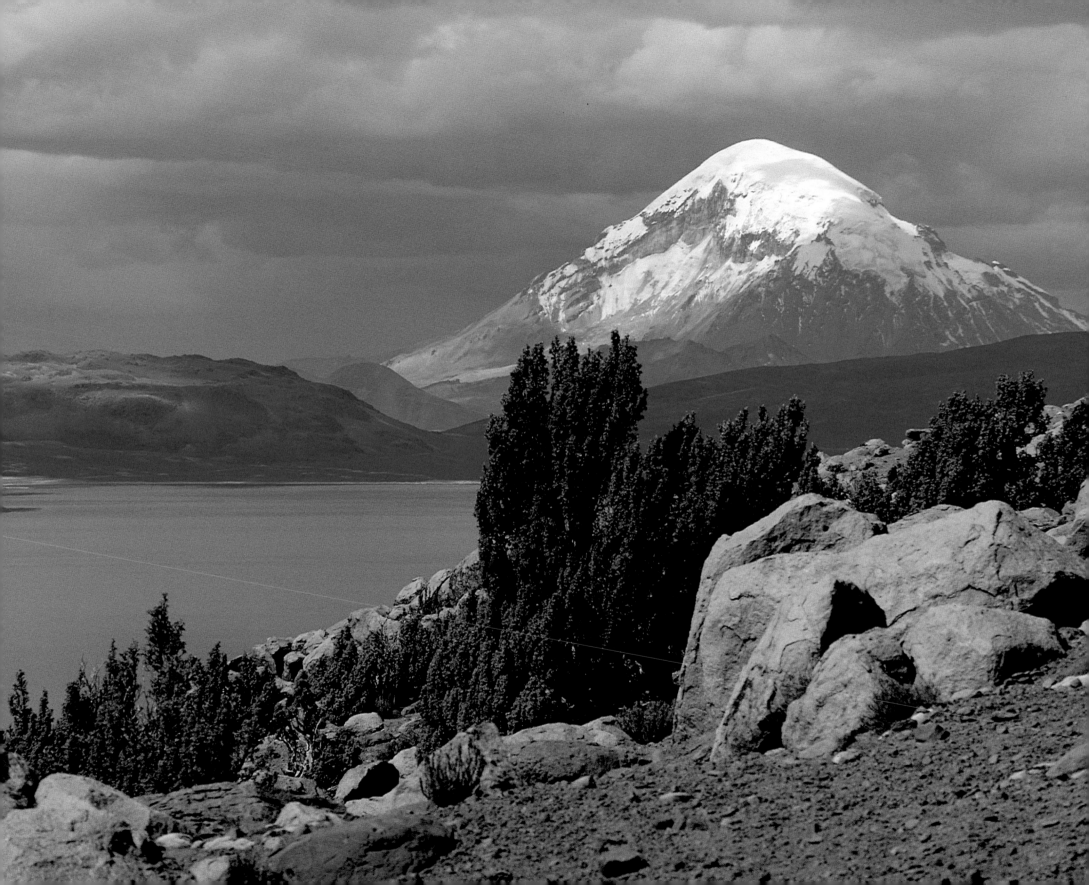

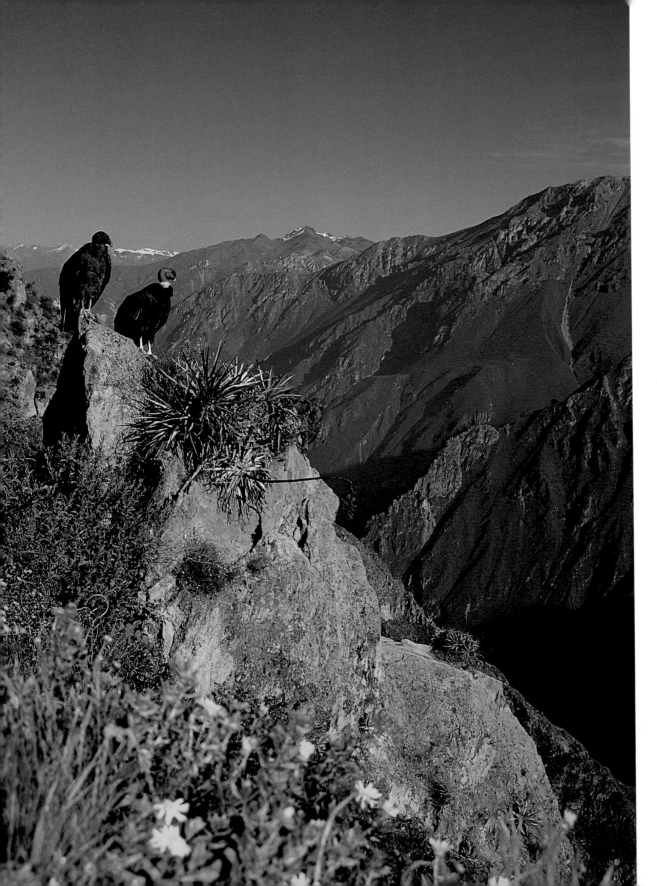

LEFT: *Two Andean condors, an adult male and juvenile female (the darker bird), perch at the edge of the Colca Canyon on a cold morning, waiting for the day to warm up.*

ABOVE: *Ancient columnar volcanic formations and hardy cacti mirror one another along the walls of the Colca Canyon.*

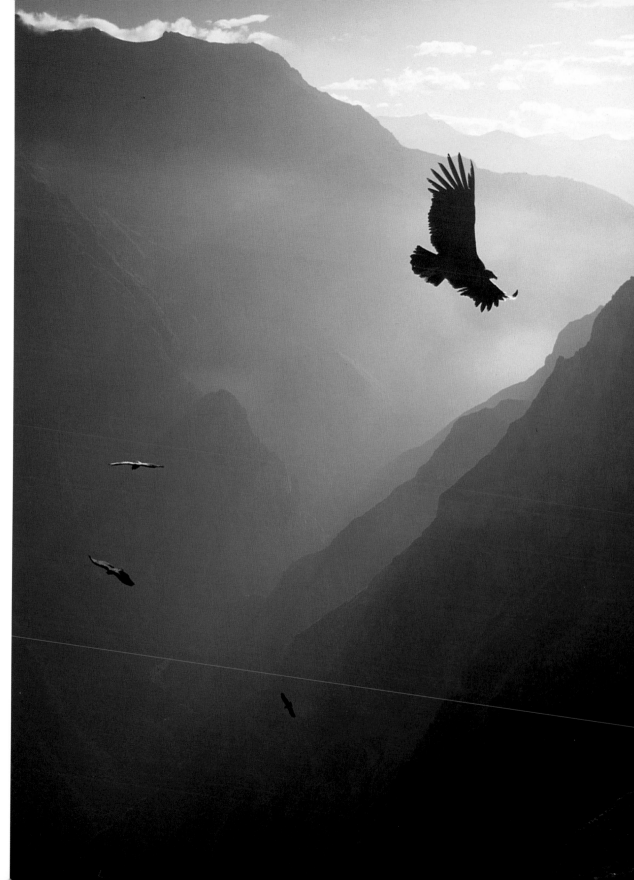

RIGHT: *Several dozen condors circle on warm air rising from the lowland desert. Once they gain enough elevation they disperse in search of food.*

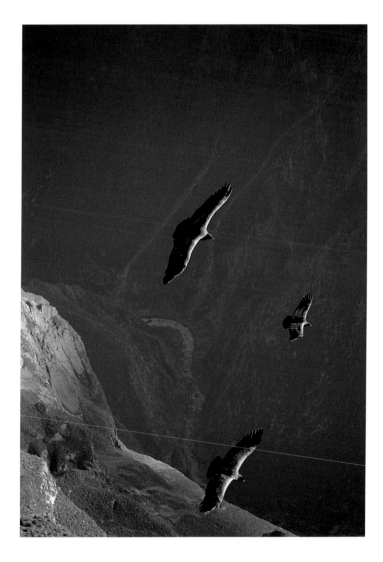

ABOVE: *As the morning sun warms the canyon wall, causing thermal updrafts, condors of all ages (the young brown and the older ones white-marked) rise majestically above the Colca River on 10-foot (3-m) wings.*

 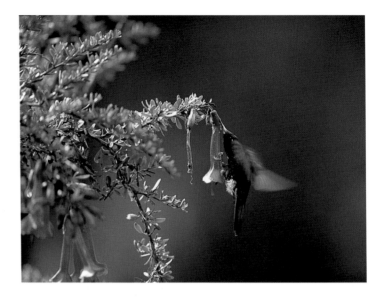

ABOVE AND ABOVE RIGHT: *Hardy bromeliads and climbing nettles are among the many flowers that burst forth along the canyon walls during the brief rains.*

ABOVE: *A discreetly colored hummingbird, the black metaltail, steals nectar by piercing the base of a blossom that is too long for its stubby beak to reach into.*

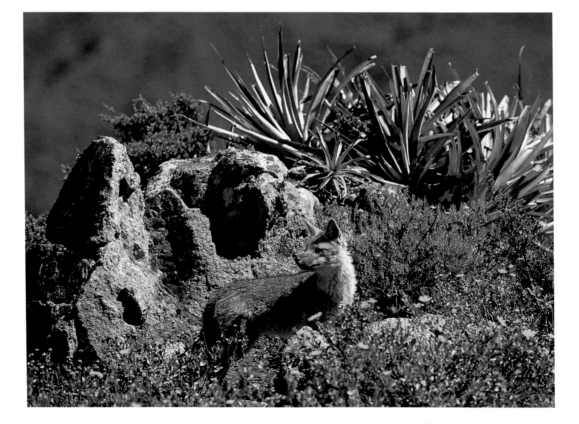

RIGHT: *Relying on its cryptic coloration to disguise it, a secretive culpeo fox emerges from its retreat along the edge of the Colca Canyon to scavenge and hunt for rodents and ground birds.*

FACING PAGE: *The Colca Canyon cuts through the Chila range as it heads toward the desert plains far below and the Pacific coast 280 miles (450 km) to the west. During the short rainy season the canyon walls are bedecked with a flush of plants.*

THE REALM OF THE CONDOR

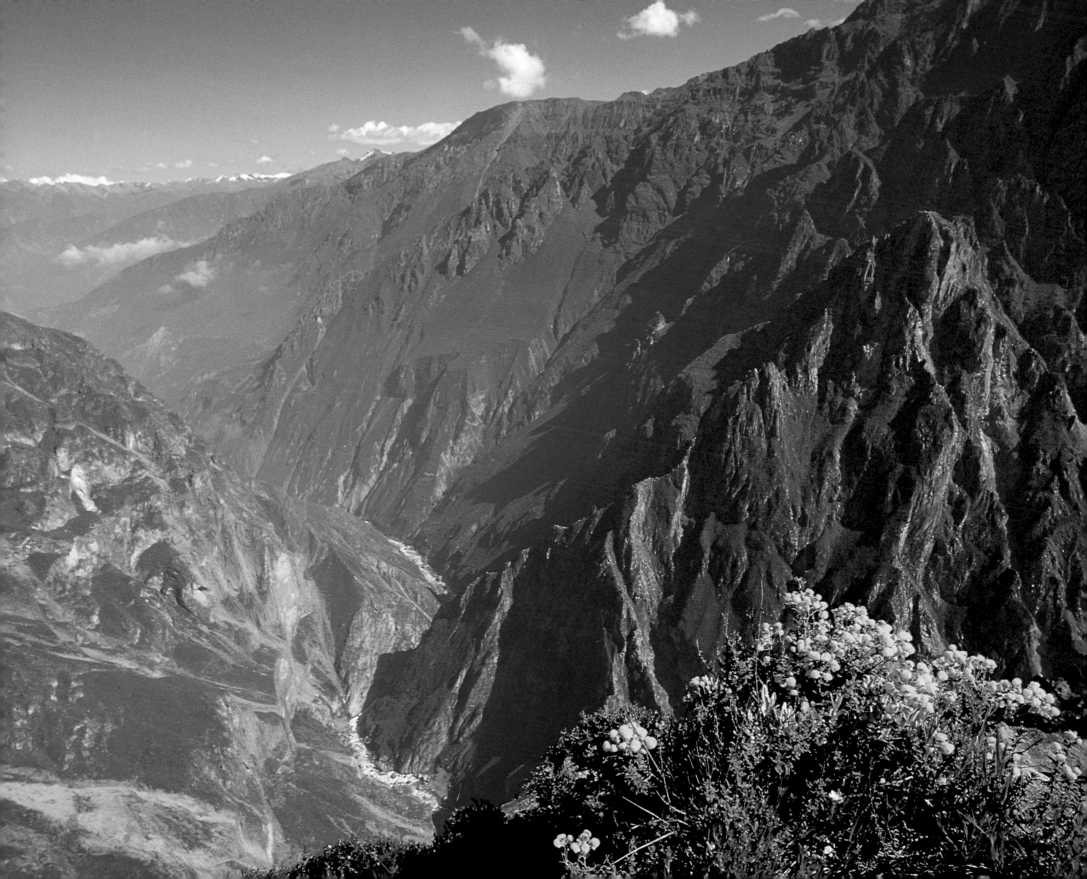

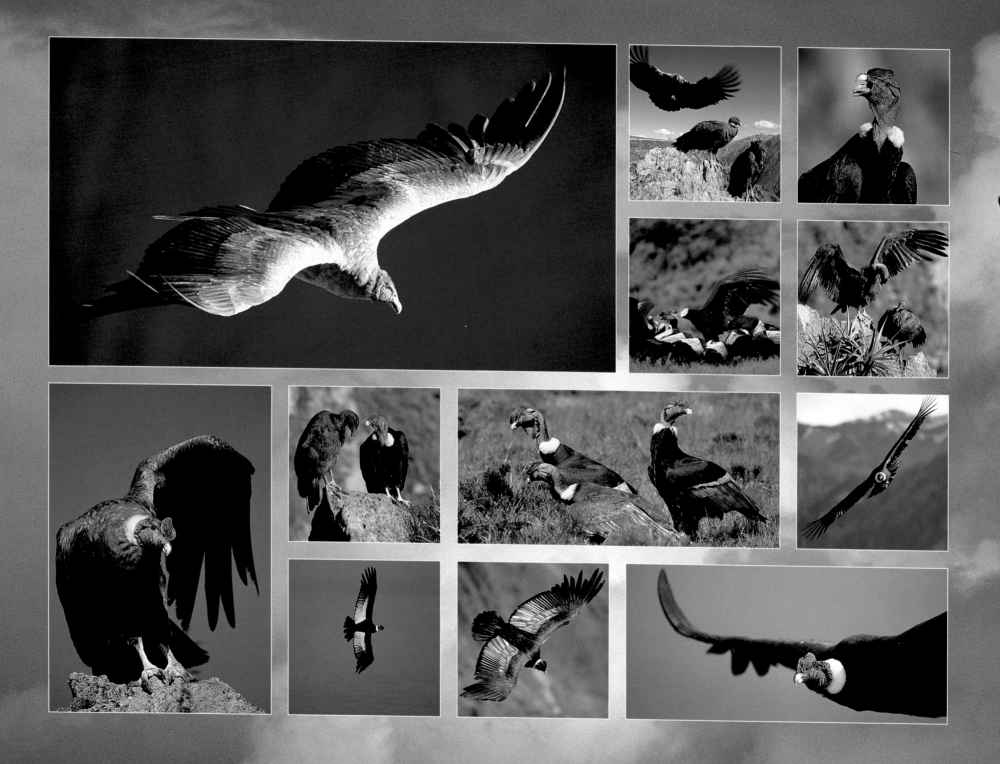

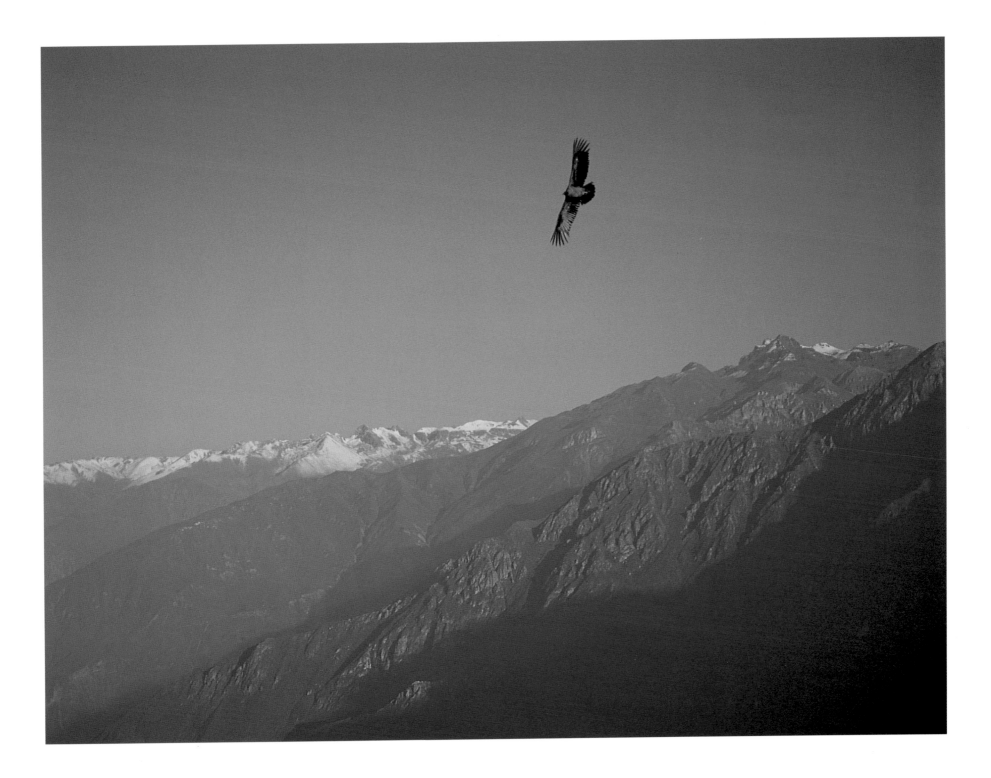

PREVIOUS PAGE, LEFT: *With a wingspan reaching 10½ feet (3.2 m) and a weight of 33 pounds (15 kg), the Andean condor is the largest land bird in the world. This threatened species finds a rare sanctuary in the vertical landscapes of the Colca Canyon of southern Peru, where it uses the powerful thermals to ascend high into the sky and search the countryside for carrion. They nest in inaccessible cliffside caves. Dark juveniles can be seen playing and courting with black-and-white adults, sometimes as many as 50 together in a group. (Top right and bottom left,* MARK JONES)

PREVIOUS PAGE, RIGHT: *Riding the air currents high above the snowy ranges, a young condor must spend years acquiring the wisdom of the older birds before it can become fully independent.*

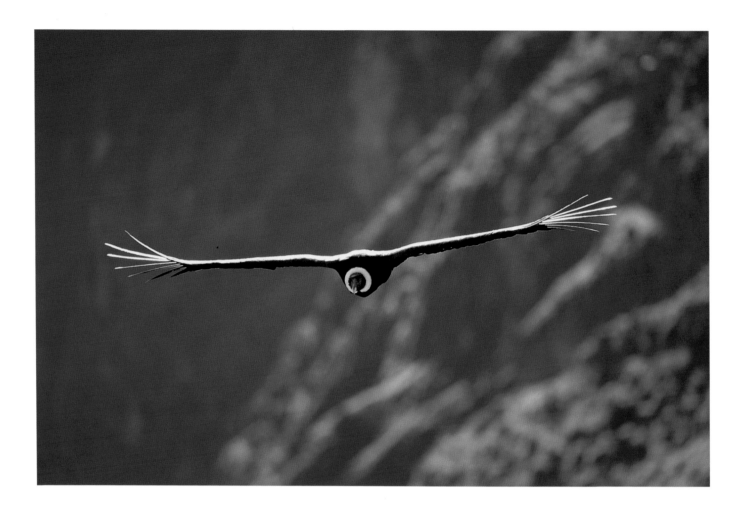

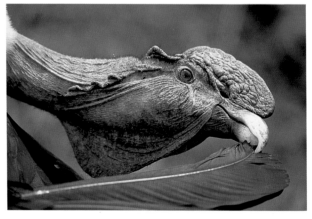

ABOVE: *A female condor soars on rigid wings in the morning sun, its wingtip feathers splayed to prevent stalling as it makes only the slightest adjustments to catch the air currents.*

LEFT: *Possibly 40 years old, this captive male condor at a rescue center exhibits the complex headgear that comes with age. He uses his powerful, cutting beak delicately to preen a tail feather.*

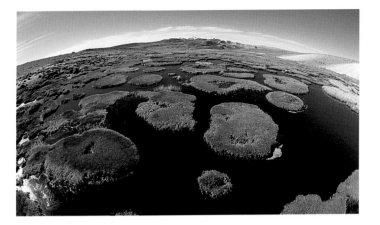

Water percolating from snowy crags re-emerges in frosty wetlands on the 16,000-foot (4880-m) plateau. These are the very first trickles of the streams that grow to feed the mighty Amazon.

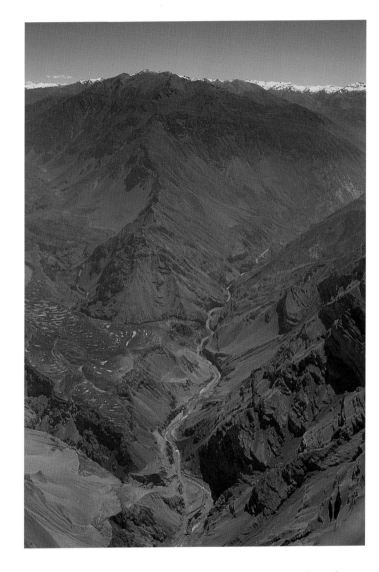

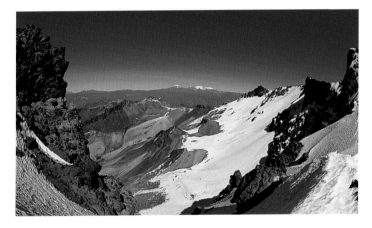

At 18,360 feet (5597 m) El Mismi's snow-spangled, eroded volcanic summit marks the divide between the watersheds of the Amazon and the Pacific slopes. Condors are said to nest on these icy cliffs.

The Colca River emerges from the mountains, carving through geologic layers dating back to before the edge of the continent rose to form the Andes. At left, young lava flows tumble down a side valley.

Frozen snowmelt streams on the slopes of El Mismi thaw slowly in the morning sunshine.

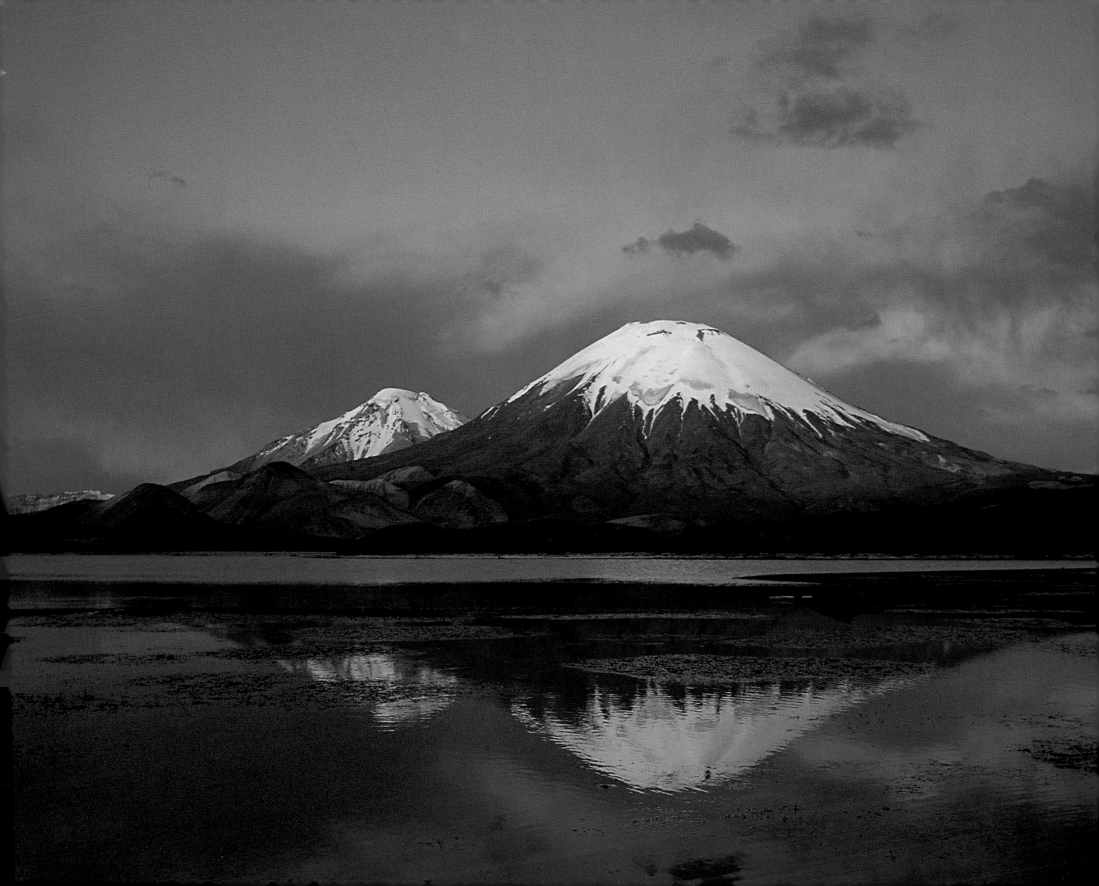

FACING PAGE: *The twin volcanoes of Parinacota and Pomerape have had no known eruptions in modern times, although their young lava flows enclose the bird-rich Cotacotani lagoons.*

Always on the lookout to defend its territory, a heavily built giant coot motors across the calm lake waters, leaving a powerful wake.

Under a windblown sky in Lauca National Park, a family of giant coots tends their floating island nest by continually piling more weeds on top while the lower structures sink.

A flightless giant coot, found only on Andean lakes, strolls along the frozen surface, waiting for the morning thaw to allow it to forage on submerged weeds.

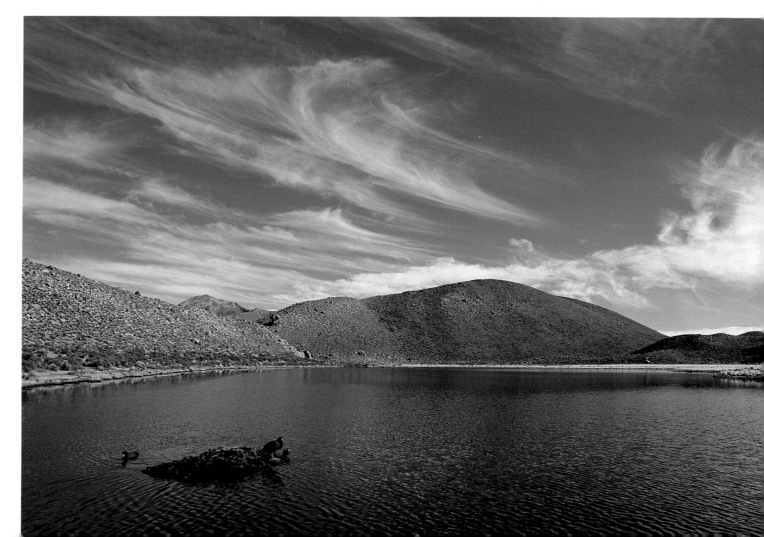

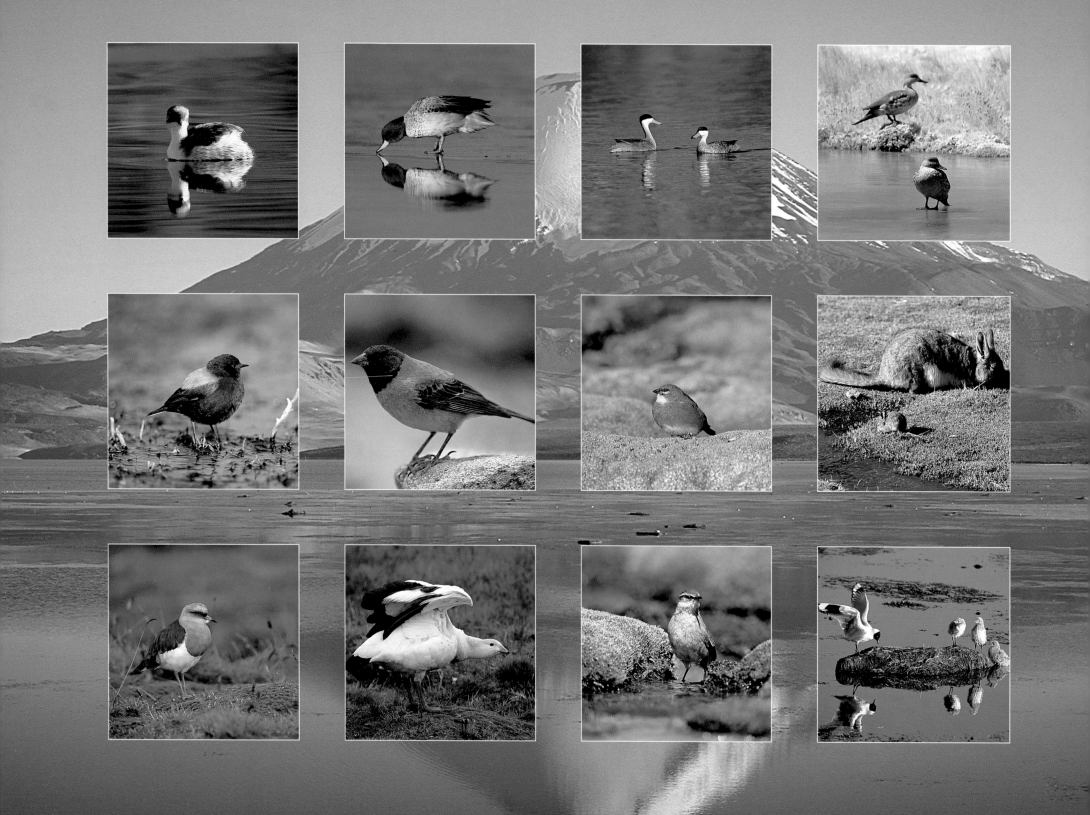

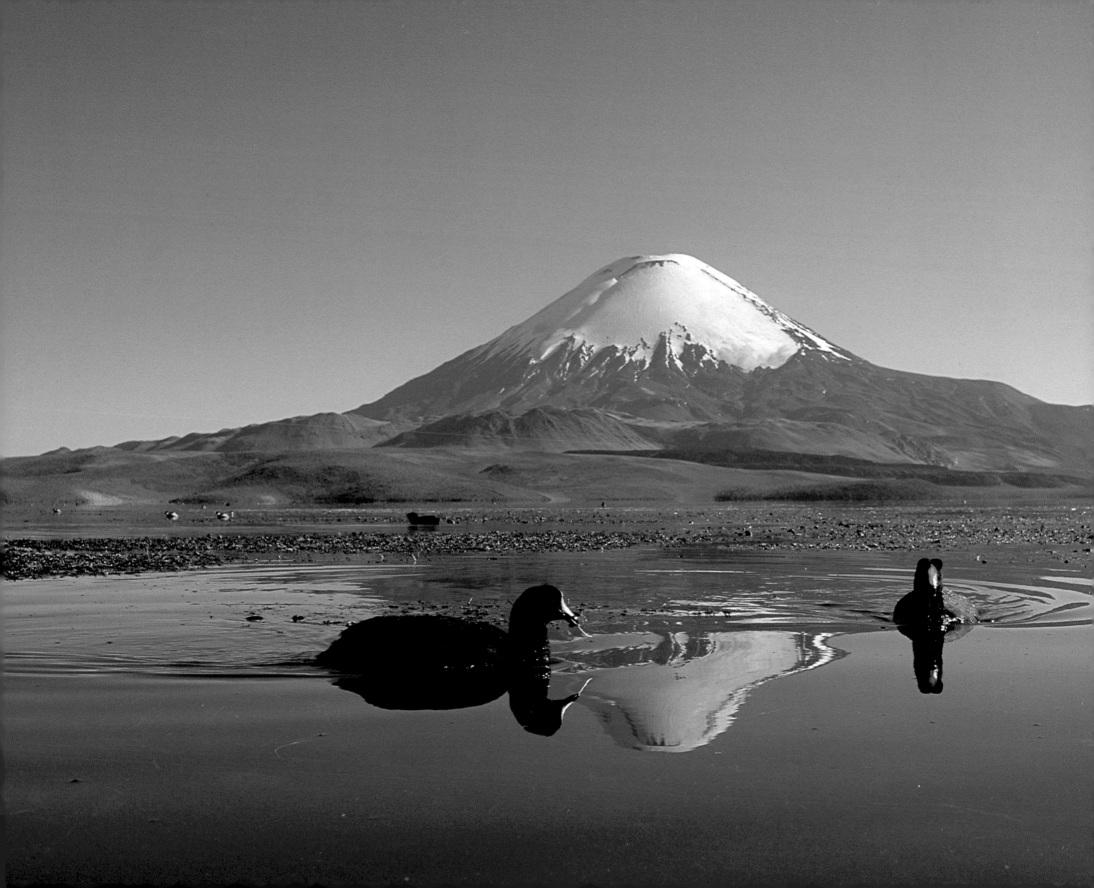

PREVIOUS PAGE, LEFT: *Defying nightly freezing temperatures, wildlife thrives on Lake Chungará and the surrounding bogs and wetlands. Top row, from left: silvery grebe, speckled teal (*MARK JONES*), puna teal, crested duck. Middle row, from left: white-winged negrito, black-hooded sierra-finch, white-winged duica-finch, mountain viscacha with small rodent. Bottom row, from left: Andean lapwing (*MARK JONES*), Andean goose (*MARK JONES*), bar-winged cinclodes (*MARK JONES*), Andean gull.*

PREVIOUS PAGE, RIGHT: *Lake Chungará at the base of 20,827-foot (6348-m) snow-clad Parinacota Volcano holds a sizable population of giant coots. Flightless and fiercely territorial, they do not leave the lake.*

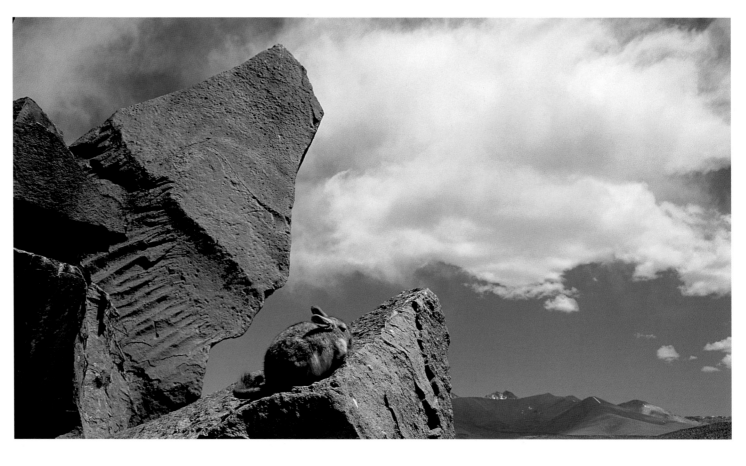

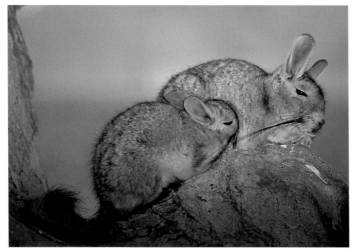

ABOVE: *Mountain viscachas live in sociable colonies in rock cavities, feeding on sparse dry vegetation and spending much time each morning and evening sunning themselves on warm boulders.*

LEFT: *A mountain viscacha mother suckles her young, while soaking up the last of the afternoon sun's warmth before the chill of the night descends on her mountain realm.*

FAR LEFT: *Plump and warmly clad in extremely fine fur, the mountain viscacha, weighing up to 3^{1}/$_{2}$ pounds (1.6 kg), looks like a three-way cross between a rabbit, a squirrel and a marmot.*

RIGHT: *Heat resistant algae, nurtured by the bubbling waters of the El Tatio geyser fields, paint the crystallized sinter formations in many delicate hues.*

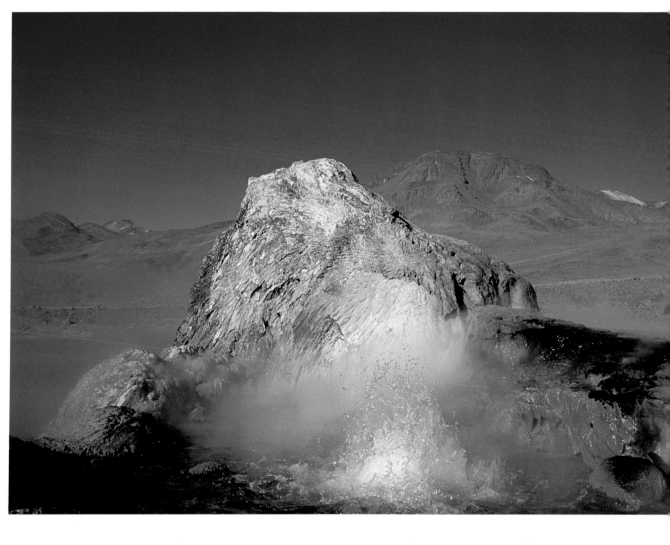

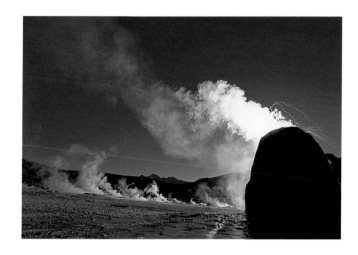

ABOVE: *In an extensive geothermal field the El Tatio geysers steam away in the frigid sunrise at 14,000 feet (4270 m), where boiling water droplets instantly turn into shimmering miniature ice missiles.*

Hardly any plants grow above 16,000 feet (4880 m) in Lauca National Park. At this altitude frost cycles have leached many of the minerals from the volcanic landscape.

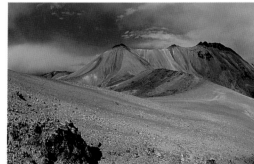

The yareta is a resin-rich cushion plant growing above 15,000 feet (4570 m) elevation, its hard, dense, rounded shapes resisting the biting, desiccating winds. Growing less than one-tenth of an inch (1–2 mm) per year each plant may live for over one thousand years.

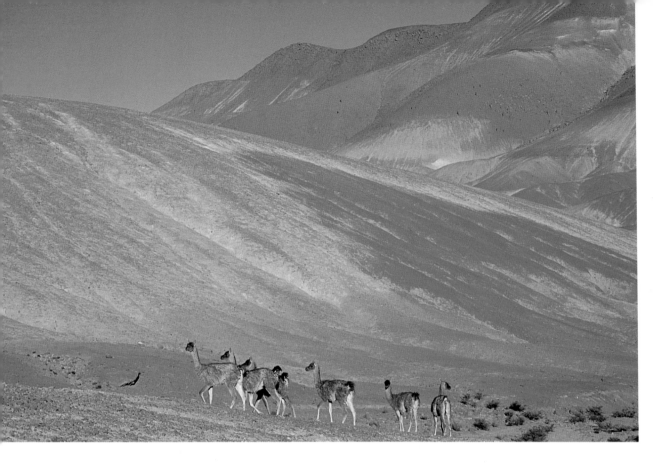

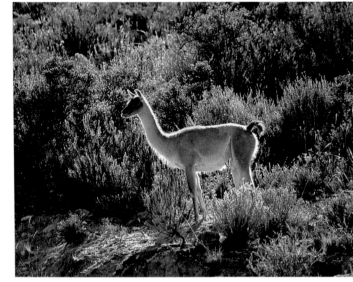

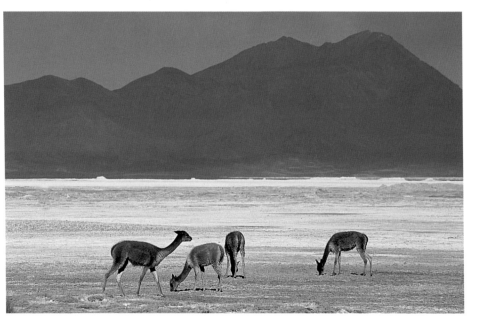

ABOVE: *Guanacos are larger and sturdier than their high altitude cousins, the vicuñas, and live in the sun-baked desert foothills of the Andes, here in northern Chile.*

RIGHT: *A vicuña family crops the tiny grass blades growing along the edge of the huge Salar de Surire salt pans. They can live off the sparsest forage but need daily access to water.*

ABOVE: *A guanaco's long legs and flexible feet allow it to move sure-footedly through rugged scrub country in the western Andean foothills of northern Chile.*

FACING PAGE: *The southern vicuñas that inhabit the volcanic plateaus of northern Chile are recognizable by their pale flanks. Above them sulfur smolders along the dormant summits.*

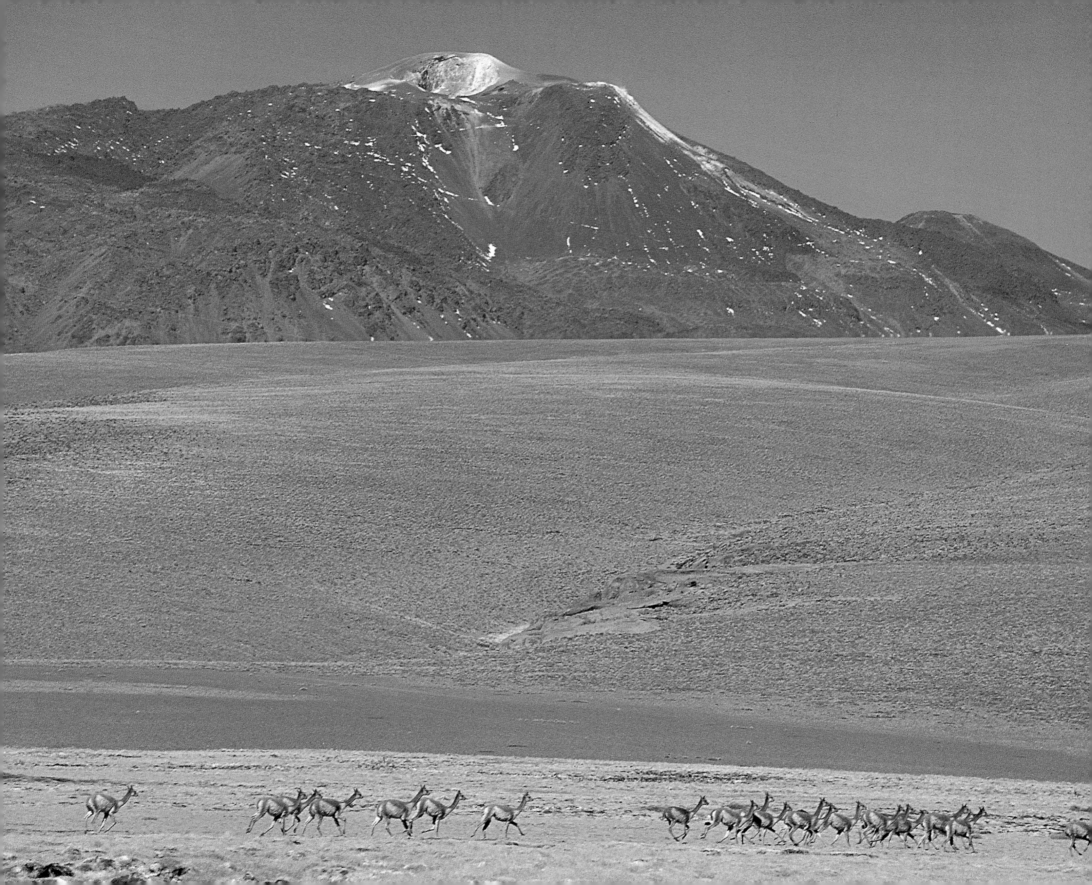

FROM STEAMY JUNGLE TO DESERT COAST

A VISUAL FORAY FROM AMAZON TO PACIFIC

ABOVE: In the half light of the mid-canopy, 100 feet (30 m) above the ground, scarlet macaws visit their favorite trees in search of fruits and nuts.

FACING PAGE: A multi-colored flock of blue-and-yellow macaws and blue-headed and mealy parrots is attracted to the nectar of a flowering Erythrina tree on the bank of the Tambopata River.

Riding on condor wings from Amazon jungle to Pacific coast in a transect across the Peruvian Andes reveals a kaleidoscope of habitat, geography and climate. To the east of the Andes one of the most riotous ecosystems on earth abuts the great cordillera. As air flow moves up from the vast Amazon basin, limitless amounts of moisture rise into the Andean foothills and cascade back down through precipitous gorges and tiered layers of habitat harboring a myriad of species, many of them still to be discovered. This exuberance is halted by the inviolate mountain barrier, where glaciers and a tundra-like environment supersedes Amazonian luxuriance. When the condor flies from its mountainous redoubts to the west instead, as it does each year to scavenge among coastal sea lion colonies, it descends into a totally different world. Only the hardiest cacti follow the course of rare flash floods down rocky canyons, where temperatures may fluctuate by as much as 70°F (40°C) between night and day. In the lee of the mountain chain, wind-blown sand dunes march across pastel-hued lowland plains. Life here hangs by a thread, and years may pass without seeing a single drop of rain. Yet the placid seas lapping the Sechura Desert coast, nurtured by the rich, cool upwelling of the Humboldt Current, are bountiful almost beyond measure. Thick plankton soups fuel a riotous food chain where swarms of anchovies support huge numbers of seabirds, whales and dolphins. Nowhere else on earth is it possible to pass through such radically contrasting biomes over so short a span.

At an elevation of about 1500 feet (460 m), where the Andean foothills begin to give way to the rainforest flatlands, the Tambopata River takes a meandering course, while macaws and myriads of tropical birds commute to their morning feeding grounds.

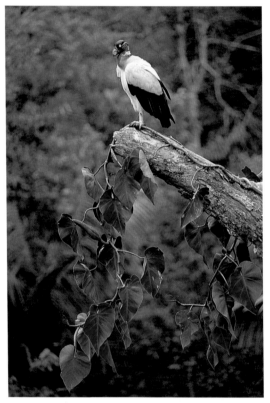

A king vulture, the jungle cousin of the condor, rests on a vine-covered snag near its nest inside a hollow tree in the rainforest canopy.

Secretive and rarely seen, the jaguar represents the apex of the complex food web that binds together all the creatures of the Amazon jungle. This one is swimming across the Manu River in Peru.

A leaf from a fast-growing Cecropia *tree, which specializes in colonizing unstable riverbanks, floats down the clear Pescado River. This river, in Yanachaga-Chemellin National Park fertilizes the vast Amazon basin.*

ABOVE: *Rainbow-colored arrays of butterflies alight to seek the salts that are concentrating on the banks of a small Amazon tributary, in an area where leaching rains make such minerals hard to come by.*

RIGHT: *The last of several parallel ranges, the Oriental Cordillera drops abruptly toward the Amazon basin. Numerous fast flowing, fish-rich rivers rush off the lush escarpments through deep valleys and gorges filled with cataracts.*

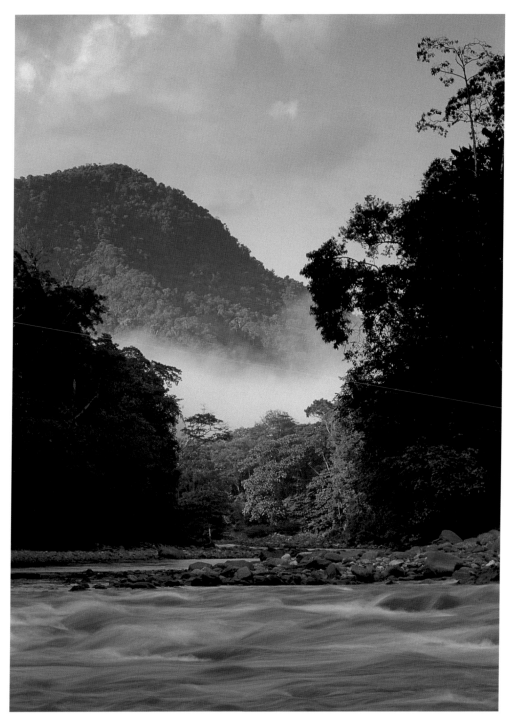

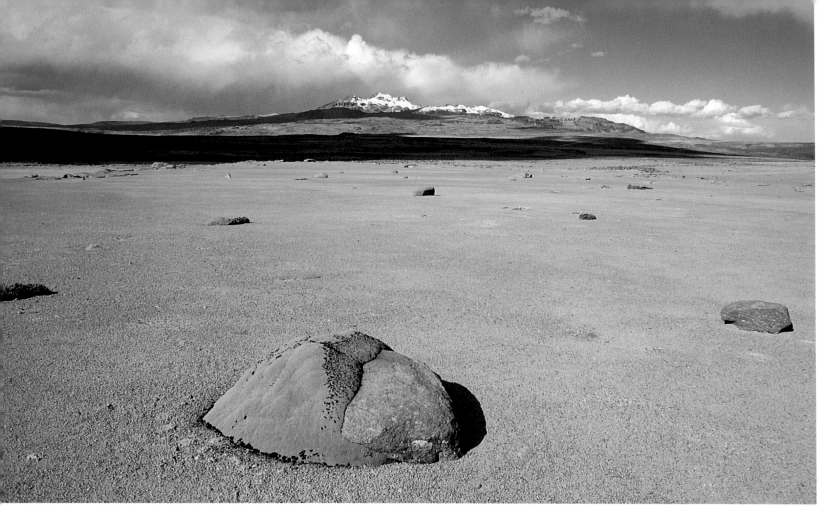

LEFT: *Like hard vegetable boulders, yareta plants dot the desert sands of the high puna near the dry western edge of the Andean plateau of Patapampa at 15,000 feet (4575 m).*

ABOVE: *In Peru's central puna on Pampa Galeras the brief rainy season can be generous enough to create afternoon clouds that build into daily thunderstorms, nurturing delicate flowers, even on high rocky ridges.*

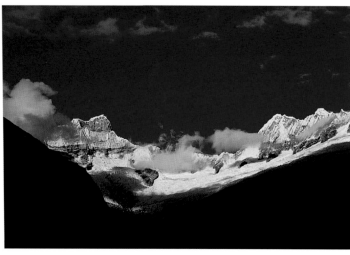

At just over 20,000 feet (6100 m), Chacraraju is one of more than two dozen peaks that rise over 19,000 feet (5800 m) in the Cordillera Blanca of northern Peru, all of them knife edges thrusting almost vertically into the tropical skies.

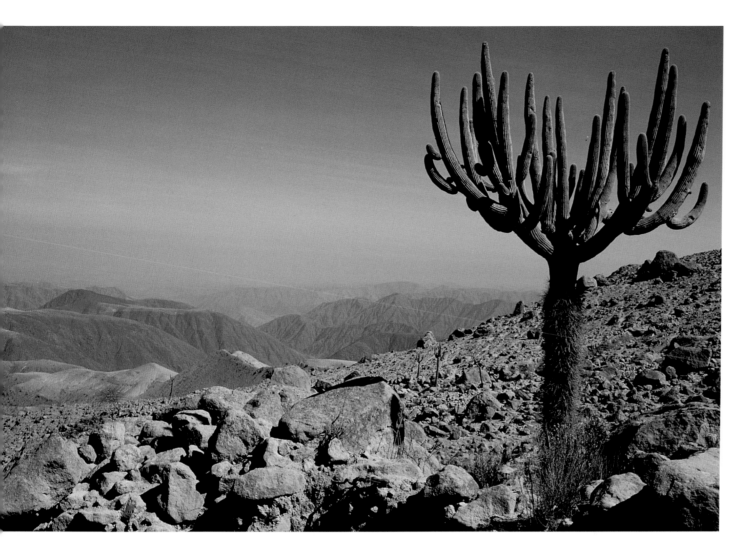

Where the desert plains give way to the foothills, flash floods occasionally bring water from the highlands into deep canyons, where cacti and scrub grow and opportunistic desert foxes glean a living from seed pods, insects and small animals.

Overlooking the hazy desert plain, this candelabra cactus grows only in a narrow altitudinal belt between about 8200 and 9200 feet (2500 and 2800 m) where temperatures between day and night may fluctuate by more than 70°F (40°C).

Sea mists flood deep into valleys and canyons carved through the coastal Andean foothills, creating small microclimates but leaving the ridges above completely devoid of life.

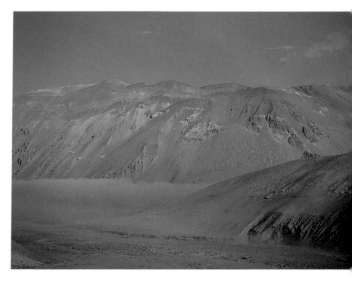

Along miles of windblown dunes, flocks of gray gulls run up and down the beach between waves to gorge on sand crabs, which they carry back to their nests far inland on the scorching desert plains.

Steady offshore breezes and cool currents flowing up the South American coast from Antarctica drive powerful upwellings that surge to the surface from deep in the abyssal Peru-Chile Trench and bathe the coastline in rich nutrients. As a result, the cool Humboldt Current produces a thick plankton soup that forms the basis of a vibrant marine food chain bordering the nearly lifeless shores of the Sechura and Atacama Deserts.

LEFT: On the high coastal dunes of the Sechura Desert, fields of tiny bromeliads grow where rain may not fall for decades, drawing moisture solely from the sea fog that condenses on their spiky leaves.

FACING PAGE: The guano islands off the Peru coast seethe with vast seabird colonies, including the Peruvian pelicans, which are a larger and more colorful version of the brown pelican. In recent decades seabird numbers have crashed due to over-fishing and the effects of El Niño, but nesting colonies remain impressive nonetheless.

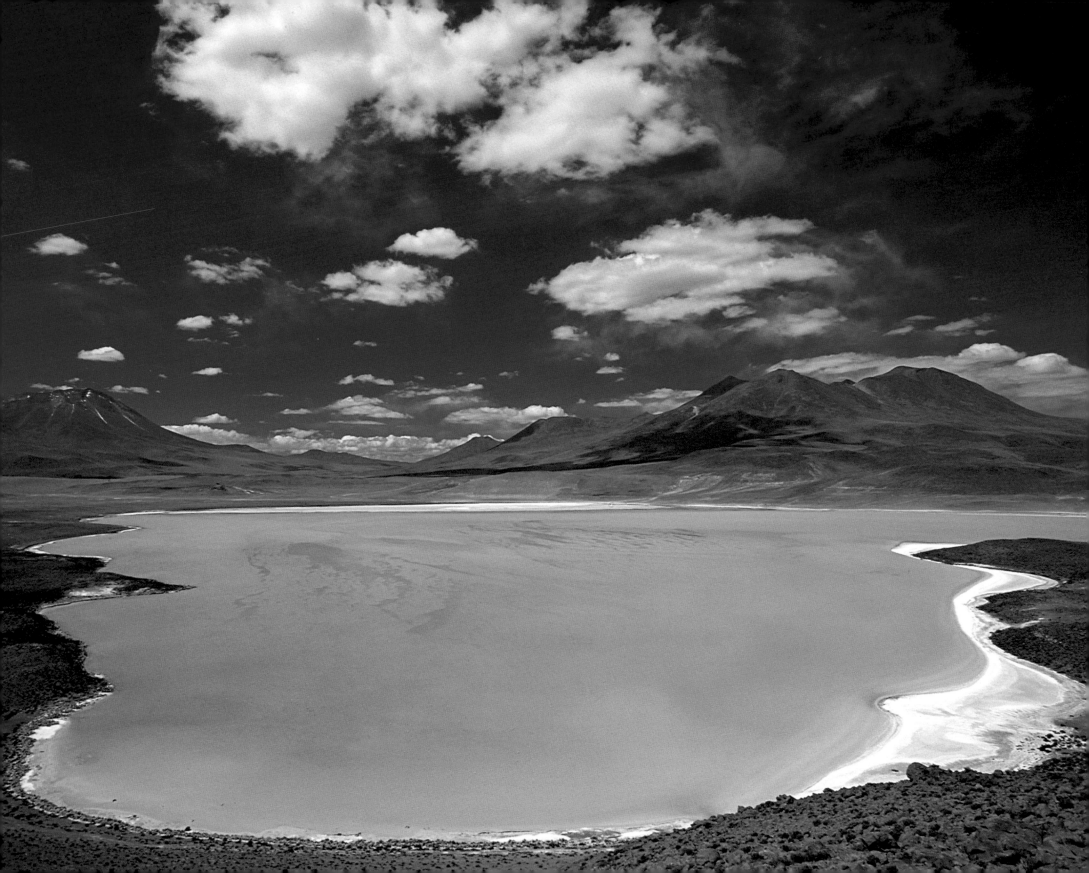

SALT, SAND AND SKY

THE ALTIPLANO OF BOLIVIA

Extinct volcanoes and mineral-rich lagoons, such as Laguna Hedionda, dot the Altiplano of southern Bolivia's Eduardo Avaroa Reserve, where little rain falls from a rarefied atmosphere.

Sunset on Bolivia's Salar de Uyuni is as close to walking on the moon as I will ever come. The view is so pure, the sky so vast, the air so still, distances so infinite and the silence so intense that no matter where I turn there is nothing familiar in which to ground my senses. In every direction stretches an immaculate white, crystalline expanse of pure salt as far as I can cast my gaze. Its surface is so perfectly level the shadow from my tripod reaches all the way to the far horizon in the faint glow of the departing sun. The only relief is a mesmerizing pattern of crystallized polygons whose raised edges catch the shearing rays, repeating themselves at infinitum. Compulsively, I begin to walk toward the tiny moon suspended in the rosy haze of a thin atmosphere. The crunching sound under my boots brings a vague sense of reality, as does the blue shadow of the earth creeping upward into the pink sky as the sun vanishes beyond a thin line of mountains to the west. I retreat to our small tent as the temperature plummets below freezing. There is no humidity in the air to retain the day's warmth, and life is nowhere to be seen.

THE ALTIPLANO BASIN

Traveling from north to south down the backbone of the South American continent, by the time one reaches southern Peru the Andes do a strange thing. Elsewhere their various incarnations tend to run parallel to one another – the twin cordilleras of Ecuador, the triplets of Colombia or the four chains of northern Peru (the Eastern, Central, Blanca and Negra) – but here the Andes part company into two quite divergent sets of mountains. Whereas the volcano-studded Western Cordillera, youthful and active, marches on down from the Colca Canyon region across the Peru-Chile border to make a narrow beeline almost due south, the ranges far to the east begin to split, contort and evolve. Flanking the Amazon basin, they rise briefly as the proud Cordillera Vilcanota near the fabled Inca city of Cusco and the Carabaya farther east, and become somewhat confused while crossing the Bolivian border as the Apolobamba mountains. Soon they are born again as Bolivia's magnificent Cordillera Real, part of a gigantic crustal fold which

embrace: the Altiplano. About 600 miles (960 km) long and 120 miles (190 km) across at its widest point, this enormous land-locked basin, its drainage blocked when the Andes rose all around it, has in past epochs contained vast inland seas. During the last Ice Age, between 10,000 and 15,000 years ago, extensive glaciers and snowfields capped its girdle of mountains. Copious runoff in the Pleistocene summers fed two gigantic lakes to a level 200–300 feet (60–90 m) higher than the present floor of the basin – Lake Ballivian in the north and Lake Michin in the south.

Today, only Lake Titicaca remains at the Altiplano's northern extremity. Although a mere shadow of its former self, at 110 by 35 miles (176 by 56 km) in area and 1200 feet (370 m) deep Titicaca remains the highest navigable lake in the world, perched 12,500 feet (3812 m) above sea level.

In the current climate, those very mountains that once nurtured the lake with glacial runoff now cut off virtually all influx of moisture-laden air from lower elevations, resulting in meager seasonal rains and snowmelt barely making up for evaporation. Yet its vast reed beds still offer a rich habitat to numerous water birds, both residents and migrants. It even harbors its own endemic species of flightless grebe as well as the largest frog in the world, a boogy-eyed, fish-eating, foot-long aquatic monster, known as the Lake Titicaca giant frog, which spends its entire life submerged in the 50–60°F (10–15°C) waters, venturing down to a depth of 100 feet (30 m) or more. From its body hang strange baggy folds of skin that enable it to absorb oxygen without surfacing to breathe. But Titicaca has been a magnet for people since pre-Inca times and its wildlife today is losing ground at an accelerating pace, placing the survival of both these unique creatures increasingly in jeopardy through direct exploitation, pollution and habitat loss.

The Altiplano basin, averaging around 12,000–13,000 feet (3600–4000 m) above sea level, deepens and broadens as one travels southward. A moderate amount of water still overflows from Titicaca and wends its way some 200 miles (320 km) to Lake Poopó, which is about 300 feet (90 m) lower in elevation. But in actual fact much of Lake Poopó is now a solidified expanse of salt, with only a remnant section at its northern extremity – Lake Uro Uro – still holding

Curved by the effect of a fisheye lens, the salt-patterned Salar de Uyuni appears to envelop the earth, a very real feeling when walking across its vast crystal surface.

proceeds by drawing a long, slow curve throughout the length of the country, first veering southeast, then southward again, and eventually morphing into the Lipez Cordillera at the south end of the country. One hundred miles (160 km) separate the great 22,579-foot (6887-m) Mount Illimani in the Cordillera Real from 21,390-foot (6524-m) Sajama Volcano, in turn part of the formidable western rampart overlooking the bleak sands of the Atacama Desert and the nearby coastal apron.

Not until the Bolivia-Argentina-Chile border juncture do the two sets of mountains converge and rejoin at last, cradling a huge high-altitude desert plain within their

increasingly saline waters. This is a dead end, with no water flowing further to the south, leaving instead a collection of glaring white salt pans reflecting the sun's heat directly back into the sky.

SALT PANS AND FLAMINGO LAGOONS

The largest of these is the Salar de Uyuni, a hard sea of salt some 85 by 100 miles (130 by 160 km) in size and possibly as much as 1600 feet (500 m) deep, with alternating layers of salt, brine and clay that represent previous climate-induced flood cycles. Numerous islands emerge from this static "sea," with concentric rings of salt "lapping" their silent shores. They are studded with giant cacti where equally giant hummingbirds seek nectar and sierra-finches nibble dry grass seeds. Mountain viscachas, those incongruous high desert rodents resembling a cross between a squirrel, a rabbit and a marmot, lead waterless lives here bounding from boulder to boulder. Great watermarks of fossilized algae and encrusting minerals trace the level to which the departed lake once stood, some 230 feet (70 m) above the existing salt surface. During the three southern summer months (January to March) a few scant rains fall, but enough to cover the salt pans with about 4–8 inches (10–20 cm) of standing water for a few short weeks. When the rains end, sublimation into the rarefied atmosphere whisks away the water at a rate of a quarter inch (6 mm) per day, and quickly rebuilds the polygonal drying patterns riddling the crystal surface.

South of Uyuni, the Altiplano, at its southern extent, rises once more, where it is sometimes referred to as the Puna de Atacama. In Bolivia's southern corner is the Eduardo Avaroa Reserve, where the plains are studded with dozens of multi-hued, mostly dormant volcanoes interspersed with small lakes and lagoons. Trapped between cones and ridges, lava flows, ash fields and valleys at elevations varying between 13,500 and 14,500 feet (4100 and 4420 m), each one lake holds its own unique brew of concentrated salts and other dissolved minerals leached from eroding hills by meager summer rains and dustings of

Dozens of volcanoes, many long dormant and crowned with sulfur deposits, roll away to the horizon at the border between southern Bolivia and Chile.

winter snows. Some pools are laced with arsenic, iron or sulfur, others with gypsum, borax, lithium and many other trace elements. Where concentrations are just right these noxious blends act as fertilizers, nurturing rich algal soups that in turn support entire microcosms of life in the desert.

In the west, Laguna Hedionda is an opaque milky blue, seething with bird-life from Andean gulls to migrant phalaropes and plovers, plus three species of flamingos: Andean, Chilean and James'. Far to the east, where rainfall is slightly higher, Laguna Celeste is crystal clear as it reflects the aquamarine sky, supporting great flocks of ducks and giant flightless coots feeding on its rich aquatic plant beds. Wedged in the southern corner, Laguna Blanca glares deathly pale and silent, with barely a few sandpipers picking at crusty shorelines, its toxic waters spilling over onto spectacular Laguna Verde, tainted a venomous emerald green by natural but lethal concentrations of arsenic.

None of these could provide a more dramatic contrast than Laguna Colorada nestled amidst a knot of time-burnished volcanic cones. Its mineral-laden waters swarm in thick concentrations of red diatoms, giving the entire lake a tomato juice tint, especially when the fierce afternoon winds churn and oxygenate its surface. Upon this prolific algae bloom feast the world's largest population of rare James', or puna, flamingos.

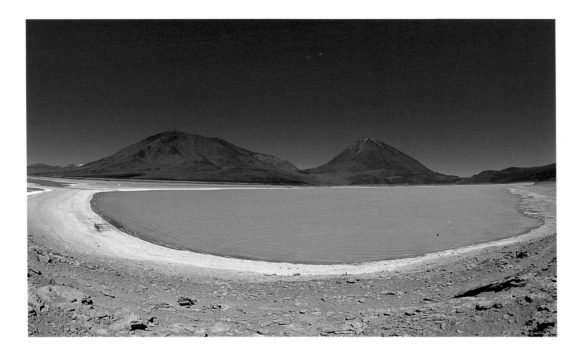

Andean flamingos taking the largest diatoms and Chilean flamingos feeding slightly higher up the food chain on larger aquatic invertebrates.

Sunrise over Laguna Colorada remains one of the most beautiful sights I have ever experienced. Not a wisp of wind ruffles the silky smooth pink waters as the first sunrays flood through the clear frozen air, igniting the plumage of tens of thousands of blazing flamingos strewn across its entire surface as far as the eye can reach. With first light they begin to stir, their squeaking calls mingling into waves of a high-pitched, almost musical babble, striding purposefully on blood-red legs toward freshwater seeps oozing from the shoreline. As they drink their neck feathers become beaded with ice crystals that form instantly in the subzero temperatures at this time of day, which reach –4°F (–20°C) and below. Others are still resting, their necks twined snugly into their vivid scapular feathers for warmth, while many more wing their way in low over the mirrored waters toward the springs, their graceful reflections mingling with the pastel shades of the volcanic slopes all around.

While the lake is a hubbub of life, the surrounding land seems silent and peaceful. Vast vistas of beige, ocher, gray and mauve washes with barely a stubble of golden grasses are home to hardy little foxes and secretive tinamous, high-stepping rheas and disperse herds of unusually pale-wooled vicuñas. In the sunny canyons the extremely rare Andean mountain cat has been spotted stalking viscachas, and on a frigid hilltop the highest geyser field in the world gurgles and splutters in pastel shaded mud cauldrons at 16,400 feet (5000 m). This is a fairytale land of color, space and sheer wonder; a wild land of raw, frigid winds and smooth, sun-warmed stones, of few people and teeming wildlife, of tender, hidden mountain bogs and hissing, steaming fumaroles. With equal ease, one can revel under the cobalt sky soaking blissfully in a thermal pool and minutes later freeze in the desiccating icy wind. In this land it is possible to lose oneself willingly by following the sun across desert sands and over wind-polished volcanic passes where boulder-like yareta plants confuse the visual boundaries between mineral and vegetal matter. It is a land where walking on the moon does seem like a real possibility.

Each small lake and lagoon in southern Bolivia's Altiplano carries a unique mineral concoction leached from surrounding volcanoes. Laguna Verde (above) is laced with deadly concentrations of arsenic, while Laguna Colorada (right) nurtures a rich algal soup the color of tomato paste, which feeds three species of South American flamingo – James', Andean and, more rarely, Chilean.

FACING PAGE: *Once considered so rare that the survival of the species was in doubt, James' flamingos thrive in the cold, rich waters of Laguna Colorada.*

Fine strainers in their beaks filter out the minute organisms whose red pigment reappears in the birds' crimson plumage. Over 40,000 at last count, they outnumber the larger Chilean and Andean flamingos whose paler shades also derive their colors from these primary producers. However, they share the resources according to their individual filtering abilities, with

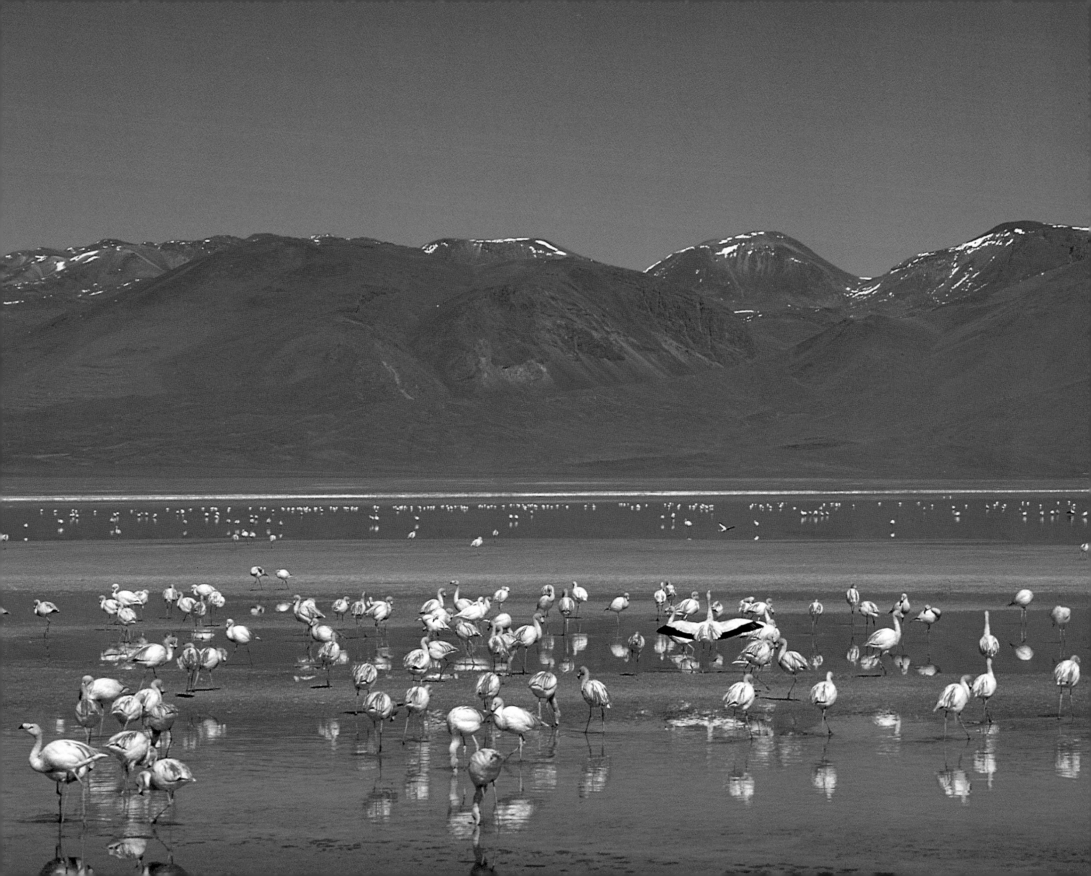

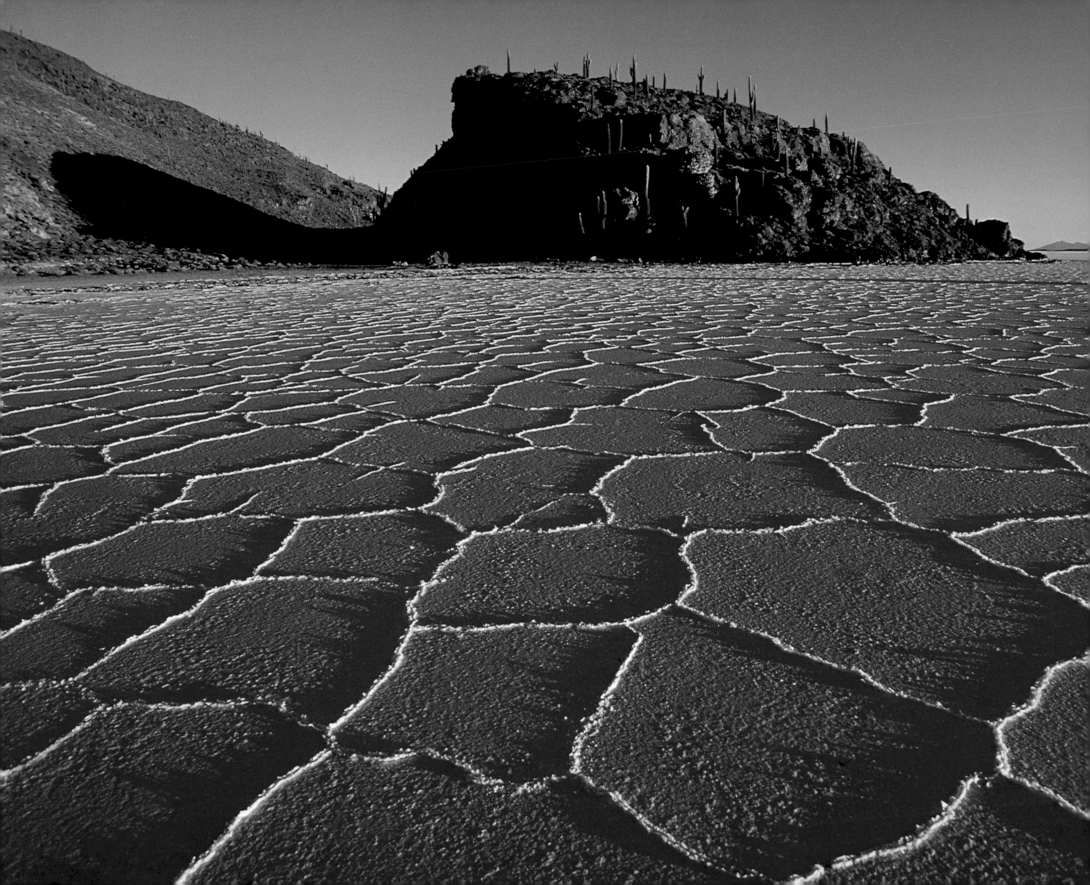

FACING PAGE: Pescado Island stands in a frozen sea of salt riddled by a mesmerizing pattern of crystal polygons. These re-form each year when the thin layer of water evaporates after the rainy season.

BELOW: Vicuñas travel through the landscape unperturbed by their harsh environment. Mirages, such as the one in this photograph, are frequent where warm winds, heated by the intense sun and dark volcanic sands, pass over cold, white salt pans.

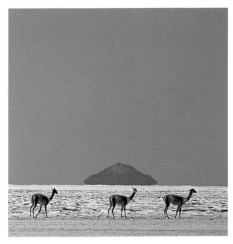

ABOVE: One hundred miles (160 km) of salt polygons stretch to the horizon under the desiccating glare of the sun. Some 12,000 years ago a huge inland sea, fed by a more humid climate, filled this landlocked Altiplano basin.

RIGHT: Magnificent giant cacti stand tall on Incahuasi Island near the center of the Salar de Uyuni, supporting their own little community of birds, insects and lizards.

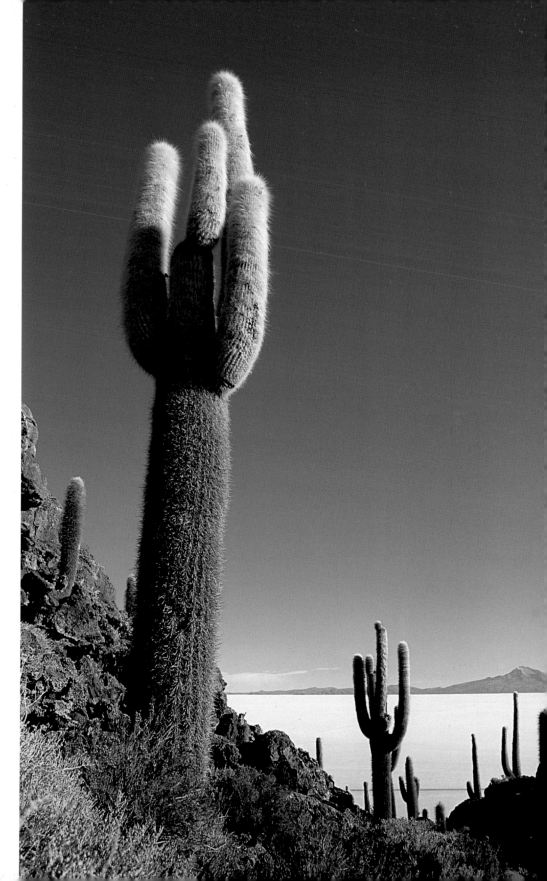

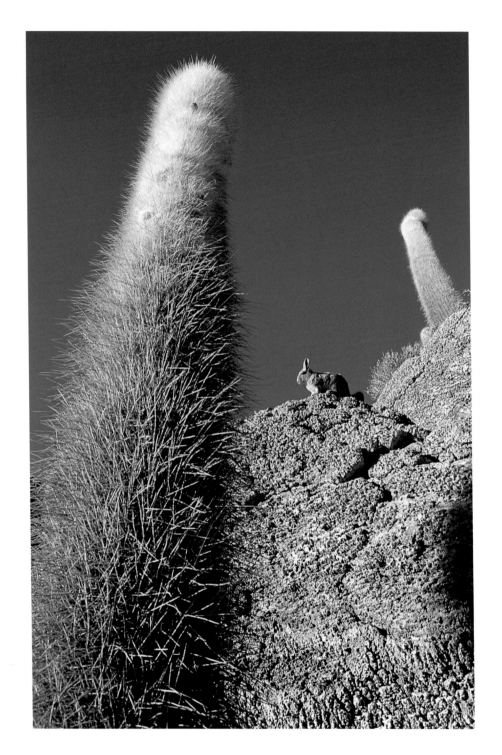

Volcanic tuffstone, perhaps hardened by past geothermal activity, is sculpted into extraordinary shapes by wind and weather.

Rare and scanty rains are no deterrent to these viscachas living on a cactus-studded island in the middle of the Uyuni salt pan. Fossil algae coat the rocks once submerged beneath ancient lake levels.

Vicuñas blend into the subtle tones of the high desert as they head to high ground to spend the night.

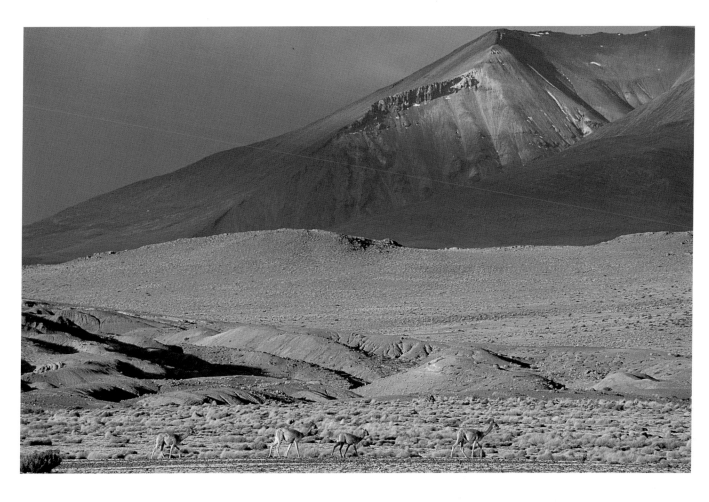

RIGHT: *Mineral-rich volcanic layers, laid bare by frost, snowmelt and wind erosion, paint multi-colored patterns across the high desert of the Altiplano.*

FAR RIGHT *In the early afternoon family herds of vicuñas nibble tiny plants as they make their way slowly across sandy flats toward spring-fed lagoons for their daily drink.*

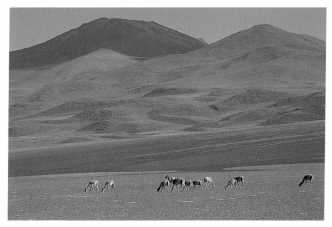

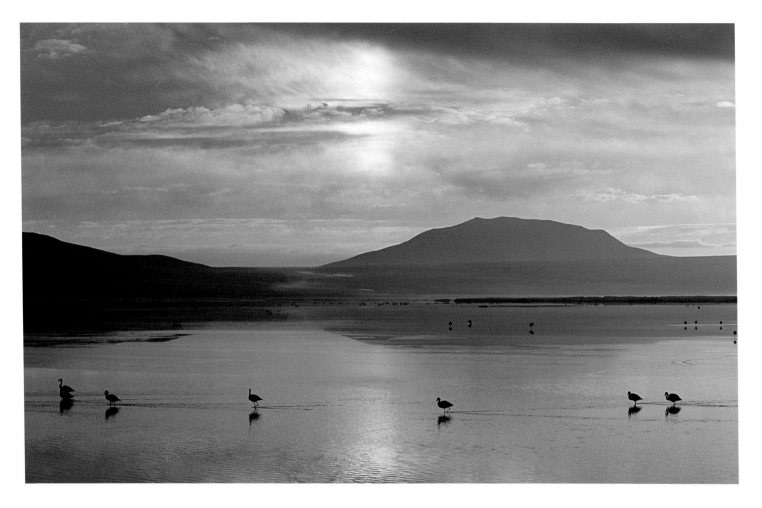

FACING PAGE: *Arsenic laces the poisonous waters of sterile Laguna Verde, whipped to froth by daily winds sweeping across the frigid plateau at 14,000 feet (4270 m).*

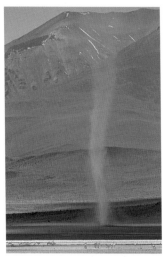

ABOVE: *A frostbow in the high stratus clouds is reflected on the tranquil waters of Laguna Colorada at sunrise.*

RIGHT: *One of the highest geothermal fields in the world at 15,750 feet (4800 m), Sol de Mañana consists of dozens of boiling volcanic mud-pots of many different color tones.*

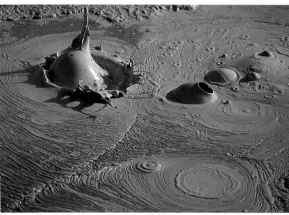

ABOVE RIGHT: *The perfect funnel of a sudden dust devil scurries across the plains as the day's winds pick up along the sun-warmed shores of Laguna Hedionda.*

RIGHT: *Wind-carved natural statues stand precariously on the wide open desert plains of southern Bolivia.*

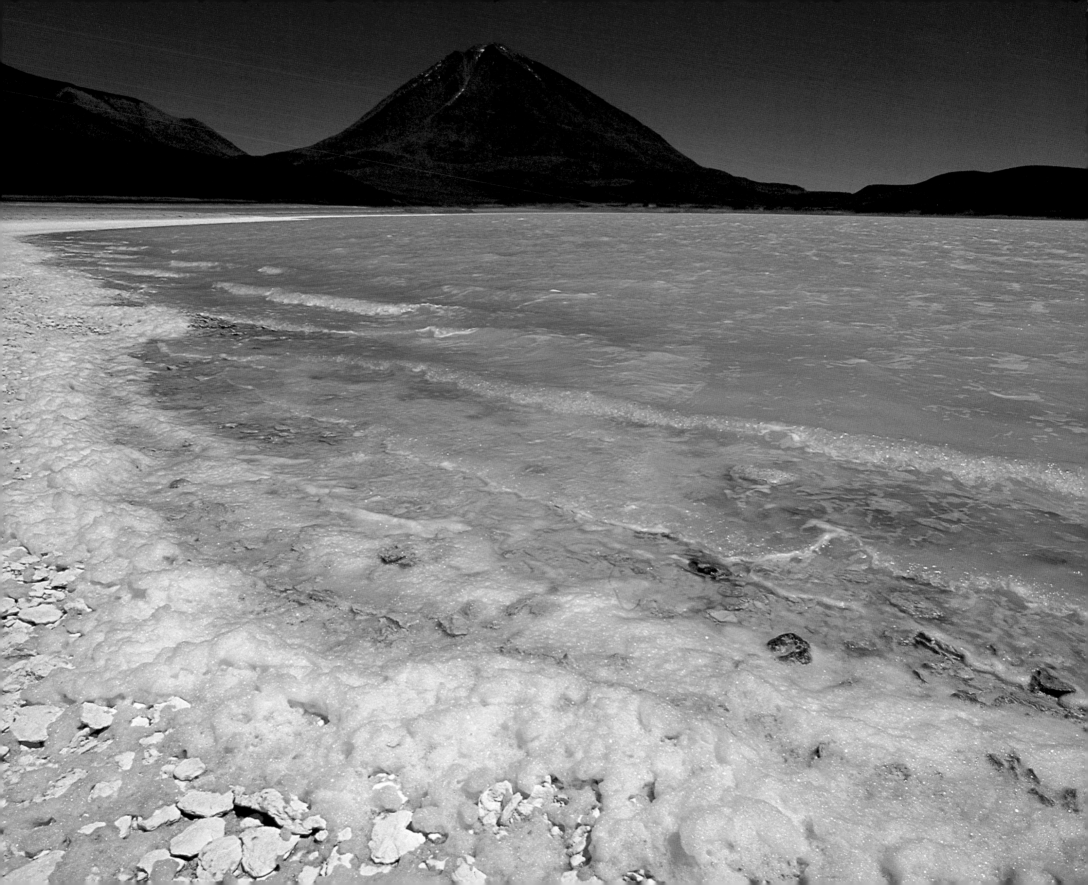

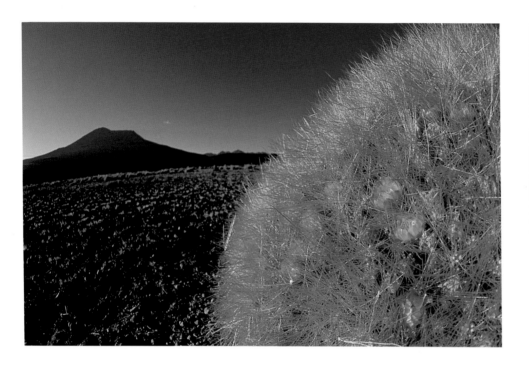

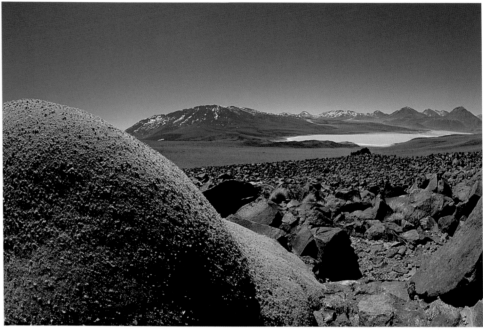

With spines as dense as a mammal's fur, a hardy cactus protects itself from the wind and resists the nightly freeze on the Altiplano.

The yareta, like most plants in this hard climate, takes on rounded shapes to ward off wind chill and evaporation while soaking up heat from the sun.

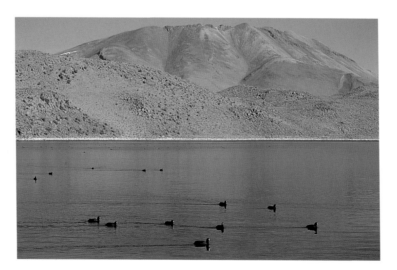

Laguna Celeste, situated farther east than other salt-laced pools, is clear and fresh, supporting large numbers of giant coots and other water birds.

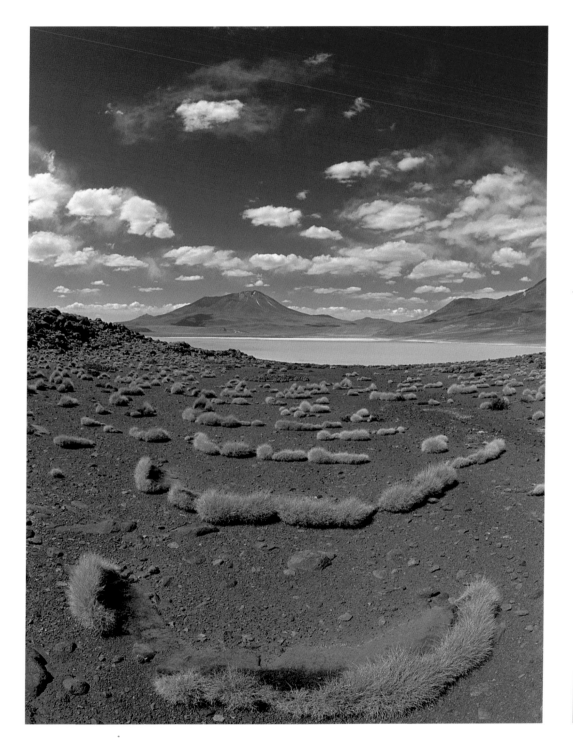

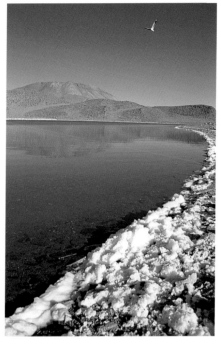

Crystal clear Laguna Celeste, near the eastern edge of the Avaroa Reserve, receives slightly more rainfall and is therefore less saline than the other lagoons, attracting many waders during the warmer months.

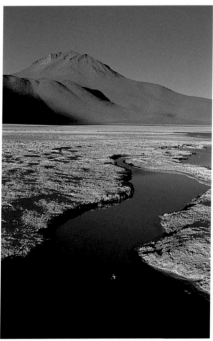

LEFT: *Many small mineral springs emerge from the frosty ground to feed Laguna Blanca, which in turn spills over into landlocked Laguna Verde.*

FAR LEFT: *Mineral-rich Laguna Hedionda teems with micro-organisms and bird life; yet only the sparsest vegetation, growing in wind-carved rows, is seen on the volcanic slopes around it.*

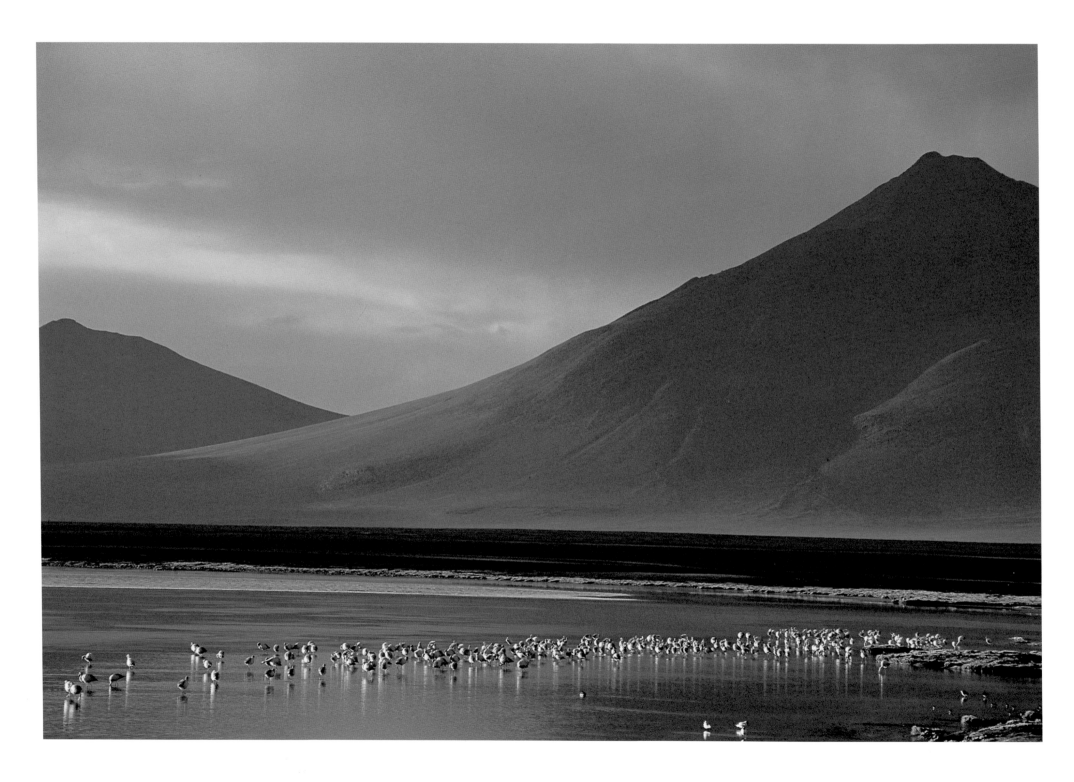

SALT, SAND AND SKY

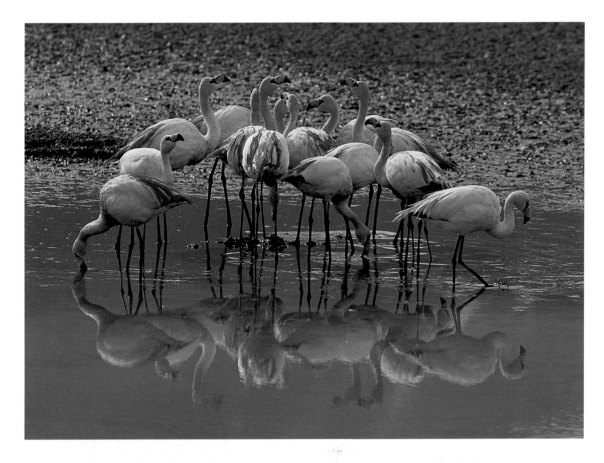

James' flamingos flock in large numbers to favorite freshwater seeps, where the water is less saline, to drink each morning and evening.

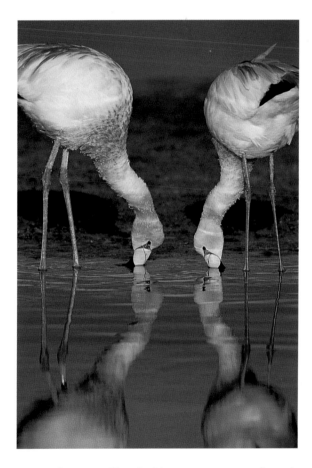

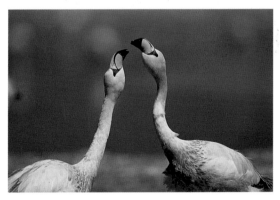

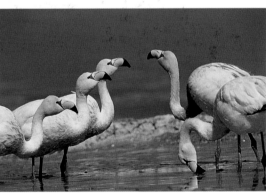

Flamingos derive their spectacular colors from the pigment of the tiny red diatoms that thrive in the briny waters. Here they quench their thirst and squabble around freshwater seeps along the shoreline.

James' flamingos filter feed by pumping water through fine combs inside their beaks.

FACING PAGE: Early morning sun casts a soft glow on Laguna Colorada, trapped between volcanic cones and home to large numbers of flamingos.

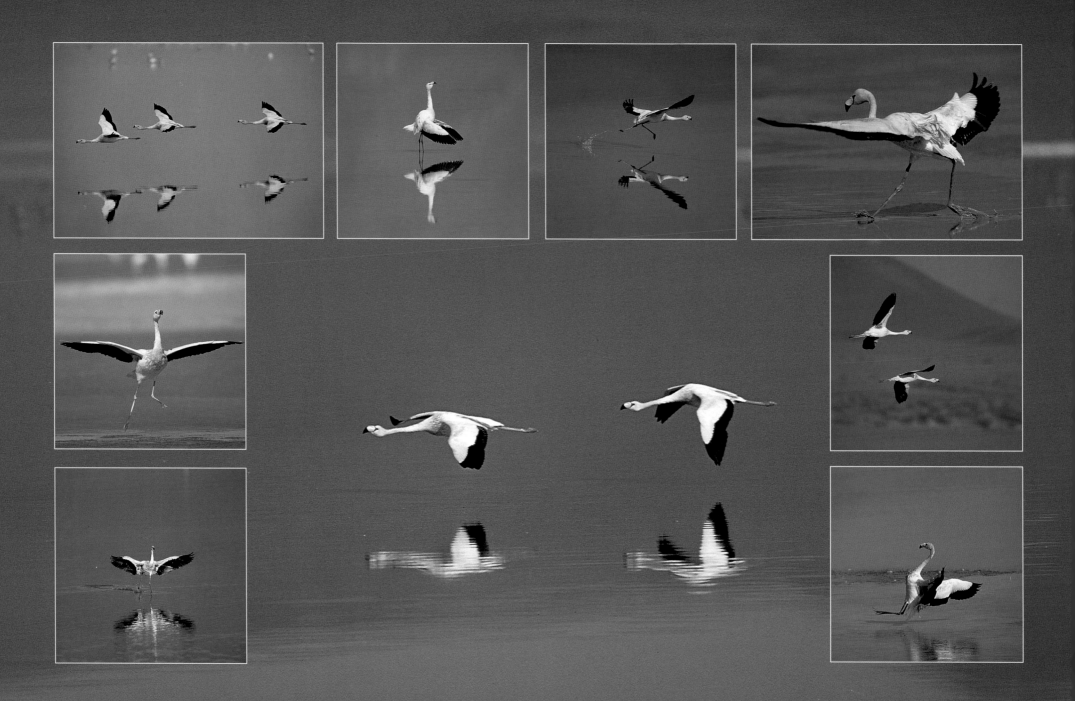

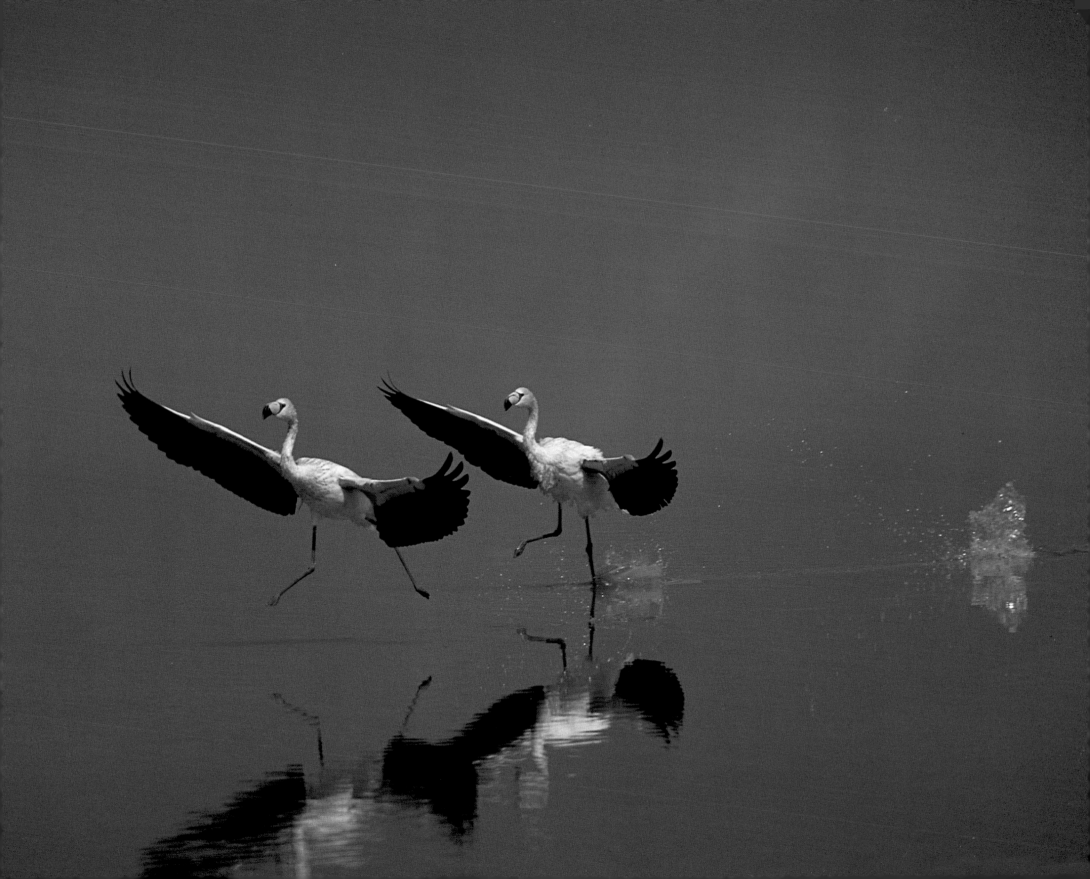

PREVIOUS PAGE, LEFT: In the windless early morning, dainty James' flamingos alight in the shallows of Laguna Colorada, which remains their stronghold at 14,000 feet (4270 m). Sometimes slithering or falling on ice, they use their striking black wings in courtship displays. (Bottom two left and bottom right, MARK JONES)

PREVIOUS PAGE, RIGHT: The James' or puna flamingo is one of the smallest and rarest in the world, confined to the high Andes of Bolivia and nearby Chile and Argentina.

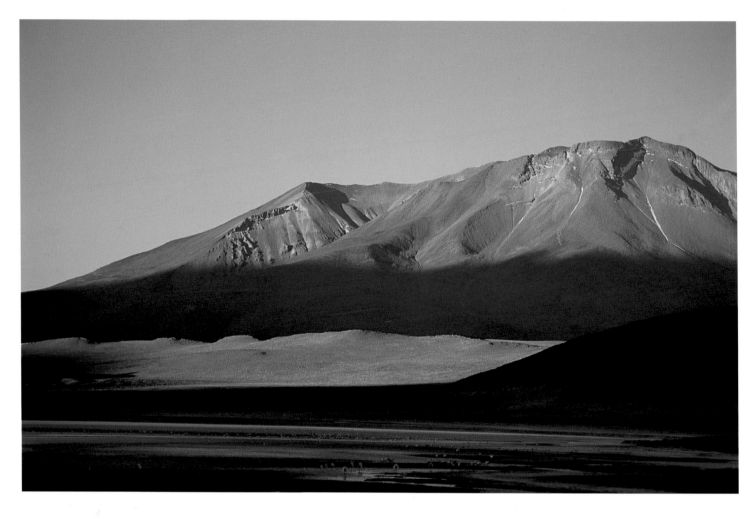

The last rays of evening sun illuminate volcanic folds as flamingos flock to drinking pools along the edge of Laguna Hedionda.

The poisonous green waters of Laguna Verde change to delicate pink as the colors of sunset linger in the cold evening sky.

FACING PAGE: Its eerie turquoise tint disguised by a perfect reflection, Laguna Verde mirrors the cone of Licancabur Volcano, which, at 19,250 feet (5870 m), guards the border between southern Bolivia and Chile.

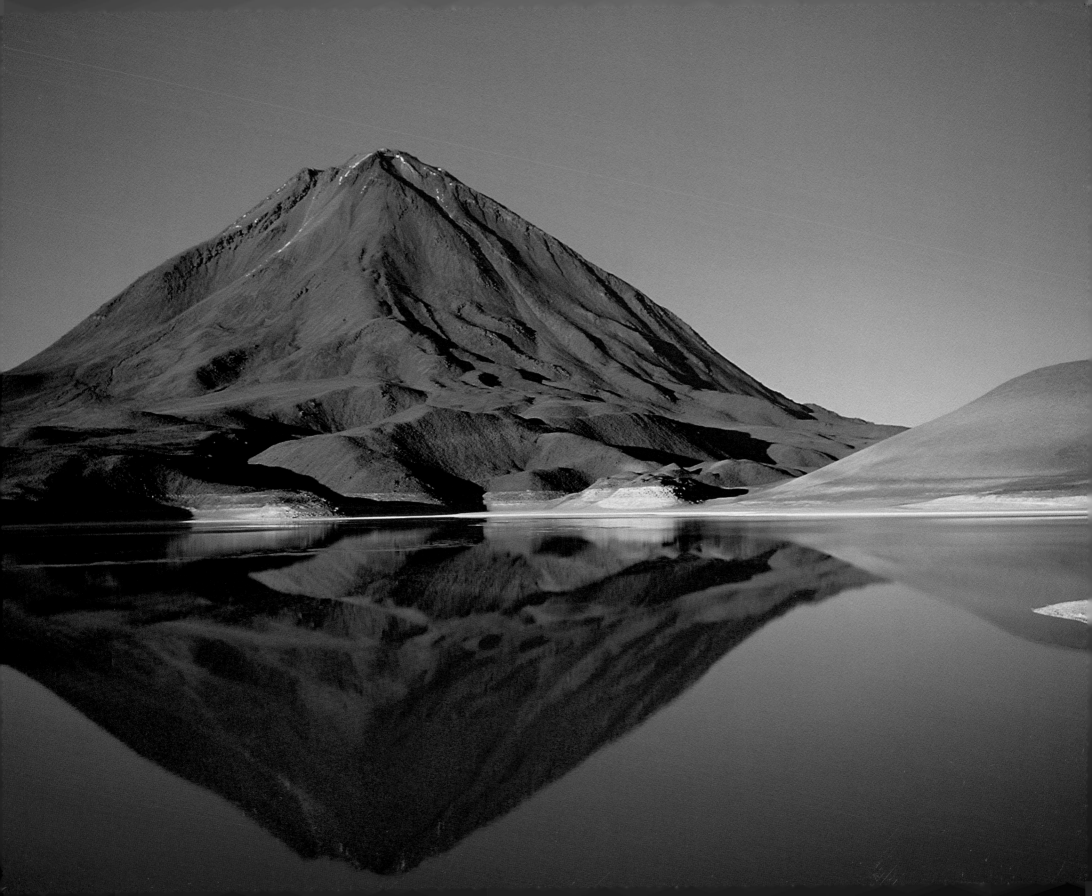

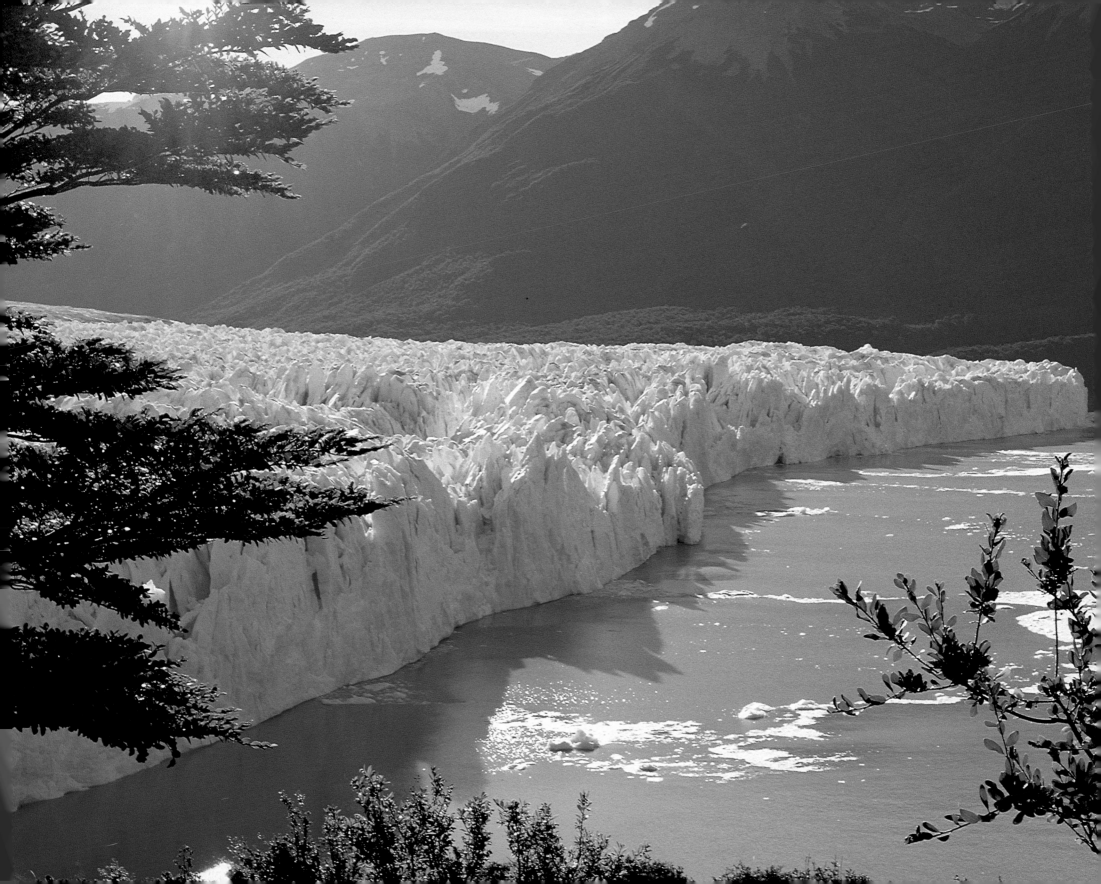

MYSTERY FORESTS OF GONDWANALAND

CHILE AND ARGENTINA'S GREAT PATAGONIAN DIVIDE

For well over 2000 miles (3200 km), along all of Peru, Bolivia and the northern third of Chile, the Andes are dominated by the scarcity of water. With tendrils of Amazon moisture all but blocked by their eastern bulwarks, less than 5 inches (12 cm) of rain per year, on average, reaches their high plateaus and western flanks. These dry conditions are the imperative that color both the Andean geography and its attendant life forms. A parched land mostly laid bare to the elements, its varied and often tormented mineral splendor is only scantily cloaked in patchy vegetation.

Departing from the tropics, the Andes regroup into a proud and abrupt backbone drawing a linear course due south into temperate climes, where an almost miraculous transformation occurs. Where the pattern of prevailing winds circling the globe reverses at about the 40th parallel – about the middle of Chile – the powerful westerlies coming from across the Pacific begin to carry oceanic moisture freely into the mountains for the first time since the Equator, turning deserts into rainforests. This metamorphosis takes place grad-

Lush beech forest frames the glowing Perito Moreno Glacier in Argentina's Los Glaciares National Park.

ually at first. The effects of the dramatic wind reversal lap far up the Chilean coast, beginning with cacti and palm scrub in the Andean foothills, then gathering momentum as rainfall increases southward. The tallest mountain in the western hemisphere, Mount Aconcagua at 22,834 feet (6964 m), acts as the gatekeeper to this changing realm.

THE VALDIVIAN FORESTS

South of Santiago the ancient Valdivian forests prevail. These appear little changed since before the continents as we know them began to drift apart, evidenced by their similarity with the forests of New Zealand and Tasmania. The region also marks the beginning of another zone of intense volcanism, where the majority of Chile's 36 historically active cones are strung over some 700 miles (1120 km). Nestled among them are idyllic valleys where summers are warm and dry and winters mild and wet. Copious rain and snowfall maintains

or monkey-puzzle tree (*Araucaria araucana*). Many centuries old, their massive lichen-festooned, arrow-straight trunks rose to well over 160 feet (50 m), sporting elegant umbrella-shaped crowns of curving, symmetrical branches. It was easy to imagine dinosaurs nibbling at their scaly leaves and coconut-size cones; these trees were once their contemporaries, as attested by impeccable petrified trunks that litter the Patagonian plains far to the east and date back 100 million to 140 million years, long before the Andes arose. Araucarias are primitive conifers that, along with cycads, are among the few survivors of the earliest Gymnosperms, the first seed-bearers that arose some 280 million years ago, before flowering plants evolved. They are the ancestors of present-day pines, firs, cypresses and redwoods.

Our nights were spent camping in windless glades, watching the sun set beyond the trailing ash plume of smoldering, snow-clad Llaima Volcano. The rat-tat-tat of the huge, crimson-headed Magellanic woodpeckers working weathered snags rang in the distance as the last sunrays caressed forested ridges. By day we walked deep in cool shaded valleys over silent carpets of fallen beech leaves between dense clumps of dwarf bamboo, while austral parakeets chattered busily overhead. Early one morning I spotted fresh puma pug marks along the sandy bank of a frosty streambed. Where the cat had lingered for a while, I found its droppings containing the tiny hooves of pudu – South America's miniature deer – offering me an imaginary glimpse into the secretive interplay of predator and prey concealed deep in the dark bamboo understory. After cresting a steep ridge with plunging views into the azure waters of Lake Conguillio, we completed our loop at the foot of rumbling Llaima Volcano in Conguillio National Park, though we could just as easily have walked on through the forest into Argentina.

Resuming the condor's eye journey along the great mountainous divide between the two countries, more volcanoes succeed one another while the forests gradually turn cooler and wetter, riddled with lakes, rivers and waterfalls. The sun-loving araucarias disappear and bamboo thickets grow deeper and darker beneath a dripping canopy festooned in epiphytes – this is pudu country par exellence. Here Villarica Volcano rises to 9317 feet (2840 m), with 65 eruptions

Splendid stands of ancient araucarias grace the Valdivian forests of south-central Chile, where the winters are mild but wet.

innumerable lakes and rivers, which run clear and pristine through breathtaking wilderness.

Some of my fondest memories of the Andes come from this region, where I have ventured far into the utter peace and solitude pertaining to eras past. From the tiny settlement of Lonquimay, reached only by old-fashioned steam train from Victoria, my companion and I walked for days through untracked wilderness around the Sierra Nevada near the Argentine border. Valley after deep valley richly clad in magnificent southern beech forests rolled away to the horizon, with robust cóihues (*Nothofagus dombeyi*) dominating low ground and deciduous lengas and ñires (*Nothofagus pumilio*) taking to high passes. High above the beeches other stately giants towered in ancient stands, the Chilean araucaria

MYSTERY FORESTS OF GONDWANALAND

recorded over the last four centuries. Farther south, beautiful Osorno Volcano, slightly lower at 8695 feet (2652 m) has been asleep for over a century, its symmetrical mass standing watch over the expansive waters of Lake Llanquihue.

From here the Andes begin to change again as they head into the sea, allowing no roads to course the bottom third of the length of Chile. To remain on the land side of the mountains it is necessary to cross over into Argentina. Amazingly, this can be achieved almost completely by boat, lake hopping all the way with only brief overland links. From Lake Llanquihue, this jaunt leads through ever more precipitous terrain until waterways are literally wedged between the peaks. Magnificent vistas succeed one another in a dizzying intermingling of vertical crags, swirling mists, hanging forests and tumbling waterfalls whose wispy waters blend with sheets of rain.

THE ARGENTINE SIDE

At the end of a long and mesmerizing day, the final boat ride slices serenely into the sparkling waters of Lake Nahuel Huapi, which is 44 miles (70 km) long. As if by enchantment, the skies clear and the sun shines warmly out of a bright blue sky. Leaving the narrow lake arm encased between glacier-carved walls, the trip across Nahuel Huapi reveals ever expanding panoramas of primal beech forests scrambling up great palisades to the west in utter contrast to the open, rolling plains stretching away to the east. The rain-shadow effect once again plays its miraculous tricks here, bringing sunny dry summers and icy winters to this side of the range. In fact, the temperature gradient is far greater running east-west across the mountains than it is following them far to the south.

The Argentine side of the Andes is a postcard wonderland of deep lakes, green forests, snow-capped mountains and sunny summer days. The massive glaciers that once overflowed from these heights gouged huge depressions as they poured out far into the plains during the Ice Age. Having all but vanished with the warmer, drier climate, their footprints linger in a string of spectacular lakes – long tentacles reaching back up deeply scoured valleys toward their origins, where remnant hanging glaciers, still shrinking, cling to forest-flanked escarpments.

Like an emerald and sapphire garland, the transition between the Patagonian steppes and the continental divide runs in a narrow ribbon of forest, barely 60 miles (100 km) wide, decorated with so many crystal clear lakes it is easy to lose count. Microclimates cling here and there, giving rise to hidden gems as one moves down along the chain. Treasured memories of my travels through this region float in my mind: tiger lilies blooming among silvery driftwood along a sunny lake shore; rich crimson fuchsia bedecking the forest edge bordering a tall waterfall; emerald lizards basking on a bed of sun-dappled beech leaves on the forest floor; a family of great horned owls perching on gnarly trunks, awaiting the night; condors spiraling in tight circles high in a glacial cirque; and buff-necked ibis, locally known as bandurias, prodding for insects in small dry meadows. On Victoria Island, at the center of Lake Nahuel Huapi, sunlight glows eerily through a dense grove of cinnamon-barked arrayán trees (*Myrceugenella apiculata*). Nearby, ashy-headed geese escort their families through the clear shallows while great grebes dive

The temperate rainforest in Chile's Villarica National Park on the Pacific slope of the Andes is a dense, rain-soaked wilderness enjoying mild temperatures year round.

On the more sunny Argentine side of the Andes the southern beech forest, consisting mainly of deciduous lenga, enjoys warm summers but bitter winters.

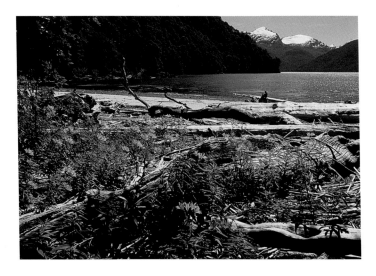

Wild lilies bloom among sun-bleached driftwood along one of Argentina's innumerable lakes.

among the reeds. Farther south, a silent stand of magnificent alerce (*Fitzroya patagonica*), sometimes referred to as a cypress or larch, shelters in a deep canyon, having defied the sawmills of progress and earned their own national park. A conifer related to the California redwood, the alerce may grow to 180 feet (55 m) high and 15 feet (5 m) in diameter, and live for well over a thousand years.

The lake-studded forest frieze huddles in the lee of the cordillera to the end of the continent. Progressively the climate becomes harsher and the tree line drops to lower elevations with the lengthening winters. By now the Andes are no longer stalwart enough to hold back the formidable weather systems assaulting them from the west. At this stage of their long southward journey incessant winds and vicious storms spill over their crests, dumping sufficient snows to maintain the only remaining icecap in the world outside of polar regions. An enormous dome of ice fills the narrow central valley to overflowing, glacial fingers snaking down any gaps available. This tempestuous complex of jagged mountains, sprawling ice fields, tumbling glaciers, enduring forests, cascading streams and expansive lakes is all captured in one huge national park, Parque Nacional Los Glaciares – simply, Glaciers National Park.

Here a remarkable formation juts up into the frigid Patagonian sky – the FitzRoy Massif. The remnants of an ancient batholith thrust up into the atmosphere from deep within the earth's crust, it is cleaved and chiseled by intense frost cycles into a series of granite spires that seems to reach for the heavens, frowned upon by scuttling storm clouds. Crazily perhaps, a breathless carefree mood lured me with two companions into wandering this primeval landscape for days without so much as a tent for shelter. With just a satchel containing sleeping bag and cheese, we strolled up pristine U-shaped valleys, through gnarled, wind-sculpted elfin beech forests and along milky glacial torrents. On a high moraine up above the tree line we savored some of the cleanest air in the world, while watching the sun sink beyond nacreous wind clouds. At night we curled up snugly out of the rain under giant erratic boulders strewn randomly across the land by the receding glaciers of the last Ice Age. We shivered in awe as the dawn alpenglow exploded onto the ice-rimed granite needles,

and later we basked in morning sun further down the sheltering valley. To walk among these mountains is to taste the spirit of freedom that only utmost wildness can convey.

DRAMA AT MORENO GLACIER

At the bottom end of Los Glaciares National Park lies another wonder of this elemental region, the Perito Moreno Glacier. It is one of the few glaciers in today's warm world that is still actively advancing, flowing off the Patagonian Icecap and snaking down the mountain pass in a huge, dynamic tongue of ice covering some 27 square miles (6993 ha). On a cyclical schedule that repeats itself every few years, this sets the stage for one of the grandest dramas of the mineral world – a drama that, through incredible luck, I once witnessed.

Impelled by the continuously replenishing snowfields far beyond, the Moreno Glacier is moving so fast it is constantly cracking and groaning as it heaves over the uneven topography. It may surge as much as 1500 feet (460 m) per year, spilling broadside into vast Lake Argentino. There it marches briskly across to abut the solid rock bank on the opposite shore, damming the lake. With no other escape through the surrounding mountains, the blocked waters of Lake Argentino's 13-mile (21-km) long southern arm, Brazo Rico, begin to rise, reaching 100 feet (30 m) higher than the rest of the lake within two or three years.

Thus was the situation when I first set eyes on the Moreno Glacier late in the summer of 1980 at the end of a three-month trip through the Patagonian Andes. Hemmed in by dark forested mountains, its glassy leading edge towering some 200 feet (60 m) above the lake waters, the glacier presented a breathtaking panorama. Immaculate and debris-free, it appeared to sparkle in the afternoon sunshine like a river of diamonds, its surface splintered into a myriad of blue and white spires, or seracs, aligned in long furrowed rows and teetering at improbable angles. Quite frequently, these would fracture and crash into gaping crevasses to the sound of tinkling glass. Little did I know that this fine March day would herald the beginning of the most extraordinary episode

Beautiful groves of arrayán trees, members of the myrtle family, grow on Victoria Island in Lake Nahuel Huapi.

of the recurring glacial saga, to be played out at bewildering speed over the next three days.

Where the glacier met the steep bank of the lake was a scene that transported me 10,000 years back to the height of the glacial advance of the last Ice Age, when expanding ice caps spread over the temperate regions of the world, annihilating all in their paths. Before my eyes, even though no motion was visible, the ice plowed inexorably into the beech forest, rumpling the ground as the earth was scoured away like putty down to polished bedrock by the unimaginable weight of the huge creeping wall. Fifty-foot (15-m) beech trees, their roots jutting loosely into the air, leaned and toppled. From time to time car-size chunks of ice sloughed off of the looming face and shattered at its foot, flying shards snapping branches and trunks like matchsticks.

Yet this was only the beginning of an awe-inspiring, real-life lesson in glaciology. That morning, a suspicious water flow appeared in the lake right next to where the glacier met the shore. Soon an ice cave began to open, creating a gaping maw around the source of this gushing surge, which was accelerating by the hour. Clearly, the trapped waters of the Brazo Rico had begun to force their way beneath the glacier, the buoyancy of the ice succumbing to the 100-foot (30 m) level difference between the two sides of the lake. Literally losing its footing, the front edge of the glacier was being prized away from the lake bed.

RIGHT: The eastern Andean pallisade is richly festooned in magnificent beech forest in Argentina's Los Alerces National Park.

BELOW: On a rare clear day, the Perito Moreno Glacier offers a stunning spectacle from the summit of Mount Buenos Aires as it snakes down from the Southern Patagonian Icecap into Lake Argentino.

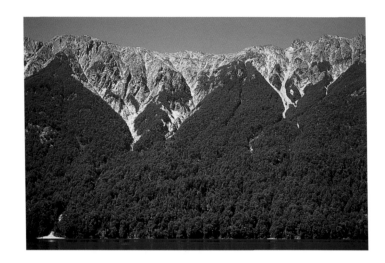

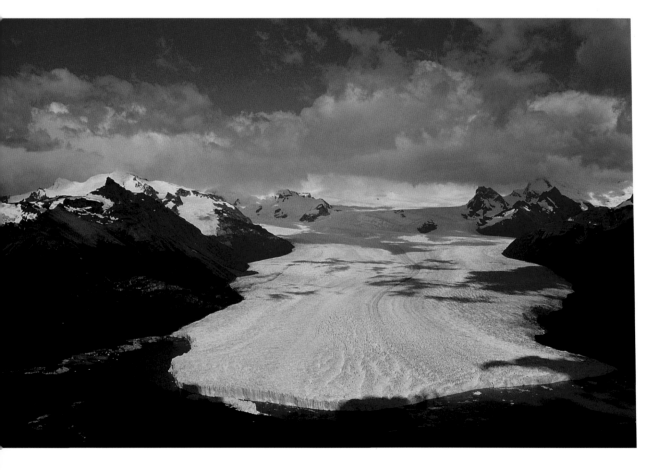

By evening the roiling waters had turned into a veritable torrent raging through an enormous ice tunnel continuously being enlarged as great sheets of ice peeled away from its ceiling. Water and glacier roared, hissed, collided and exploded in a deafening maelstrom of foam, mist and shattering ice. Sleep that night was out of question. The next day the show intensified as the entire crumbling face of the glacier was being undermined and cut back by the fury of the released waters, dislodging towering pillars of aquamarine ice the size of apartment buildings. As more and more ice collapsed, great arches were carved out momentarily, balancing like gothic cathedral buttresses for a few minutes before being whisked into oblivion by the frantic waters, calculated to be flowing at something like two million gallons (nine million liters) per second. At last, 36 hours after it had begun, the sum of this wild unleashed energy climaxed into one electrifying uproar as the entire cavern, by now more than 100 feet (30 m) high and over 300 feet (100 m) long, collapsed in a gigantic explosion of ice and spume.

The fourth day dawned utterly still and peaceful. The two sides of Lake Argentino were finally level and reunited, the mighty glacier carved back by some 150 yards (140 m) from the shore. Swarms of new icebergs spread far across the lake's surface, with hundreds more bus-sized blocks left stranded high in the forest by the great tidal waves of the day before. Lake Argentino's entire 500-square-mile (13-million-hectare) northern expanse had risen by some 6 feet (1.8 m) from the added influx of water, flooding much of the Santa Cruz River that drains toward the far Atlantic. I felt as though in those four short days, I had seen the entire cycle of glaciation pass before my eyes, eliciting images of cave dwellers hurling stone-tipped spears at mastodons in the shadow of the Andes. But for now, on the shores of Lake Argentino, nature's cataclysmic powers had reached an uneasy truce, until the next time the unstoppable force of gravity would pitch ice and water against each other once more.

FACING PAGE: Morning alpenglow strikes the polished granite face of Mount FitzRoy in Argentina's Glaciers National Park.

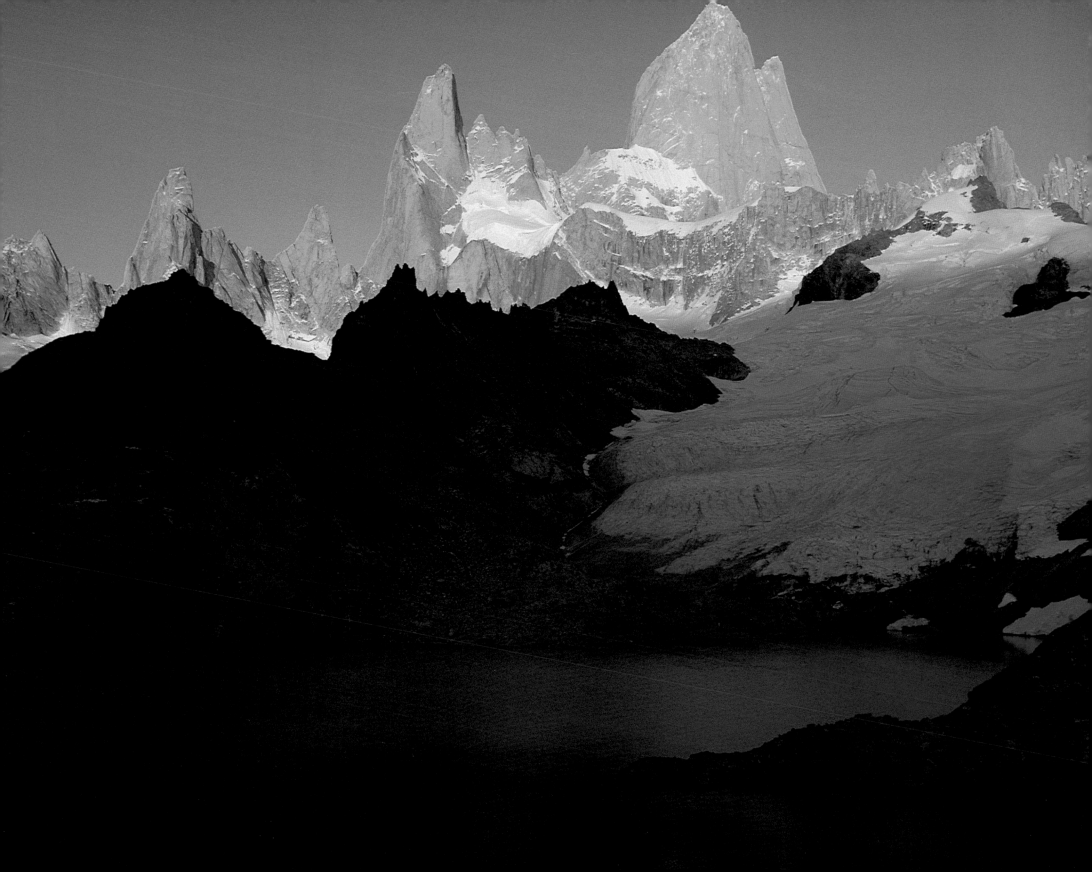

Araucarias are among the most ancient of conifers and mark the first appearance of seed-bearing plants on earth, having remained virtually unchanged for some 200 million years.

Magnificent stands of araucarias, or monkey-puzzle trees, overlook Lake Conguillio.

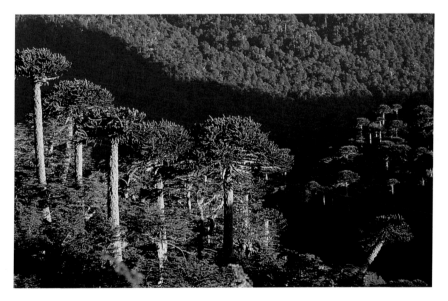

FACING PAGE: *Abundant humidity from the Pacific brings heavy winter snows to the stately araucaria forests of Chile.*

Araucarias several centuries old tower above beech forest that rolls away across the Chile-Argentina border.

Before the Andes rose up, vast araucaria forests once stood in what are now the Patagonian steppes, as revealed by these petrified trunks buried in volcanic ash from early Andean eruptions.

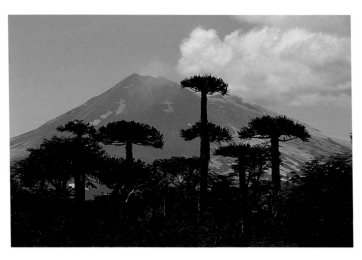

Tall parasol-shaped araucaria are outlined against the active cone of Llaima Volcano in Chile's Conguillio National Park.

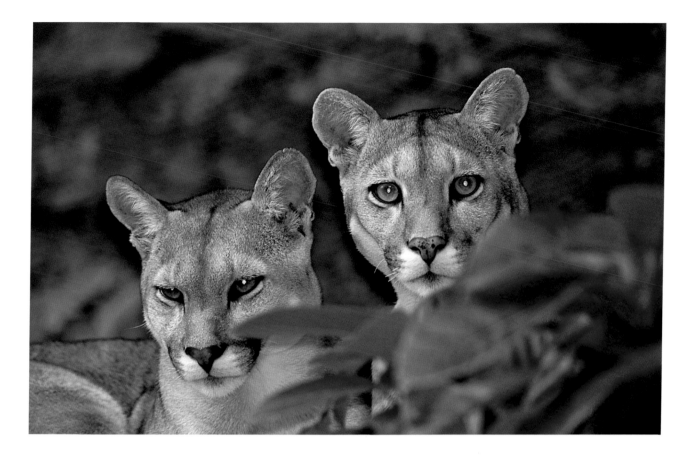

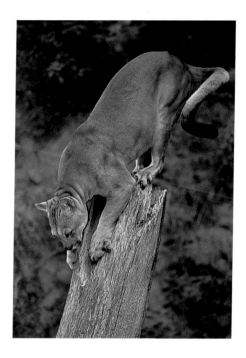

ABOVE: The puma is a stealthy predator of the southern forests and is usually a solitary hunter. LEFT: Littermates, however, may stay together for a while.

RIGHT: On the Chilean side of the Lakes Route across the Andes into Argentina, beech forest climbs up some of the wettest mountain slopes in the world.

FAR RIGHT: The miniature pudu is the smallest of all deer. Standing just 1 foot (0.3 m) high and weighing about 20 pounds (9 kg), it leads a secretive life in dense bamboo thickets.

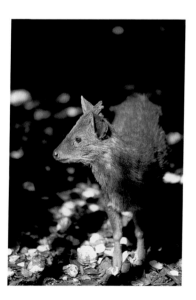

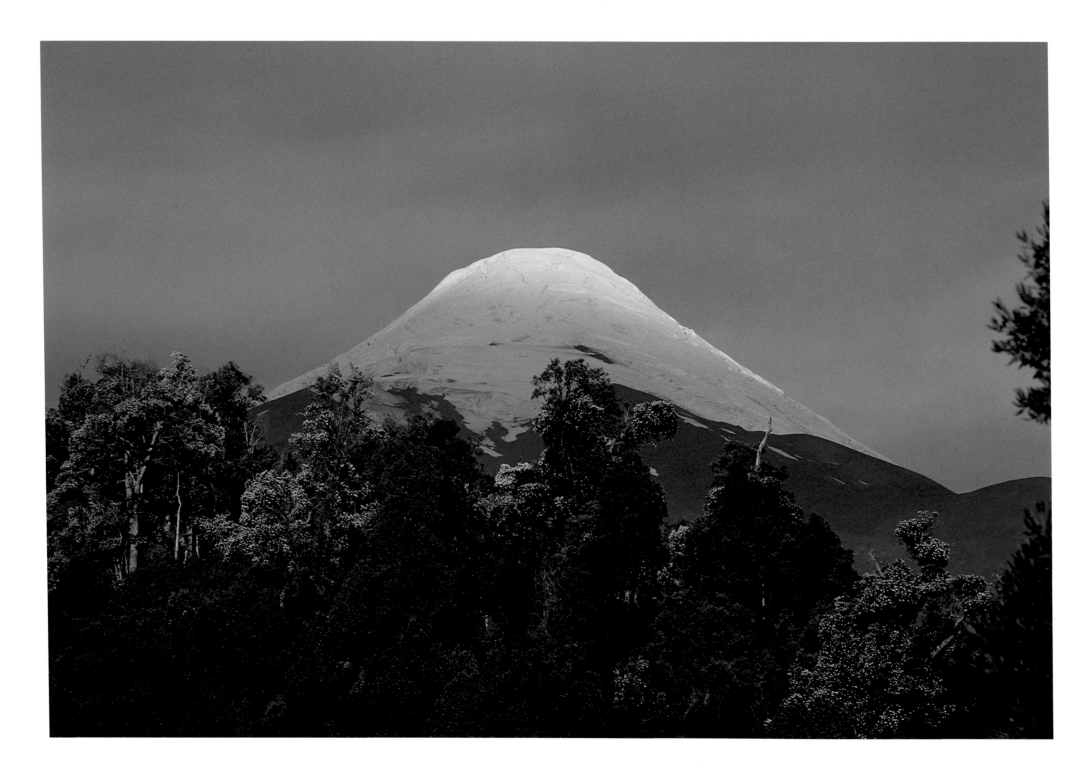

MYSTERY FORESTS OF GONDWANALAND

LEFT: *A great horned owl blends in with the bark of a southern beech tree in Los Glaciares National Park, Argentina.*

RIGHT: *Frias Lake is one of many along the so-called Lakes Route between Chile and Argentina. This route can be navigated in a day, with only short overland hops.*

BELOW: *The austral parakeet is an incongruous sight in the stormy temperate forests of the south.*

LEFT: *A tiny emerald lizard basks in dappled sunshine on the mossy floor of the beech forest.*

FACING PAGE: *Osorno Volcano's 8700-foot (2653-m) snow-covered cone, marking the gateway to the lakes region in southern Chile, last erupted almost 150 years ago.*

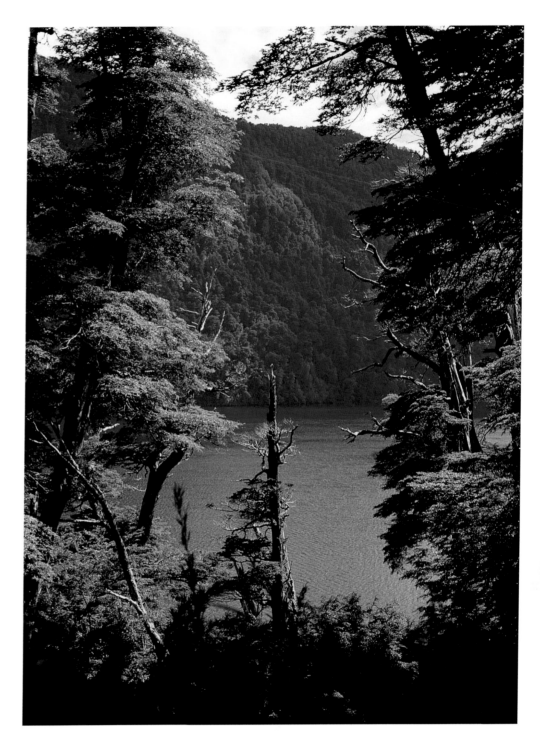

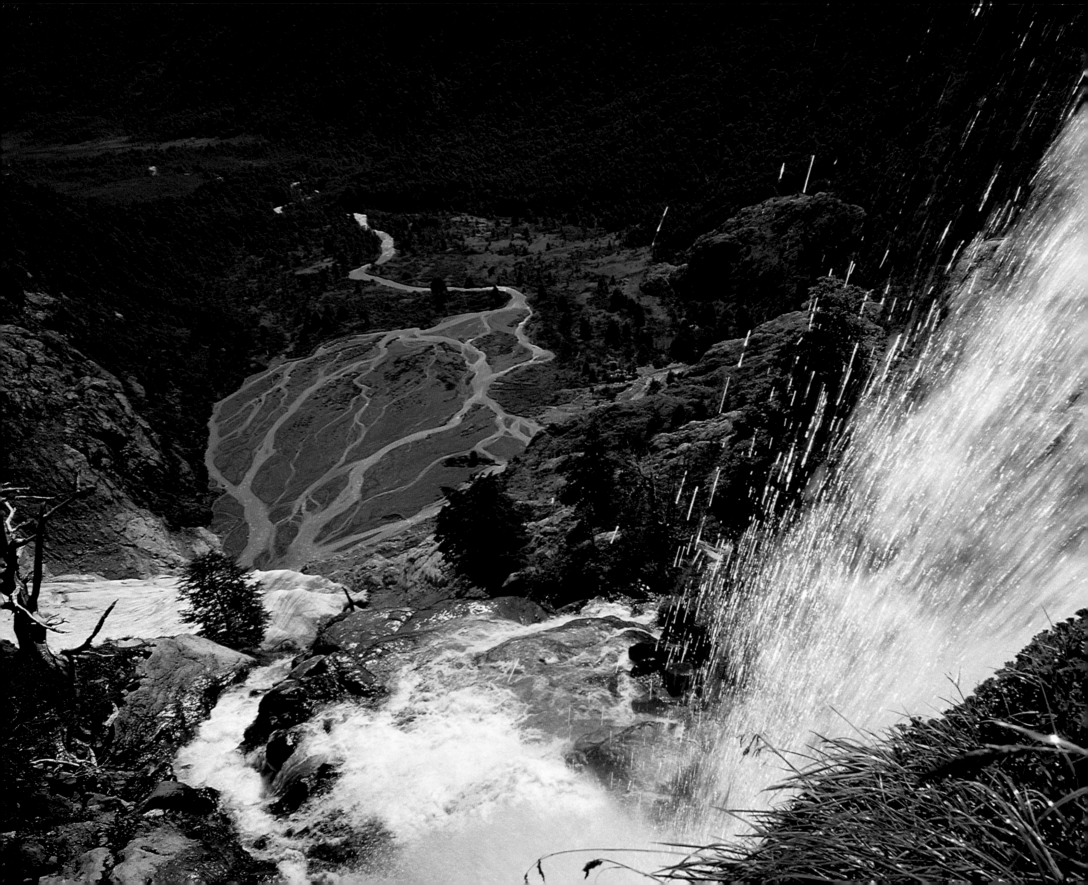

LEFT: *The stout buff-necked ibis forages for insects in meadows and along the many lake shores of the Patagonian foothills.*

LEFT: *Burberry blooms where the mountains give way to the Patagonian steppes in Tierra del Fuego.*

RIGHT: *A cluster of flowers provides a splash of brilliant color deep in the forest understory of Nahuel Huapi National Park, Argentina.*

FACING PAGE: *Magnificent waterfalls and huge, lush, sunny valleys in Nahuel Huapi National Park are a wonderland for summer hiking.*

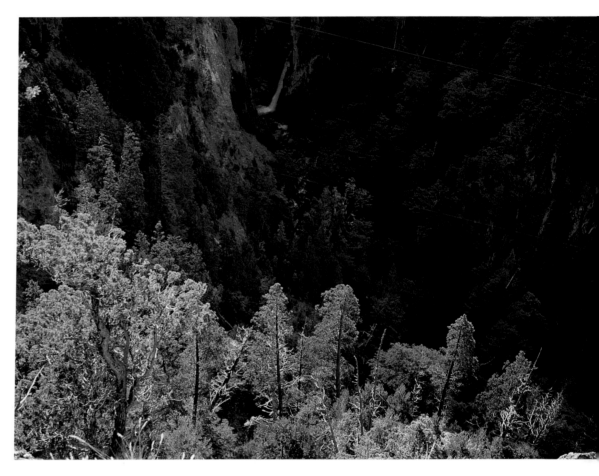

Los Alerces National Park on the Argentine side was created primarily to protect remnant stands of the magnificent Chilean redwood, or alerce, which rivals California redwoods in age and size.

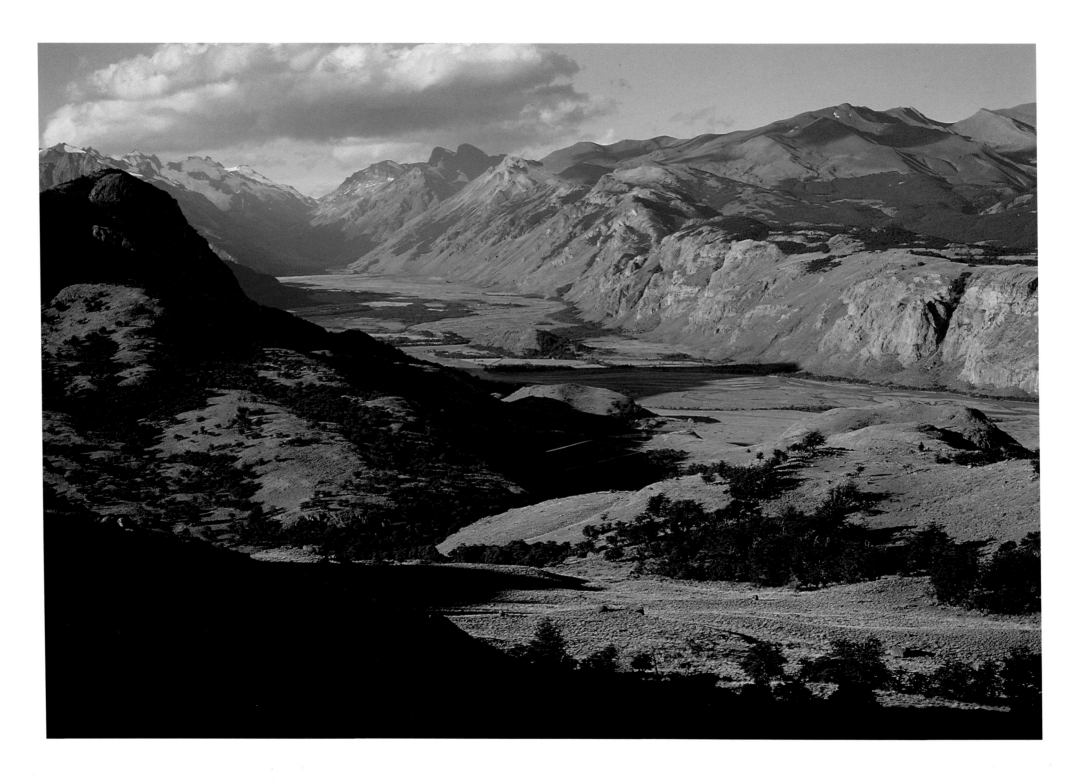

MYSTERY FORESTS OF GONDWANALAND

ABOVE: *Stunted and windworn, the deciduous lenga, which is widespread in both Chile and Argentina, is one of several species of southern beech that divide up the habitat according to altitude and rainfall.*

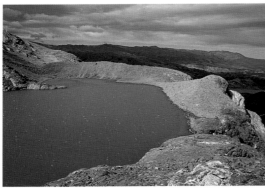

ABOVE: *A small tarn, dammed by a moraine as glaciers receded, stands above the Patagonian plains, which stretch to the Atlantic.*

FACING PAGE: *Enormous glacially carved valleys in Argentina's Glaciers National Park spread out from the base of the Andes into the Patagonian plains.*

RIGHT: *The sheer, ice-rimed granite spires of Cerro Torre pierce the sky above the beech forest on the Argentine side of the divide.*

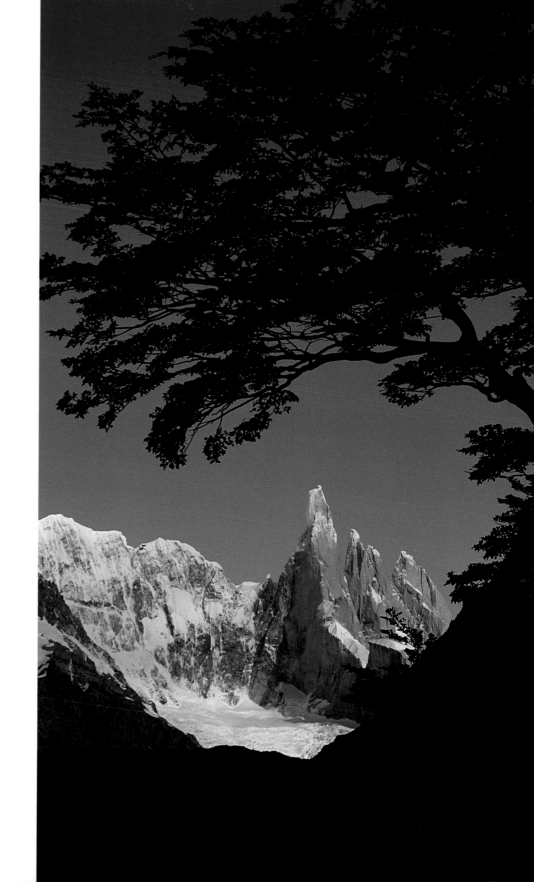

Morning calm reigns as a shaft of sun strikes the recently carved channel where the trapped waters of Lake Argentino have cut back the advancing Moreno Glacier.

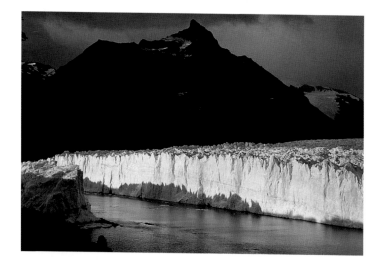

Seen from the air, the Perito Moreno Glacier is deeply riddled with crevasses and seracs as it races down from the Andes, splitting and cracking as it passes over rough ground.

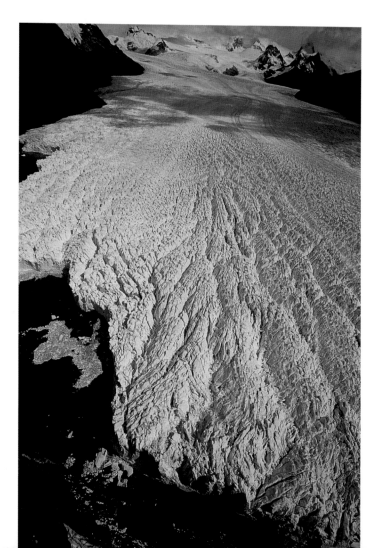

Storm clouds hang over the Patagonian Icecap as the calving Moreno Glacier roils the waters of Lake Argentino.

130

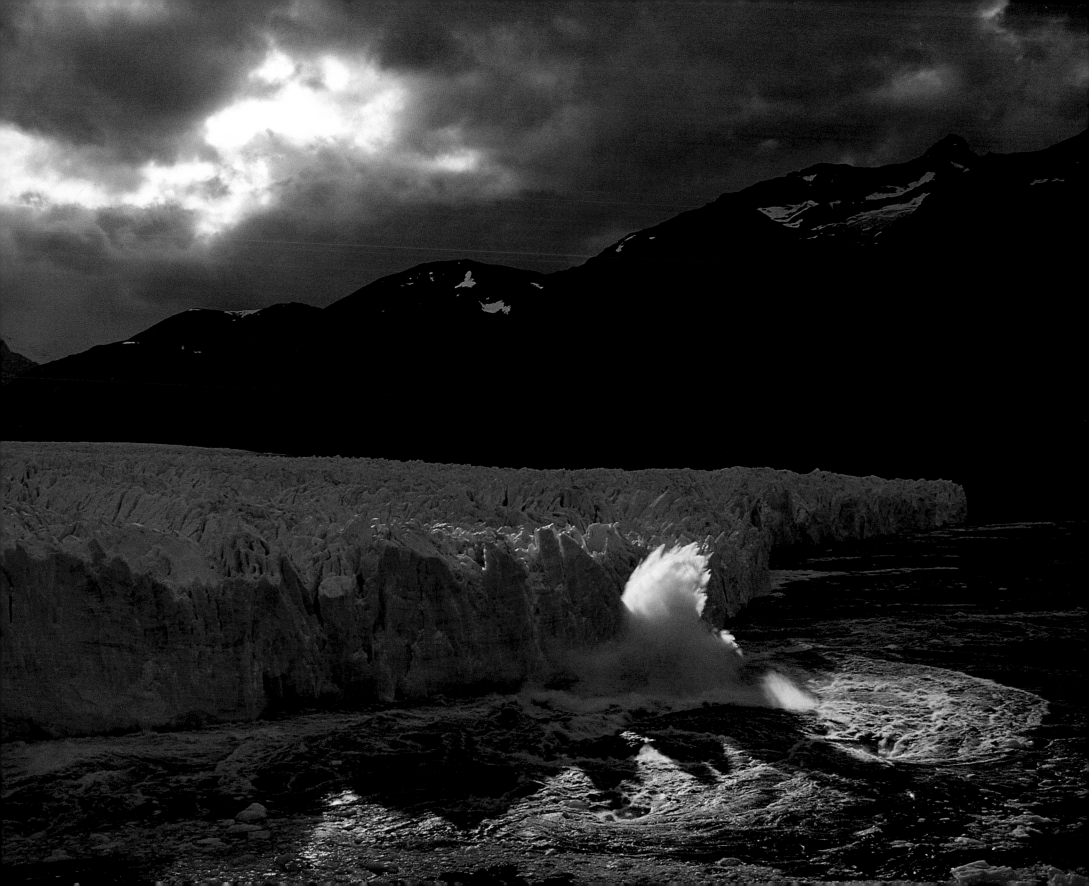

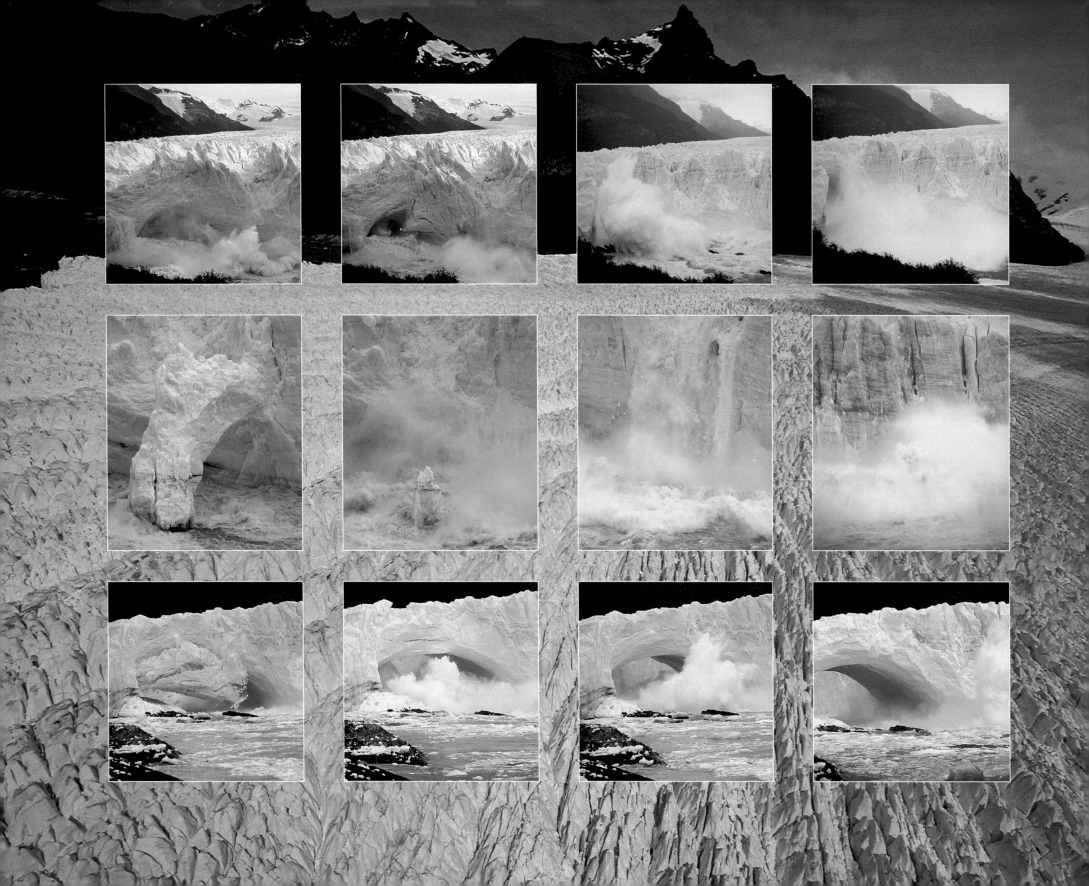

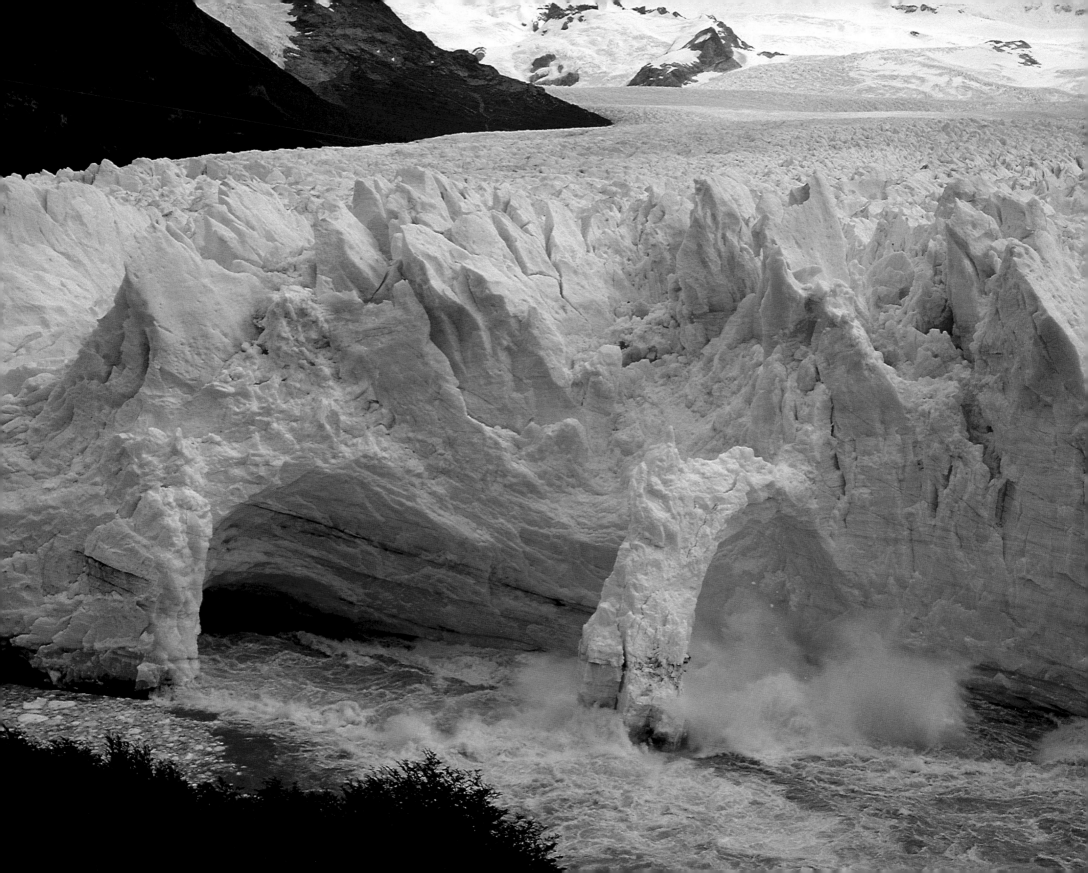

PREVIOUS PAGE, LEFT: The Perito Moreno Glacier of Los Glaciares National Park in southern Argentina is one of the few glaciers still actively advancing today and is fed by heavy snowfalls on the Patagonian Icecap, which are driven by Pacific storms. The glacier cuts across Lake Argentino, blocking its southern arm. Once these trapped waters have risen about 100 feet (30 m) the pressure suddenly carves its way under the foot of the glacier, undermining and carving back the ice rampart in an almost cataclysmic event that takes place over a period of some 36 hours. This same cycle is repeated every few years.

PREVIOUS PAGE, RIGHT: At the height of the lake's breakthrough, water is rushing through the glacier at a rate of two million gallons (nine million liters) per second, causing huge blocks of ice 200 feet (60 m) high to collapse almost continuously.

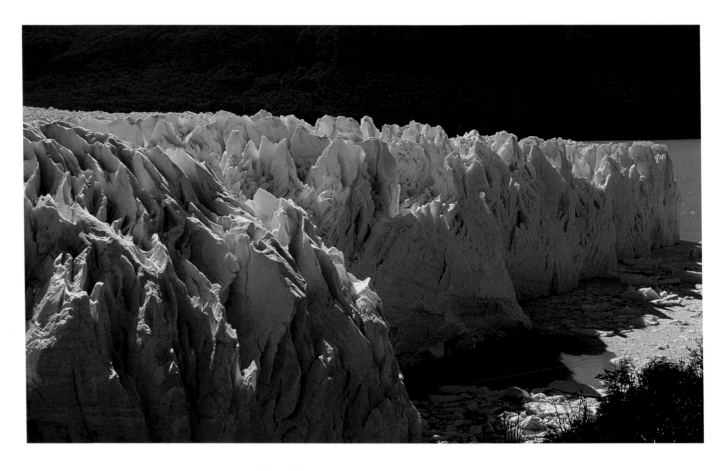

ABOVE: Creaking and tinkling sounds emanate from the splintering depth of the Moreno Glacier as it marches across Lake Argentino.

Bulldozed by the unstoppable force of the ice, the beech forest gives way where the advancing Moreno Glacier encroaches.

FACING PAGE: Like a scene out of the Ice Age, the 200-foot (60-m) high wall of the Perito Moreno Glacier in southern Argentina plows inexorably into the beech forest.

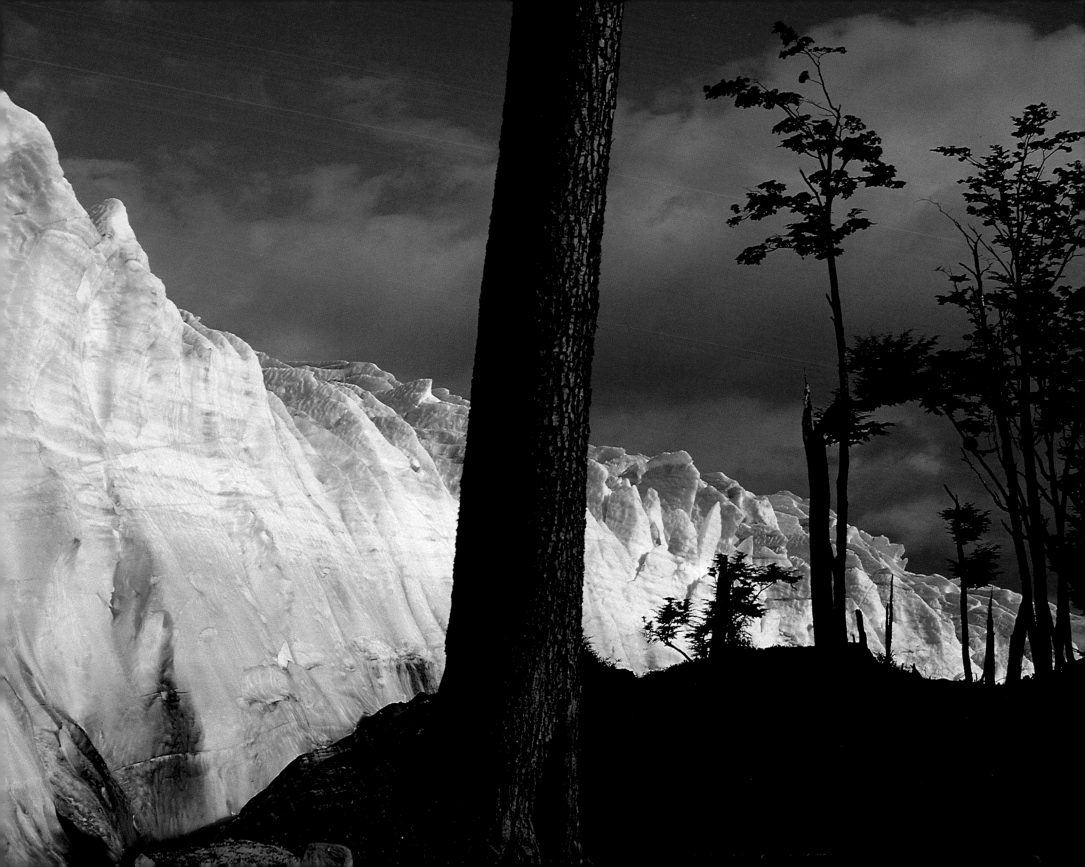

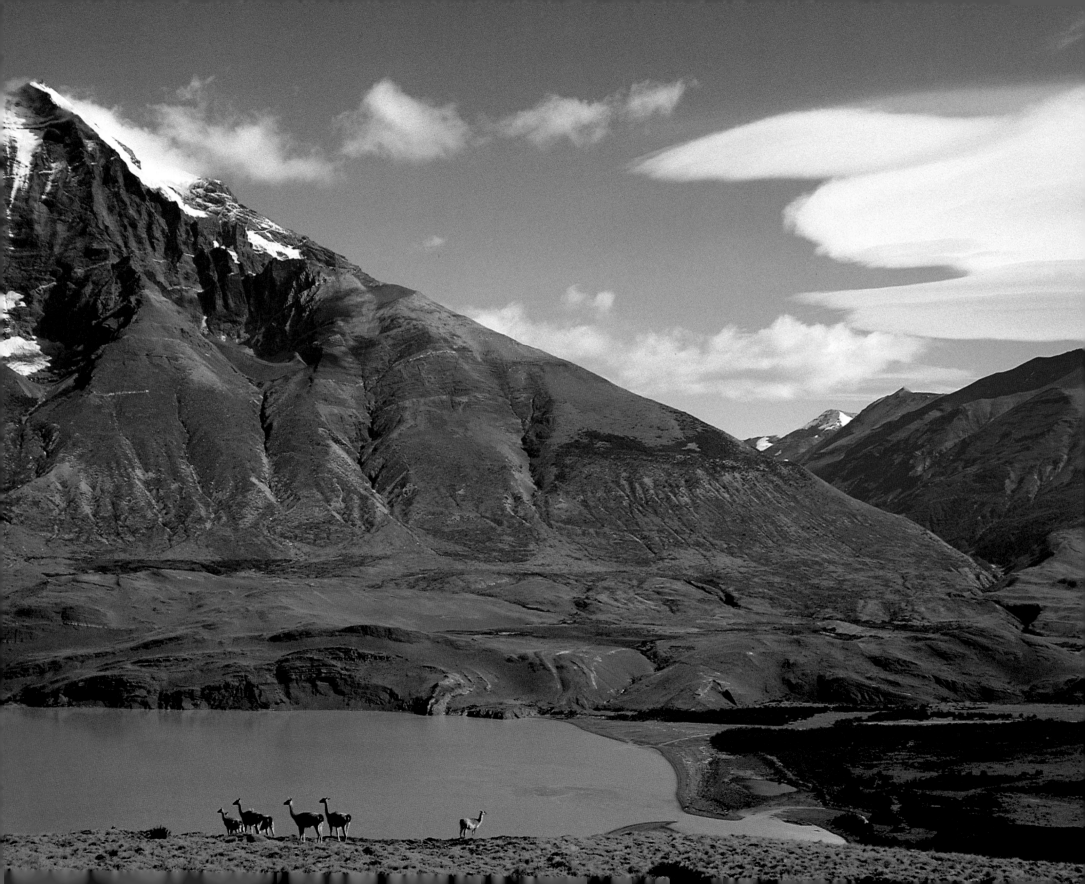

FJORDS, ISLANDS, GLACIERS AND STEPPES

FROM THE PATAGONIAN ICECAP TO CAPE HORN

Family herds of guanacos dot the breathtaking landscape of Torres del Paine National Park in southern Chile.

It would be easy to imagine that the gigantic glaciers and lakes of southern Argentina represent the wildest part of the Andes, the ends of the earth – or at least the end of the continent. Yet only a few wing-beats to the west as the condor flies lies an even more forbidding environment, the lush strip bordering the Chilean coast on the Pacific side of Patagonia.

This is where the Andes literally sink into the sea. From the big island of Chiloé, on down through the bottom third of Chile, stretches an astounding forest-clad maze amounting to thousands of miles of utterly wild shoreline where not a single road is to be found.

Less than 20,000 people live in this vast region, scattered in small towns wedged between the mountains. Half a dozen of these towns have airports, the rest are serviced only sporadically from the sea or through short, dead-end roads hopping over the border from Argentina. Even today this land remains untamed and seemingly untamable.

THE MARITIME ANDES

These are the latitudes known as the Roaring Forties and Furious Fifties, raked by the raw fury of oceanic storms that drive across thousands of miles of open Pacific and dump their accumulated energy where they meet the land. Rarely are the highest crags or the active volcanoes visible through the layers of cloud and mist that shroud this complex geography like a protective cloak, with the climate changing little between summer and winter. The near-constant precipitation and scant sunshine on this side of the divide nurture the Patagonian Icecap, its overload spilling in numerous steeply encased glaciers that tumble directly into the sea.

Though mere remnants of its former self, the Patagonian Icecap, now divided into two sections, still covers roughly 9000 square miles (2.3 million hectares), filling large stretches between the Eastern and Western Cordilleras Patagónicas. A third parallel chain, the Patagónica Insular conforming to the Chilean archipelagos, is separated by

137

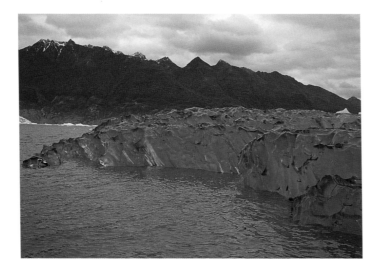

Dense ice calved from the steep San Rafael Glacier drifts on the lake of the same name in Chile's fjordland.

extensive waterways that make it possible to sail right down to the end of the continent, ducking only momentarily out of the Andes into the open sea.

Not so long ago the enormous ice sheets spanning much of the bottom end of South America may have reached a thickness in excess of 4000 feet (1220 m). At the peak of the last glaciation the sheer weight of this frozen burden depressed the earth's crust, forcing the mountains down into the sea. When the ice began receding again in recent times, this left a sunken landscape in its wake, where the Andes and the sea unite – a land where salt spray laps at fern glades in the beech forest understory, and calving glaciers strew their icebergs across kelp beds. The once proud cordillera is much lower here. It is fragmented instead into an infinity of islands, in turn bisected by bewildering labyrinths of channels and fjords, rivers, lakes and glaciers. This freshly emerged, rugged topography is blanketed in squat evergreen Magellanic forest growing in a low belt near sea level. Far wetter and colder than the Valdivian forest to the north, it is dominated by another beech species, the gnarly and stunted *Nothofagus betuloides,* which has adapted to the waterlogged soils thinly beginning to cover the exposed bedrock. Broken branches and fallen trunks take years to decay in the constant cool temperatures, and they litter the steep forest floor in an almost impenetrable latticework of mossy rotten logs, inter-

spersed with peaty sphagnum muskegs carpeted in dark red carnivorous sundew plants.

Cold ocean currents sweep up this coast from Antarctica, keeping temperatures low in summer yet preventing heavy or prolonged frosts in winter. These fuel the seemingly limitless amount of rain and snow strafing the area, averaging 160 inches (400 cm) annual precipitation. The heaviest dumps fall on the outermost coastlines, such as Madre de Dios Island which at latitude 50° south receives between 240 and 360 inches (610 and 915 cm), whereas Punta Arenas, sheltered behind the first line of mountains on the Magellan Strait, gets only 24 inches (60 cm).

SAILING THROUGH THE CHILEAN FJORDS

Having twice sailed the length of the Chilean fjords I find my curiosity about this harsh but wondrous corner of the earth can never be satisfied, the sheer scale of the geography defying my limited human senses of time and space. Beginning nearly 3000 miles (4800 km) south of the Equator, the voyage conveys a strange feeling of leaving behind all that is known as one enters this water-worn, storm-lashed landscape, heading forever south. Notwithstanding place names as ominous as Gulf of Pains, Port Famine, Desolation Island, Useless Bay, Last Hope Sound and other desperate titles, vignettes of these mysterious wild enclaves between the end of the road and the end of the continent remain etched in my memory, like gems glinting from a long garland of precious Andean experiences.

As I left Puerto Montt on an exceptionally clear day, the snowy wedge of Corcovado Volcano rose from the sparkling waters of Corcovado gulf. An even rarer vivid sunset set the skies afire later that day over the oddly domed islands of the mosaic Chonos Archipelago to the west. Next morning a display of playful Chilean black dolphins in Estero Elefantes (Elephant Strait) preceded a long excursion up a meandering, fast-flowing tidal channel leading to San Rafael Lagoon. Here the spectacular icy ribbon of the San Rafael Glacier rumbles down directly from the icecap not far beyond, its jumbled aquamarine snout spawning flotillas of icebergs from which

the Canal de Témpanos (Iceberg Canal) gets its name. In the impenetrable forest lining its banks the Chilean huemul deer, a smaller relative of the Peruvian huemul or taruka of the arid puna, lurks unseen.

With land and sea so closely intertwined, more marine mammals made their presence known. Rounding the many-fingered Taitao Peninsula, which juts out to sea barely 100 miles (160 km) west of the Northern Patagonian Icecap, a bull sperm whale surfaced. Then an elusive pod of rare so-called southern-right-whale dolphins appeared, their strange name stemming from their finless profile. These elusive, arrow-shaped, black-and-white creatures are among the fleetest cetaceans known. Even closer to shore, shortly before we sneaked back into the intricate narrow waterways leading ever southward among the island-mountains, a pair of blue whales – the largest living creatures that ever existed – were feeding inside the Gulf of Pains.

More contrasting moments followed. The giant parasol leaves of tropical-looking gunnera plants overhung the dripping shoreline above kelp beds where skeins of imperial cormorants, another classic Antarctic seabird, were diving. Even within these tendrils of sea deeply sheltered between solid mountains, black-browed albatross – icons of the open ocean – were feeding in tidal eddies alongside families of flightless steamer ducks. These massively built ducks come in two nearly indistinguishable forms – one flightless weighing up to 13 pounds (6 kg) and the other smaller and much lighter, and able to fly. Both are adept divers, using their vice-like bills to crush mussels and other hard-shelled mollusks and invertebrates, a rather startling ability for a duck. Fiercely territorial, the flightless brutes evict interlopers in vicious battles and high-speed "steamer" chases, flailing their powerful stubby wings like paddles across the water.

By about latitude 52° south fingers of sea penetrate so deeply among the mountains that it is possible to take large vessels onto the leeward side of the main range, such as Puerto Natales, where the Patagonian steppes meet the Andes. On the windswept plains within sight of the forest-clad mountains graceful Chilean flamingos, oblivious to the raw climate, dot saline lakes. Darwin's rheas (also known as lesser rheas), smaller South American counterparts to the

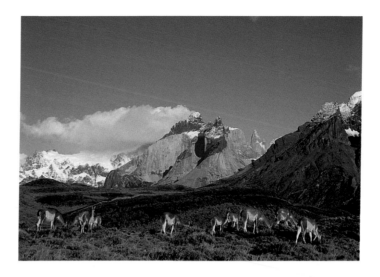

Guanacos graze the rough, dry grasses of the Patagonian steppes. Beyond lie the sharp peaks of Torres del Paine.

African ostriches, lope across the scrubby grasslands at speeds up to 38 miles per hour (60 km/h), while splendid flocks of striking black-necked swans grace tidal inlets, along with many different types of ducks.

Three varieties of sheldgeese, a beautiful kind of small goose related to the Andean goose of the northern high plateaus, are found in vast numbers in wetlands bordering the beech forest. Mixed flocks of ashy-headed and upland, or Magellanic, geese throng estuaries and grasslands by the thousands, their black and white wings offering dazzling spectacles upon take-off and landing. Even more striking are the exclusively seaweed-eating kelp geese living in pairs along the rocky shorelines throughout the fjords region, the female delicately patterned in black and white, the gander snowy white. A fourth species, the ruddy-headed goose of more southerly coastal grasslands and meadows, by contrast, is rare and declining.

TORRES DEL PAINE NATIONAL PARK

Tucked along the southern extent of the Patagonian Icecap sits stupendous Torres del Paine National Park, another deeply sculpted, exposed batholith. A complex collection of granite spires and giant "horns" rival the FitzRoy Massif of

Argentina in dramatic grandeur and sheer picturesque presence. Sandwiched between glaciers, forests and arid plains, this park also presents ideal habitat for virtually all of the wildlife species of the region. Patagonian gray foxes slink among the thorny bushes under the wary eyes of rheas, while great herds of long-legged guanacos – taller and heftier relatives of the vicuñas – keep a lookout for the many pumas that make incursions from the surrounding rocky ravines and caves. The higher peaks and canyons make ideal condor territory, from where these birds can search the pampas for the predators' spoils.

Deservedly, this delightful bonanza attracts many thousands of visitors to Torres del Paine. But long before the bridges, roads and hostels that make it so accessible today had been completed, I was lucky enough to take a week-long hike all the way around this breathtaking wilderness. Teaming up with a couple of other hikers, we bush-whacked through tangled forest, forded glacial rivers, tip-toed on fallen logs across thundering torrents, camped in secluded meadows and crossed over rocky passes above the tree line. We marveled at the great sea of ice where the huge Grey Glacier flows off of the icecap, watched the blood-red sunrise wash over the rocky needles in the distance, played in the cooling spray of rainbow-spangled waterfalls, and gasped at the raw force of the wind tearing spume from the lake surface and piling lenticular clouds over the highest peaks. Then as now, Torres del Paine is a glowing gemstone in the natural treasure chest of the Andes, deserving of the long-standing protection it has received.

THE END OF THE CONTINENT AND CAPE HORN

After sailing south for over a thousand miles my sea voyage makes a sudden dogleg due east. This is where the mountains descend to their lowest levels and the Magellan Strait cuts a huge, unprecedented gash directly across the very backbone of the continent, connecting the Pacific Ocean with the Atlantic and severing Tierra del Fuego from the rest of South America. Along the southern edge of this 28,455-square-mile (7.37-million-ha) island the Andes regain their stature in the Darwin Cordillera rising above 8000 feet (2400 m), from whence bejeweled glaciers pour almost vertically down into the narrow Beagle Channel. And here too soars the condor above the most inaccessible cornices of rock and ice, its sharp eyes scanning the intricate shorelines for stranded whale carcasses. From these lofty heights it may gaze over both oceans in the distance, like a mountain spirit presiding over the very tip of the continent.

Indeed from here the Andes, fragmented into a final jigsaw puzzle of interlocking islands, curl eastward as if swept away by the ferocious winds that blow round and round the globe, looping unimpeded through the Southern Ocean surrounding Antarctica. Innumerable islets and rocks pepper these notoriously tempestuous waters.

The final expression of the Andes raises its head defiantly at Cape Horn – in fact not a cape at all but the southernmost of all the Andean islands of Patagonia. Miniature trees cling to its ravines while tussock grass covers its fog-enshrouded hills and lichens encrust its seaward cliffs, where thousands of desperate shipwrecked sailors met their tragic end over the centuries. At home in these tumultuous waters, Magellanic penguins come ashore on Cape Horn's beaches to dig their nesting burrows, stalked by massive South American sea lions hiding in the kelp fringe. Daintier rockhopper penguins nest on even more exposed islands to the west, while great albatrosses soar right on past, nesting on the remote Diego Ramirez Islands just 60 miles (96 km) further offshore. Beyond the Drake Passage to the south, the Antarctic Peninsula reaches its thin arm up as if trying not to let go of its sister continent from which it separated all those eons ago.

And so the Andes end – far, far away indeed from the Caribbean Sea, having defined the entire edge of a continent and given rise to the most magnificent variety of natural habitats on earth.

The mist-shrouded shores of legendary Cape Horn mark the last outpost of the Andean mountain chain. Buffeted by vicious storms, these shores have claimed innumerable sailing vessels.

FACING PAGE: *Icebergs calved from the massive Grey Glacier flowing off the southern icecap are stranded along the silty lakeshore in Torres del Paine National Park.*

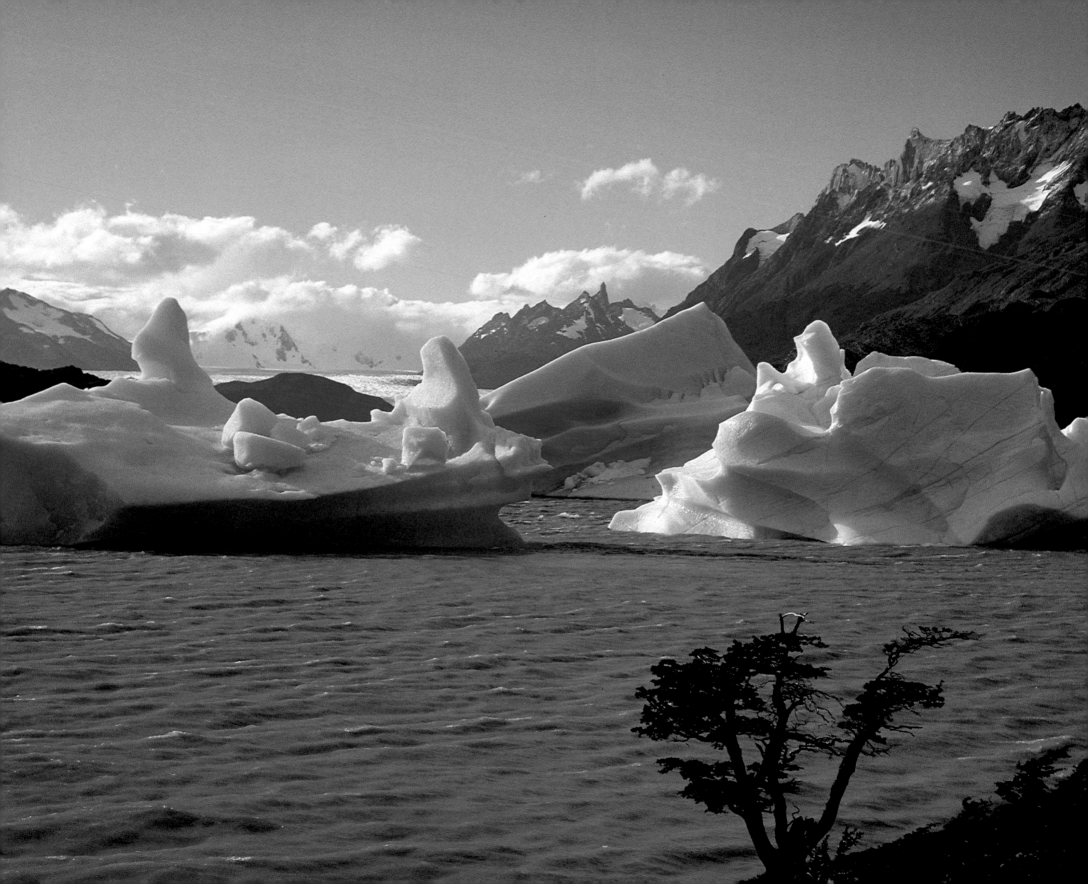

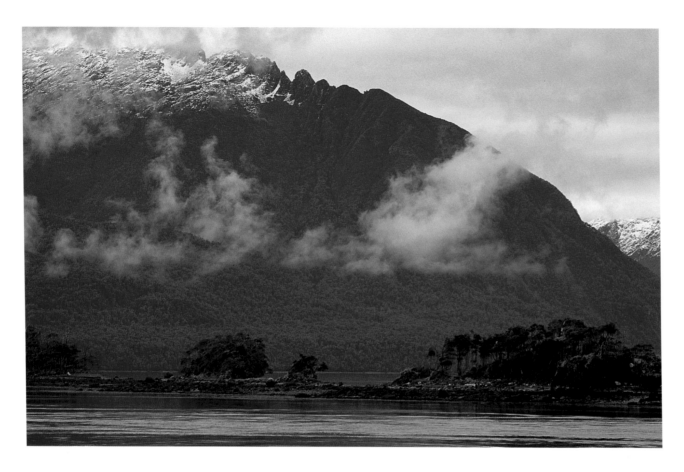

A tidal arm, Rio Tempano connects Laguna San Rafael with the sea.

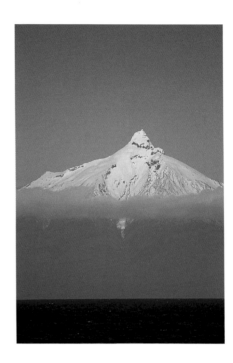

Snow-clad Corcovado Volcano rises out of the sea haze to 7550 feet (2303 m) above the Gulf of Ancud.

Icebergs on Laguna San Rafael come in many hues, shapes and sizes.

FACING PAGE: *Tiers of towering mountains with stunted beech forest flowing down to the sea are the hallmark of the Chilean Fjords.*

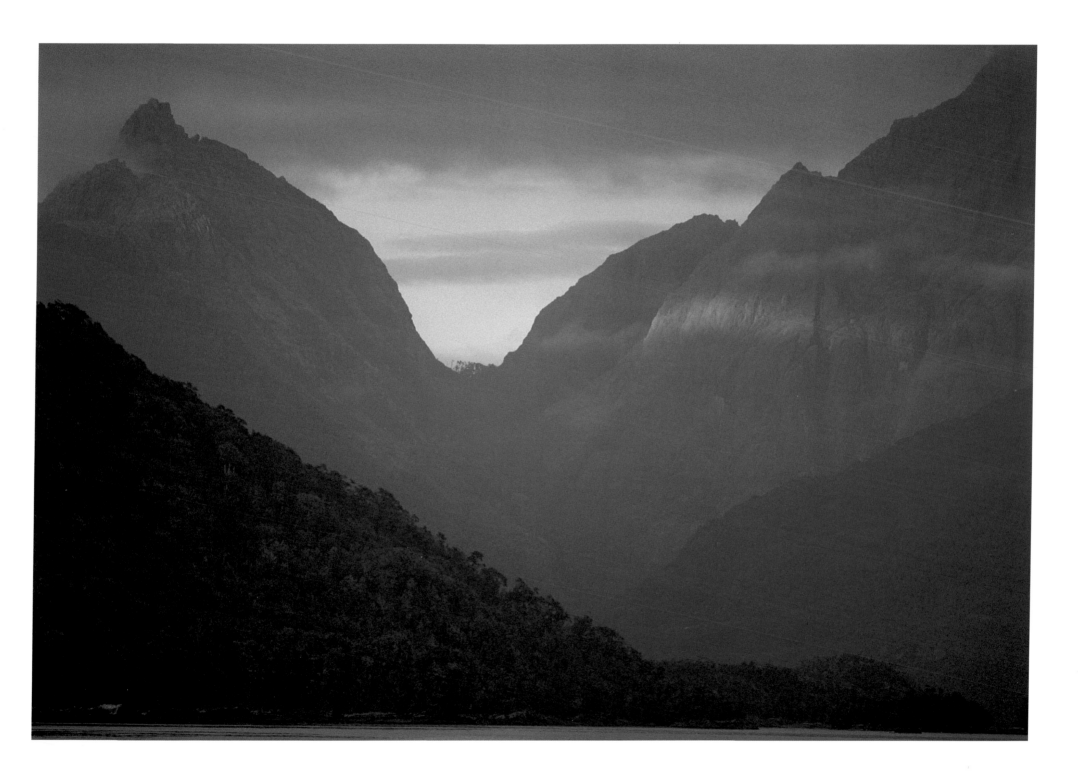

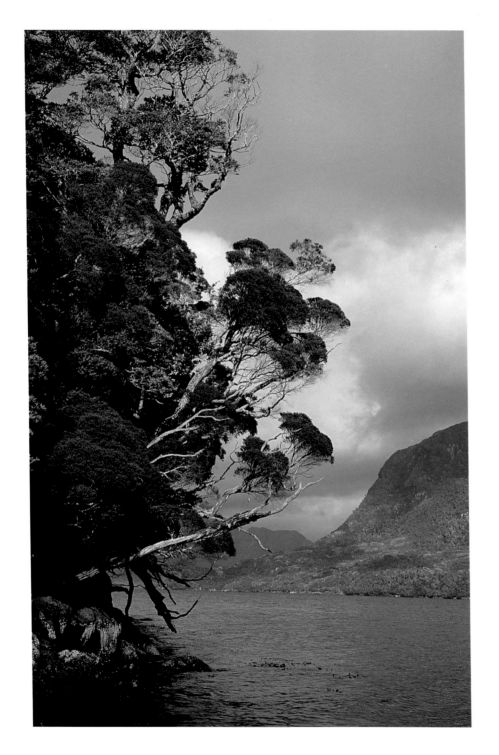

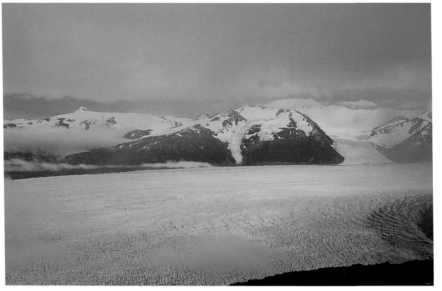

ABOVE: *Like a sea of ice, the vast Grey Glacier wends its way down from the southern extremity of the Patagonian Icecap.*

LEFT: *Dense temperate forest overhangs the sea in the southern fjords, while the tree line soon gives way to bare rock above.*

ABOVE: *Ferns and tropical-looking* Gunnera *plants lining the shores of many fjords contrast with glaciers stretching down to the sea.*

A tiny island at the entrance of one of the fjord systems is crowded with nesting imperial cormorants.

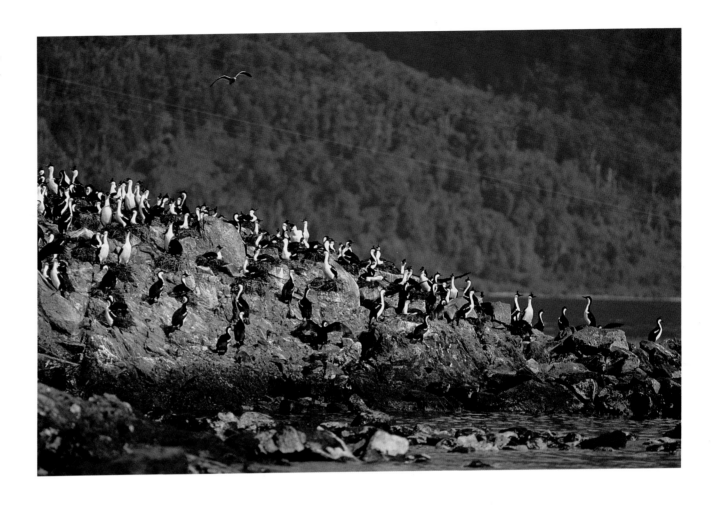

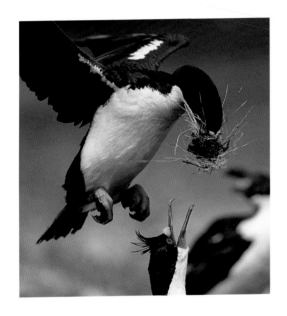

An imperial cormorant delivers a beakful of nesting material to its mate.

Deep in the inland passages of the Chilean Fjords the sun breaks through the clouds between two storm systems.

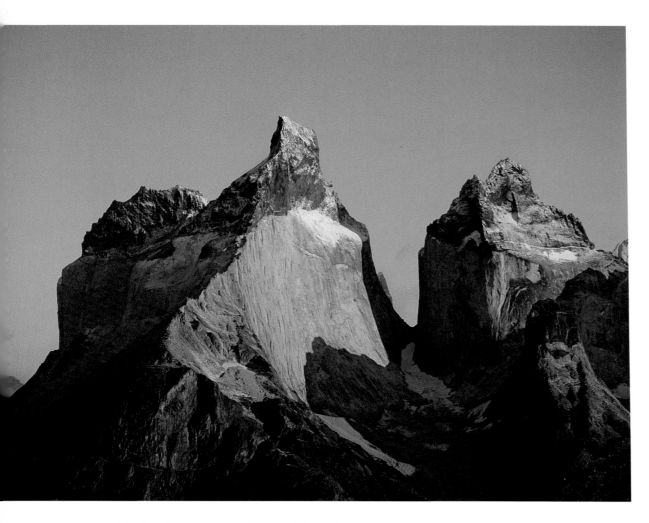

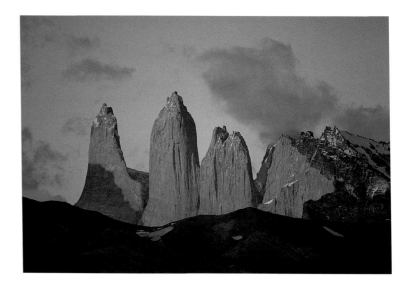

Perfect needles of wind-polished granite catch the blood-red sunrise in the center of the Torres del Paine massif.

The famed "cuernos," or horns, of Torres del Paine consist of a granite batholith overlain with various layers of other minerals.

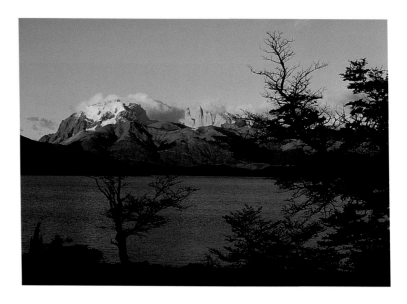

Numerous lakes surround the storm-lashed peaks of Torres del Paine.

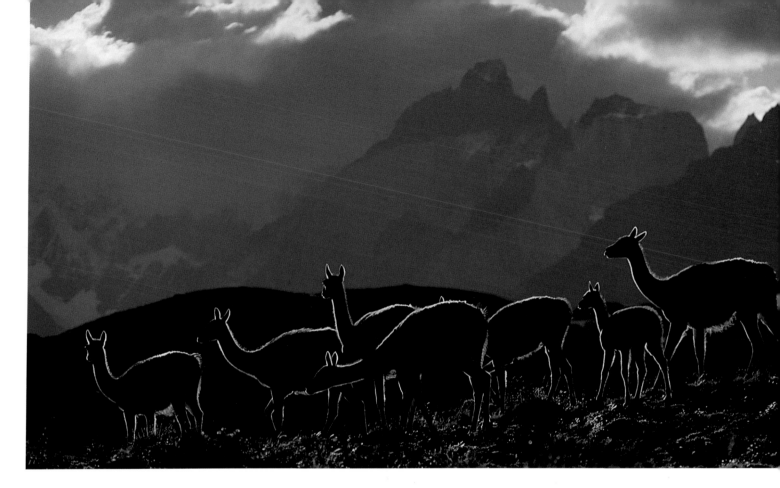

Guanacos and clouds catch the cold light of
an afternoon storm where the peaks of
Torres del Paine tear at the roiled sky.

A grazing guanaco is outlined against a
tapestry of scuttling clouds over Torres
del Paine National Park.

Where the mountains
give way to the plains, a
Patagonian gray fox rests in
the shade of a spiny bush.

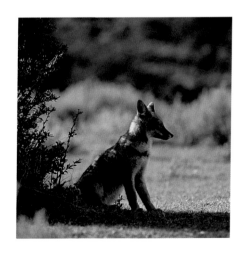

A lesser, or Darwin's, rhea feeds
on the dry grasses and seeds typical of
the steppes that border the southern
sounds and Magellan Strait.

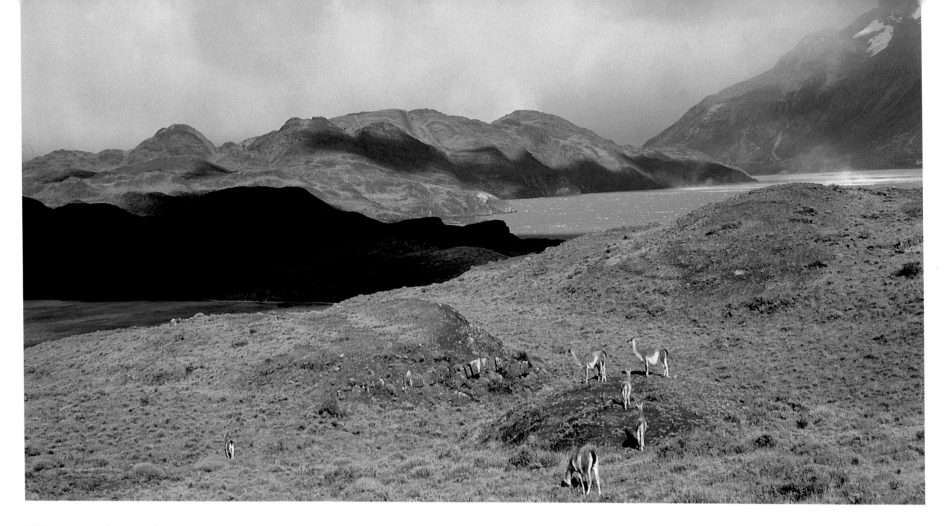

While squalls lift spume from the surface
of Lake Nordenskjold, guanacos remain
impervious to the harsh climate of these
southern latitudes.

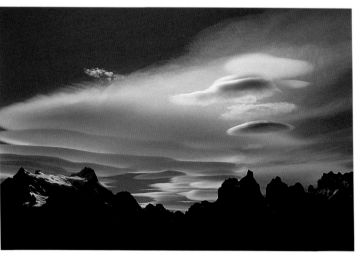

Layer upon layer of
lenticular wind clouds mimic
the contours of the Torres del
Paine mountains.

FJORDS, ISLANDS, GLACIERS AND STEPPES

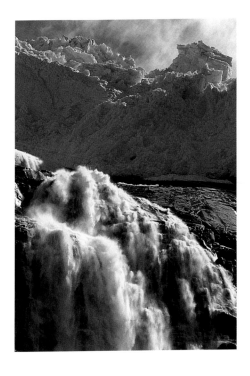

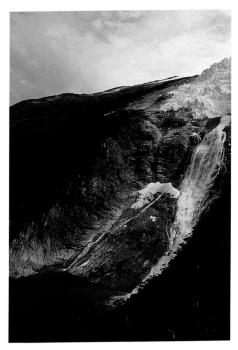

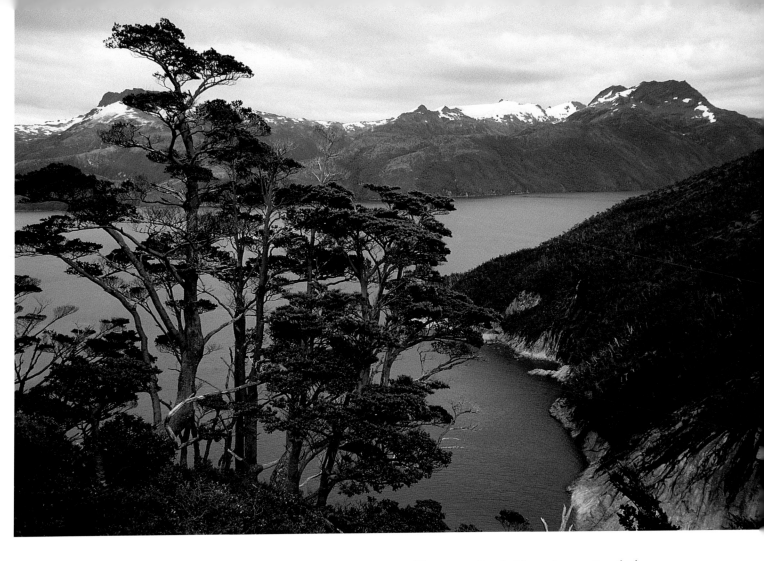

ABOVE LEFT: *A roaring waterfall surges from the base of hanging Romanche Glacier and cascades into the Beagle Channel.*

LEFT: *The further south one travels through the Chilean Fjords the stronger the impression that the sea rises into the mountains. Here the Romanche Glacier spills directly into the sea.*

The narrow Beagle Channel separating the large island of Tierra del Fuego from Hoste Island is an encased waterway that connects the Atlantic and Pacific Oceans south of Magellan Strait.

Elegant black-necked swans cruise the calm waters of the deep sounds at Puerto Natales.

RIGHT: Wetlands and estuaries are favorite feeding areas for flocks of ducks, geese and Chilean flamingos.

FAR RIGHT: The territorial flightless steamer duck is a massively built bird that feeds on mussels and other shells, which it crushes in its vice-like beak.

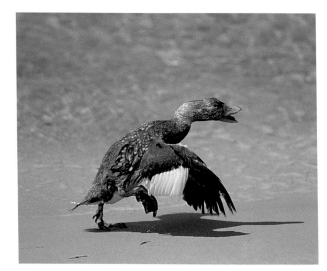

On a perfectly windless day a giant petrel skims the surface of the silky smooth waters of Magellan Strait.

BELOW LEFT: *The kelp goose gander is completely white, while his mate sports complicated black patterns. These birds feed exclusively on sea lettuce.*

BELOW CENTER: *The ashy-headed goose is the rarer and more southerly of the three sheldgeese found in the Chilean Fjords.*

BELOW RIGHT: *An upland goose family strolls proudly across the coastal heath vegetation.*

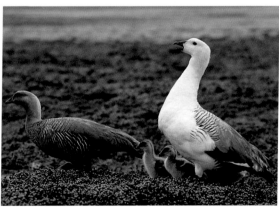

PREVIOUS PAGE, LEFT: *A courting gray-headed albatross stands over its partly constructed nest on the tussock covered tops of the Diego Ramirez Islands, small rocky outcrops some 60 miles (96 km) offshore from Cape Horn.*

PREVIOUS PAGE, RIGHT: *Seabirds of the Southern Ocean frequent the maze of islands around Cape Horn and travel deep within the fjords to feed in tidal upwellings. Top row, from left to right: imperial cormorant in courtship plumage; rock cormorant landing at the nest and another rock cormorant in breeding color. Middle row, left to right: southern giant petrel; Magellanic penguin. Bottom row, from left to right: rockhopper penguin, wandering albatross, gray-headed albatross and black-browed albatross.*

Black-browed albatrosses glide on the wind as the islands and sea stacks surrounding Cape Horn loom through frequent squalls.

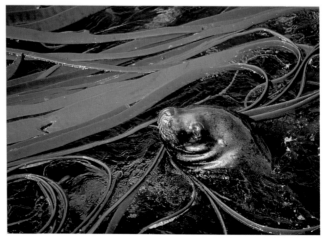

A South American sea lion bull hunts in the fringe of bull kelp along wave-beaten shores.

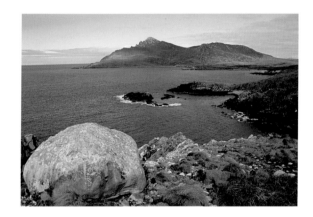

ABOVE: *Cape Horn loses its foreboding air on this rare calm sunny day, when the Southern Ocean appears as tranquil as the tropics.*

RIGHT: *The first sight of land at the tip of South America as a dawn rainbow illuminates a storm over the rugged south cliffs of Cape Horn.*

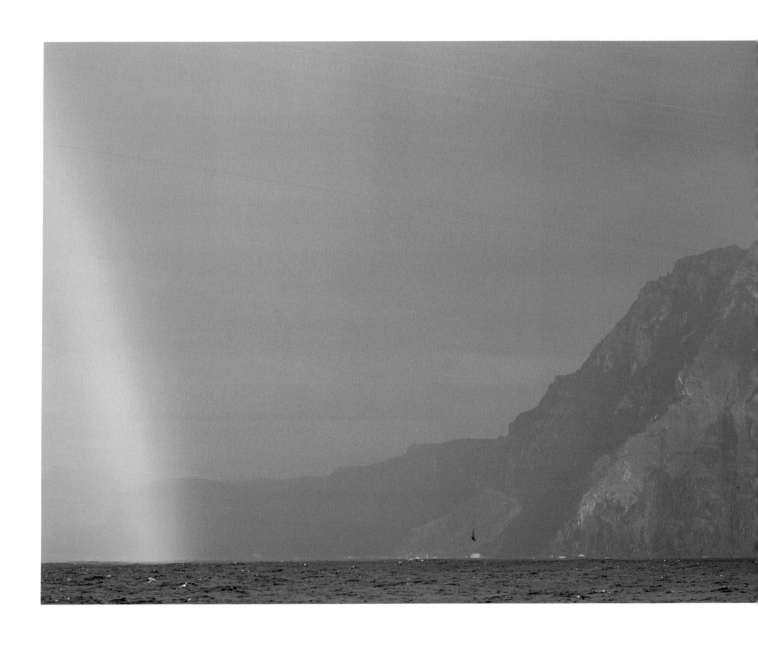

GLOSSARY

Any travel through the Andes is, by necessity, also a journey in linguistics. Although all Andean countries are Spanish-speaking, there are also the ancient and mystifying tongues of the Quechua and other native Indians. The peoples of the Andes and their dialects are as diverse as the mountains and valleys they inhabit, and their place names reflect these roots.

While a basic knowledge of Latin American Spanish pronunciation would perhaps make names like Chuquibambilla flow more easily, in the interest of readability Hispanic references have been translated into their English equivalents. Thus in the text Volcán Llaima becomes Llaima Volcano, Lago Argentino becomes Argentino Lake, and so on. There are, however, a few exceptions, where translation would have rendered the name meaningless (as in Cerro Torre, Brazo Rico, etc.), so for those interested, below is a lexicon of these Spanish words. Also, where possible, throughout the text technical terms and processes have been explained as and when they arise. For clarity, a few of these are further expounded below.

Altiplano Vast high-altitude plain or plateau in southern Peru and western Bolivia, bounded by mountains, covering some 72,000 square miles (185,000 km²) and averaging 12,000–13,000 feet (3600–4000 m) elevation. *Compare: paramo and puna.*

Amazon basin Vast lowland area with the Andes to the west, the Atlantic Ocean to the east, and the Guyana and Brazilian highlands to the north and south. Extending over 2.2 million square miles (6 million km²), with its river systems carrying a fifth of the world's running freshwater, the area generates its own weather systems that penetrate deep into the Andes, greatly influencing high-mountain climate and habitats.

Atacama Desert Cold, generally lifeless coastal desert in northern Chile, contiguous with the Sechura Desert (q.v.) to the north, and one of driest areas on earth.

batholith Massive dome of volcanic (or igneous) rock solidified underground and later exposed by erosion.

Beagle Channel The winding, navigable channel between the large island of Tierra Del Fuego (q.v.) and Navarino and other islands of southernmost Chile.

blanca/blanco White

bofedal Permanent high-altitude bog and spongy wetland.

brazo Arm or branch, used here in reference to sea or lake.

celeste Blue, usually sky blue.

cloud forest High-altitude, tropical rainforest wreathed in almost perpetual mists, and characterized by heavily overgrown and tangled vegetation festooned with epiphytes (q.v.).

colorada/colorado Red (or colored)

Cordillera Contiguous chain or range of mountains.

El Niño Periodic disturbance in regular weather patterns and ocean currents along the Ecuador-Peru coast; the term means "the child" since it manifests itself around Christmastime. Characterized by exceedingly high rainfall and warm waters associated with a catastrophic crash in productivity of the marine ecosystem, which may cause enormous mortality among the seabirds of the Guano Islands (q.v.).

epiphyte Any plant growing upon, but not parasitic on (i.e., not deriving its nutrients from or otherwise detrimental to) another plant.

geyser An intermittently gushing or fountaining hot spring. The term derives from Geysir, a particular hot spring in Iceland.

Gondwanaland Name of the vast Southern Hemisphere landmass that comprised today's Arabia, Africa, South America, Antarctica, Australia and the peninsula of India. It is believed to have broken up around 300 million years ago, at a time when reptiles dominated and during the rise of the mammals.

Guano Islands Scattered group of arid islands and islets off the desert coast of Peru, famous for their large concentrations of nesting seabirds, and historically exploited and mined of their vast deposits of bird droppings for the fertilizer trade.

Humboldt Current Named after the German explorer-scientist who traveled extensively in the Andes in the early 1800s. With its roots in Antarctic waters, this vast, cold and nutrient-rich upwelling flows for some 2000 miles (3000 km) along the continent's western seaboard, the last tendrils petering out as they veer towards the equatorial Galapagos Islands. Flowing at about 2¼ miles per hour (3.7 km/h) it is one of the planet's most influential currents, defining coastal climates and nurturing the diversity and abundance of wildlife of one of the most fertile marine ecosystems.

Inca Elite and aristocratic American Indian social class of people of uncertain origin, conquering and despotic in their rule, yet highly skilled and technical. Routed during the Spanish conquest, their empire peaked in the 16th century, extending over Ecuador, Peru, Bolivia and parts of Chile and Argentina. Many of their irrigation systems and mountain roads still survive.

lek Specific location, patch of ground, tree etc., frequented by groups of certain birds during their breeding season, where males gather and display collectively to visiting females.

Magellan Strait The wide body of water that links the Atlantic and Pacific Oceans, separating the end of the South American continent from Tierra Del Fuego (q.v.) and associated islands beyond.

massif Closely linked or compact group of mountains or peaks.

muskeg Swamp or bog; a term derived from arctic regions and equivalent to the Andean bofedal (q.v.).

negra/negro Black

nuée ardente *See pyroclastic flow.*

paramo In Ecuador, the wet and lush high-altitude grasslands above the cloud forest (q.v.) tree line. *Compare: altiplano and puna.*

Patagonia The vast, loosely defined region of southern South America beyond 40 degrees south, comprising the mainly arid, windswept steppes (q.v.) and plateaus of both Argentina and Chile, and extending to the islands and fjords of Tierra Del Fuego. Named after the Patagones, an extinct tribe of very tall, "large-footed" Indians.

Patagonian Icecap Remnants of the continental ice sheets of the last ice age some 10,000 years ago, and the only one outside of polar regions.

plate tectonics Accepted theory and mechanism of geologic forces by which the nearly rigid pieces of the earth's crust drift slowly across the earth's surface relative to one another. The boundaries between adjacent plates are associated with well-defined belts of crustal deformation, seismic and volcanic activity.

Pleistocene Geologic epoch that lasted from about 2 million to ten thousand years ago, noted for its succession of ice ages and many extinctions, as well as the evolution of modern mankind.

puerto A port (e.g., Puerto Montt).

puna In Peru, the semi-arid high-altitude plains above 13,000 feet (4000 m). In places grassy or boggy (q.v. bofedales), or sere and desert-like, this region is the principal domain of the largest vicuña herds. *Compare: altiplano and paramo.*

punta Point, used here to refer to a point of land, e.g., Punta Arenas.

puya General name for any of several species of odd-looking flowering plants, found throughout the Andes and belonging to the family Bromeliaceae: a favorite food of the spectacled bear.

pyroclastic flow One of the most violent and devastating types of volcanic eruption, it is essentially an avalanche of superheated ash, lava, incandescent gasses and other debris that can travel many miles at phenomenally high speed. From Pompeii to Pinatubo, these types of eruptions have been responsible for many of the world's biggest natural disasters.

real Royal (or magnificent), as in Royal Cordillera.

Rucu and **Guagua** Quechua words for old and baby (or youngster), describing the two peaks, the latter still active, of Pichincha Volcano in Ecuador.

salar Salt pan (q.v.)

salt pan Mineral deposits, sometimes caustic, left from the evaporation of saline lakes and inland seas.

scoria or cinder Fine gassy fragments of lava, coarser than ash, ejected from a volcanic vent.

Sechura Desert In Peru, contiguous with the Atacama Desert (q.v.) to the south. Though it receives little or no precipitation it is, ironically, characterized by frequent coastal fogs.

steppe Level (or gently rolling) grassy plain.

subduction zone One of several types of crustal boundary (q.v. plate tectonics) whereby the relative motion results in one section of earth's crust being forced beneath another. This is usually a zone of high seismic and/or volcanic activity.

Tierra del Fuego Archipelago comprising South America's largest island, discovered in 1520 by Magellan and named the "Land of Fire" by early seafarers after the many constantly burning fires of the Fuegian peoples. Politically split down the middle by Argentina and Chile, its rugged, ice-shrouded mountains feed multiple glaciers directly into the sea.

Torres Del Paine Towers of Paine, the stark, sheer granitic peaks that lend their name to Chile's most famous national park.

tuffstone Rock formed of consolidated volcanic ash.

verde Green

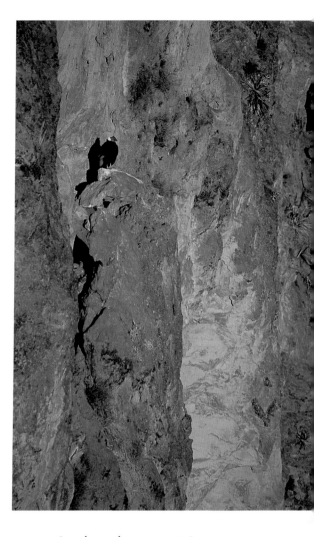

A male condor warms up in the morning sun along the sheer volcanic wall of Peru's Colca Canyon. MARK JONES

INDEX

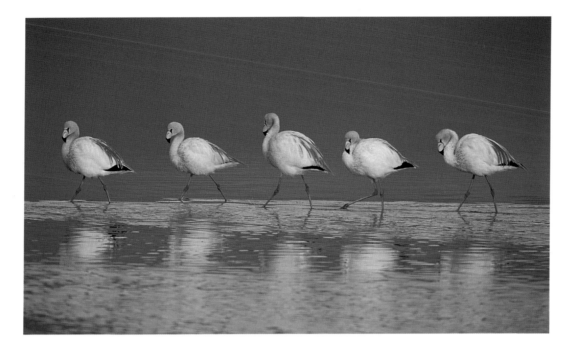

Always sociable, small James' flamingos walk single file through the pink shallows of Laguna Colorada towards their drinking springs.

159